THE
HISTORY OF ART
IN PICTURES

THE
HISTORY OF ART
IN PICTURES

WESTERN ART FROM PREHISTORY TO THE PRESENT

By Gilles Plazy

Preface by Jean Lacouture

MetroBooks

MetroBooks

An Imprint of the Michael Friedman Publishing Group, Inc.

©2001 by Michael Friedman Publishing Group, Inc.

Library of Congress Cataloging-in-Publication Data available upon request.

ISBN 1-58663-331-7

Printed in China by C&C Offset Printing Co., Ltd.

1 3 5 7 9 10 8 6 4 2

For bulk purchases and special sales, please contact:
Friedman/Fairfax Publishers
Attention: Sales Department
230 Fifth Avenue
New York, NY 10001
212/685-6610 FAX 212/685-3916

Visit our website:
www.metrobooks.com

Works reproduced in this book are described as completely as possible.
However, certain information is not provided (dates, dimensions, etc.)
if its accuracy cannot be determined.

H: height
L: length
W: width
D: depth
diam: diameter

Dimensions are described using metric measurements and may be converted
as follows:

1cm = .39 inch
1m = 39.37 inches (3.28 feet)

FOREWORD

The reader of this book may be wondering: Is it really necessary to add another book to the already impressive list of works dedicated to the history of art? What can be added to a field that has been exhaustively explored? The answer lies in the title we have chosen for our book—*The History of Art in Pictures*—a program that aims to fill what we felt was a gap. The 1980s saw the emergence and development of cultural politics: the creation of museums, the organization of exhibitions, pay-what-you-will days, and other initiatives widely covered in the media. Since then, the general public has shown a renewed interest in art in all its various forms, but also a certain confusion when faced with what this audience sometimes considers a closed universe.

The number of general art books, monographs, and exhibition catalogues has since multiplied. However, a large proportion of these works—which tend to be long and dense and assume that the reader has prior knowledge—remain difficult and are often expensive. At the other end of the spectrum, the public is being offered books of lesser quality at a lower price.

What was missing was a book like ours: a history of Western art that is as comprehensive as it is possible to be in a medium-sized book, a sort of condensed encyclopedia that is accessible, but with high-quality text and reproductions.

Above all, the book's originality and interest lie in the primacy given to the image. We thought it was stimulating to trust in the didactic power of the image to illuminate what are, after all, artifacts of the visual domain: painting, sculpture, and architecture, the major forms of art that have played a privileged role in the history of humanity and human societies.

The reader may browse through this book as if wandering through a museum that displays key works of Western art in chronological order and gives the works themselves pride of place.

Like a museum, we have grouped the works in a way that sheds light on their significance. A general introduction summarizes each period in the history of art (prehistory, Egyptian civilization, etc.); a few lines of commentary accompany the reproductions of the works that follow. The brief texts throw historical light on the works as well as introducing the aesthetic concepts (schools, styles, etc.) that help in understanding them.

Representing in less than 200 images the essence of Western painting, sculpture, and architecture obviously required that choices be made, and entails regret at the absence of certain painters, monuments, or sculptures. We attempted to draw the map of a vast heritage—vast in space and in time—with its main byways, territories, and frontiers, rather than surrender to the artistic hierarchy that would have imposed itself on a longer work. This approach allowed us to present more artists and in a more "egalitarian" manner—with one work apiece.

Another of our ambitions was to include side by side in this book the most widely known and loved works, which have long been appreciated by consensus (such as Leonardo da Vinci's *Mona Lisa*), great watershed works (Paolo Uccello's *The Battle of San Romano*, the Il Gesù church in Rome), and works once considered marginal (Art Pompier, Symbolism) but later reevaluated.

We thus hope to offer the reader a history of art that is rich, lively, and accessible.

The publisher

ART—THE BEAUTIFUL ENIGMA

Blaise Pascal was surprised that painters were admired, as they do nothing but reproduce the most ordinary objects—flowers, pitchers, faces—instead of paying homage to the one and only Creator. Pascal thus demonstrated how a great thinker could approach a subject every bit as worthy of attention as mathematics the wrong way—even as the wealthiest of his contemporaries in Antwerp or Madrid hurried to acquire paintings by Rubens or Velázquez because they found them lifelike enough to ornament their halls.

Was it necessary to wait for Diderot, Baudelaire, and Élie Faure to recognize that art is nothing but discrepancy, rupture, and transgression? That it is precisely the thing that disrupts nature, either by

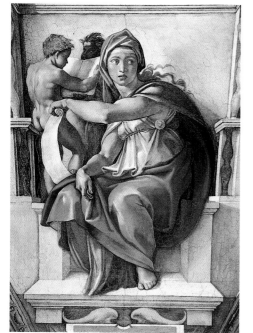

[1]

affront or by addition? "Produced, not reproduced," wrote Gaétan Picon, as much about Manet as about Kandinsky, thus suggesting that the artist is he or she who jumps from the known into the unknown. Are painters and sculptors God's rivals? More Promethean than Prometheus, they do not steal fire, but rather create a different light.

The subject of this book is vast. It is about art: where does it start, or finish, its insurrectionary competition with nature? With the aurochs of the Altamira caves? With a Sumerian bracelet? With the first bridge built across the Yangtze or with the woven cloth covering Alexander's saddle?

We are told—by Ruskin among others—that art is defined by its uselessness. How does that apply to the votive *ushtebi*, which was made and then left at the feet of the statue of the Nile god Api? To a bust of Cybele or the harvest god of the Uzbeks? Are these objects, intended to raise the water level or increase the harvest, useless? What is there to say about the *Visitation*, piously painted by Fra Angelico to ensure his salvation? Perhaps the act of artistic creation can be defined, in the end and arbitrarily, as the act of someone who thereby proclaims himself or herself a creator—even if such an act consists of attaching a rag to the picture rail.

In this book, we will concentrate on "Western" art. This is an audacious qualification and more difficult to apply to art than to industry or military strategy. The physical border is unclear in the Urals, Shiraz, and the Horn of Africa. Who is west of whom? And the spiritual border? Should it be sought in the concept of the individual, in the relationship between the artist and the museum, or the one between the work and money?

Malraux held that the idea of the museum (a very recent phenomenon: two centuries old, strictly speaking) is unknown in Asia and that, in China, the notion of the work of art is more closely tied to wealth than it is in the West. It is also true that, in Christian Europe, the conjunction of the figure

[1] Michelangelo Buonarroti (1475–1564); *The Delphic Sibyl*, 1508–1512. Fresco. Detail of the vault, Sistine Chapel, Rome.

[2] Pablo Picasso (1881–1973); *The Sculptor*, December 1931. Oil on plywood. H: 1.28m; W: 0.96m. Paris, Musée Picasso.

and the eternal is an incomparable and very specific source of creation—until their dissociation led to an unreality that feeds the art of today.

We usually situate this West where creation originated in the Greece of twenty-five centuries ago. But isn't it tempting to see it manifested on the margins, where the symbiosis between Egypt and Hellenism took place on the banks of the Nile in the epoch of the Ptolemies? Or, even more, around the fourth century A.D., when Christianity and Latinity informed the portraits of El-Fayoum? At the same time we are tempted to say that, for centuries in the West, just as glory is said to be mourning bursting with happiness, so art seems to be mourning bursting with faith.

Things get complicated when, talking about art, one arrives at its history. Is the very concept of history—the search, amidst the fragments of tangible "truth," for a necessary or accidental causality between the successive phases of collective life—only applicable to monuments of creation?

What links Pepin the Short to Louis-Philippe—a certain material, a certain space, a certain human group, a certain climate, if not a specific project—may also link the painter of the Saint-Savin frescoes to Soulages or Jean Fouquet to Yves Klein. But by what routes? For what reasons? The historical process

doesn't really fit with aesthetic creation. At the same time as he was involved with Marxists in Moscow, André Malraux, keen on history as he was, warned his comrades against reducing the work of art to history. In *L'Intemporel* (The Timeless), he wrote, "The history of art does not give an account of the world of art. The masterpiece belongs to history, but not only to it. It is of its Time, but also in our Time." (André Malraux, *L'Intemporel* [Paris, Gallimard], p.132) (This is not, of course, a stranger to history, to its flow and its rhythms.)

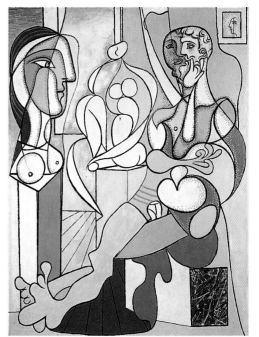

[2]

This is not to dismiss the power of time or the misadventures of duration, or to ignore the watersheds. There is, for instance, the well-defined break that (at least in the West) separates the art-prayer, based on petition, adoration, or ritual, from a creative activity inscribed since the Renaissance into power relations, be they ecclesiastical, political, or economic. Or the gulf between the ambition of Maurice Denis, master of "forms and values in a certain order assembled for delight" and that of creators who were indifferent to references to "the beautiful" (beginning with Manet, with *Les Demoiselles of Avignon*?), seeking only the emergence of an alternative world.

So, in the end, history. A very free history of something that we will call art, that is linked to this collection of forms and concepts held to constitute the West. A West with neither borders nor shores...

SIGNS IN THE NIGHT

Prehistory is the very long first period of human history. For our purposes, let's agree that history began with the appearance of writing. Writing is supposed to have enabled the development of civilization, but more importantly, it is what furnishes historians with archives. We only have a few objects, often reduced to fragments of debris, that document the oral cultures that preceded writing. We have the accounts of travelers to tell us about those cultures that didn't have writing but whose neighbors did.

Humanity, however, did not wait for writing to have an intellectual, artistic, and spiritual life. Language—and therefore thought—achieved great complexity before it was written down: works of art are evidence of this. People sang, danced, prayed, and created before writing existed, and we know— we have proof—that the making of art mattered to the primitive beings who are our ancestors.

As for the plastic arts, their appearance in Europe can be dated to around 35,000 B.C., during the Upper Paleolithic Age. Humanity had already experienced two great revolutions, those of fire and of carved stone, but its economic activity was still limited to hunting, fishing, and gathering. Around 7000 B.C., human beings discovered agriculture, and their way of life was completely transformed: once content to use the world, people started to transform it and a new age began—the Neolithic.

The most ancient works are tablets of bone or stone, marked with incisions and often colored with ocher. We have no clues to their significance or to how they were used. They were the first objects, the first signs, the first paintings. Then came the first images—animal figures, incomplete at first, then more elaborate, designed or engraved on rock walls; small female statues with opulent curves; and handprints. The first are thought to have a magical function linked to hunting, the second are thought to have been used for fertility rites, while the function of the third remains a mystery.

[1]

Ever since, art has been part of human life, and a sumptuous figurative style flourished for some 10,000 years, resulting in the splendid horses, bulls, stags, bison, and other animals painted in the darkness of the caves of Lascaux in France and Altamira in Spain. Artists about whom we know nothing were already capable of a great figurative style, which had no decorative goal, since it

[1] Bison. Magdalenian (c. 18,000 B.C.). Deer antler, H: 10.5cm. From the cave of La Madeleine (Dordogne, France). Saint-Germain-en-Laye, Musée des Antiquités nationales.

[2] Head of a woman, known as the "Venus of Brassempouy." Gravettian (c. 27,000 B.C.). Mammoth tusk, H: 3.6cm; W: 1.9cm; D: 2.2cm. From Brassempouy (Landes, France). Saint-Germain-en-Laye, Musée des Antiquités nationales.

[3] Painted stones. Mesolithic (c. 10,000 B.C.). From Mas-d'Azil (Ariège, France). Stone, L: 7–10cm. Saint-Germain-en-Laye, Musée des Antiquités nationales.

[2]

could only be seen by torchlight or simple oil lamps. These cave paintings by primitive humans, who left no other wrought traces of their passage, were only discovered in the nineteenth century; however, they have endlessly surprised us since then with their technique, sensitivity, and beauty. All the more so as the researchers who specialize in prehistory are now convinced that the abundant ornamentation of the caves, produced under extremely difficult conditions, was not only not haphazard but may have been executed according to a plan extending to several chambers.

At the end of the Paleolithic Age, humans were great artists, although they were still only primitive beings who could scarcely be distinguished from animals. But they evolved more and more quickly, fashioned tools that were better and better made, developed sophisticated techniques, constructed shelters, worked the land, domesticated animals, and formed complex societies in towns of several thousand, perhaps even several tens of thousands of inhabitants.

In the seventh millennium B.C., Çatal Höyük, in present-day Turkey, spread over thirty acres (12ha), its houses decorated with frescoes and bas-reliefs. The Neolithic Age is the period during which human beings slowly entered history by inventing civilization. Pottery, which appeared in Japan around 10,000 B.C. and in Africa during the eighth millennium B.C., spread throughout Asia around the end of the seventh millennium B.C., at the same time as copper began to be worked. We can thus speak of several civilizations that were developing more or less in parallel in Asia and the Middle East, while the European continent marked time. The Peloponnese and Crete only discovered agriculture and pottery around 5000 B.C.; northern and western Europe seemed to develop very little.

In Mesopotamia, Egypt, and the Indus valley, cities organized into states and very rich cultures developed, marked by the architecture of temples and collective funerary monuments. Unfortunately, we know little about them and time has left few traces—too few to allow us to draw any convincing conclusions. And then, with the advent of writing, prehistory was no longer prehistory.

[3]

THE STRENGTH OF IMAGES

Circa **30,000** B.C.	Circa **18,000** B.C.	Circa **10,000** B.C.
Cro-Magnon man	Cave paintings of Lascaux	Invention of pottery in Japan

From the beginning, human beings have been artists. Instinctive painters, they have left behind great works, like those discovered in 1940 in the cave of Lascaux. With such an accomplishment, it is not possible to speak of primitive art, but simply of the surging forth of art in all its beauty. Other drawn, painted, or sculpted forms may seem less "aesthetic" to us; they nonetheless represent a singular presence, undoubtedly because they were not born out of a simple game, nor were they merely a pastime. Isolated from the rituals that gave them sense, they bear witness for human beings who are not as foreign to us as the history separating us would have us believe.

An Old Primate

Humans are primates, in the anthropoid category—apes who have lived on Earth for 35 million years. No longer completely ape and not quite human, the Australopithecus made its appearance around 10 million B.C., followed by *Homo habilis* (2 million B.C.), who knew how to use rocks as tools, and then *Homo erectus* who mastered fire and carved stone. The last avatar, *Homo sapiens sapiens*, was a creature who resembled us. Thus, for some two million years and more, the approximate length of the Stone Age, humans have been—human.

❝Before discovering Lascaux, we had never seen the reflection of that inner life that art—and only art—can communicate.❞

Georges Bataille

[1]

[2]

[1] Female statue known as the "Venus of Lespugue." Gravettian (c. 27,000 B.C.). Mammoth tusk, H: 14.7cm. From Lespugue (Haute-Garonne, France). Paris, Musée de l'Homme.

[2] Hunters. Neolithic (c. 5000 B.C.). Red ocher paint on rock, H of figure on left: 19cm. Séfar (Tassili-n'Ajjer, Algeria).

[3] Bull, horses and stag. Magdalenian (c. 18,000 B.C.). Detail of a painted wall, Chamber of the Bulls, Cave of Lascaux (Dordogne, France).

[3] ▶

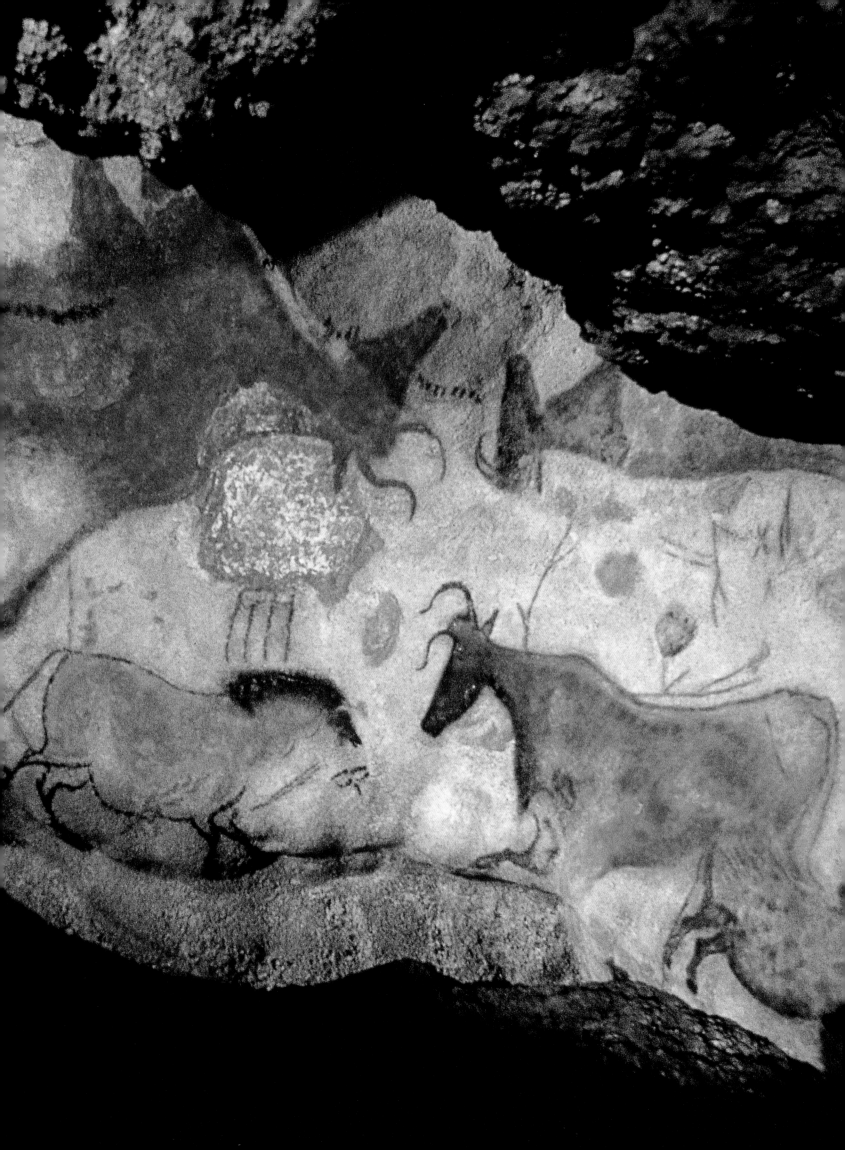

CONSTRUCTION

Circa 4000 B.C.
The first megaliths are erected.

Circa 3800 B.C.
Invention of writing

Circa 2000 B.C.
Bronze Age in Europe

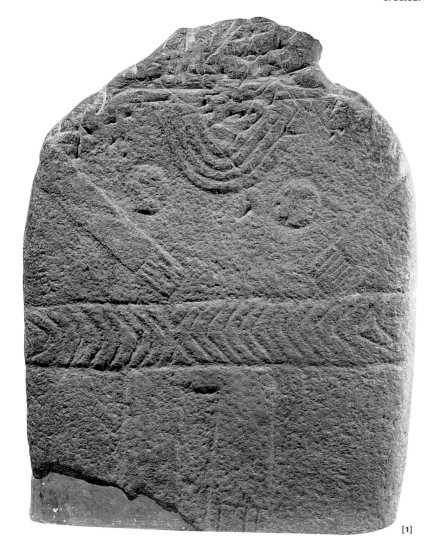

Raised stones and menhirs, signs joining heaven and earth, indicated places of worship. Who met among the alignments at Stonehenge? How could people so primitive accomplish such tasks? A dolmen—a large stone placed on two vertical stones—was the beginning of architecture. Other assemblies were no less extraordinary: tombs containing human remains were already elaborate constructions, their walls a mass of stones. In Barnenez, Brittany, several mortuary chambers were built that supported the weight of millions of stones.

[1] Statue-Menhir, c. 2500 b.c. Sandstone,
H: 80cm; W: 38cm; D: 13cm. From Serre Grand
(Aveyron, France). Saint-Germain-en-Laye, Musée des
Antiquités nationales.

[2] Group of megaliths, Stonehenge (England).
3100–1550 B.C. Diam: 110–120m.

[3] Funerary chambers of the burial mound, Barnenez
(Finistère, France), known as the "Barnenez Cairn,"
c. 4600 B.C.

[3] ►

[1]

[2]

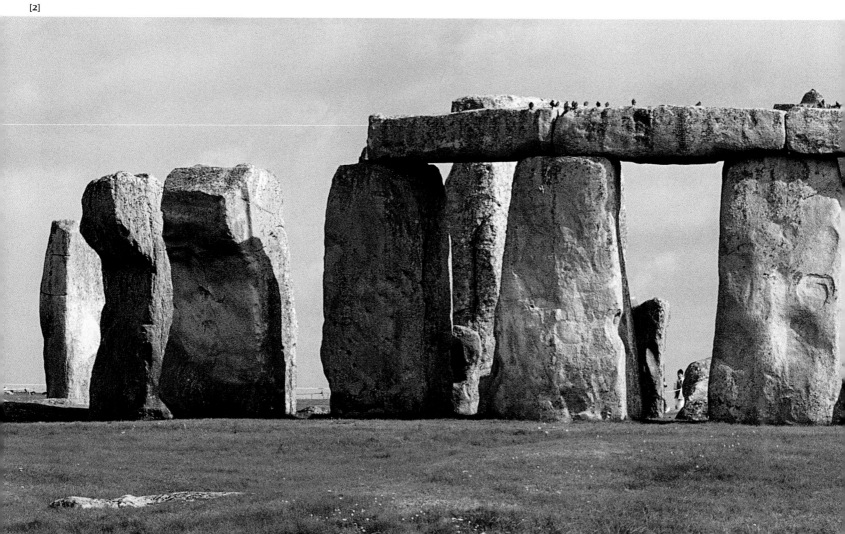

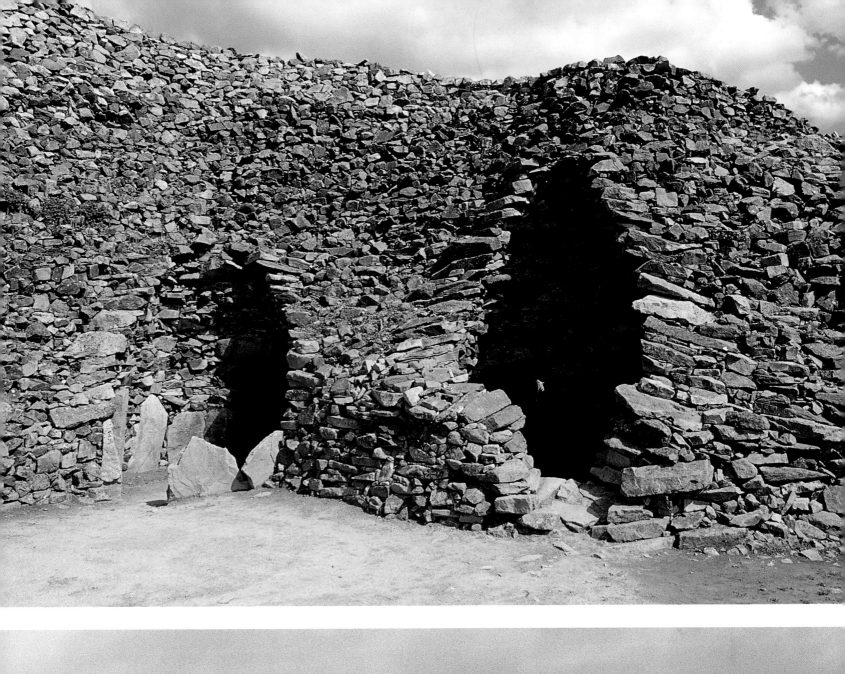

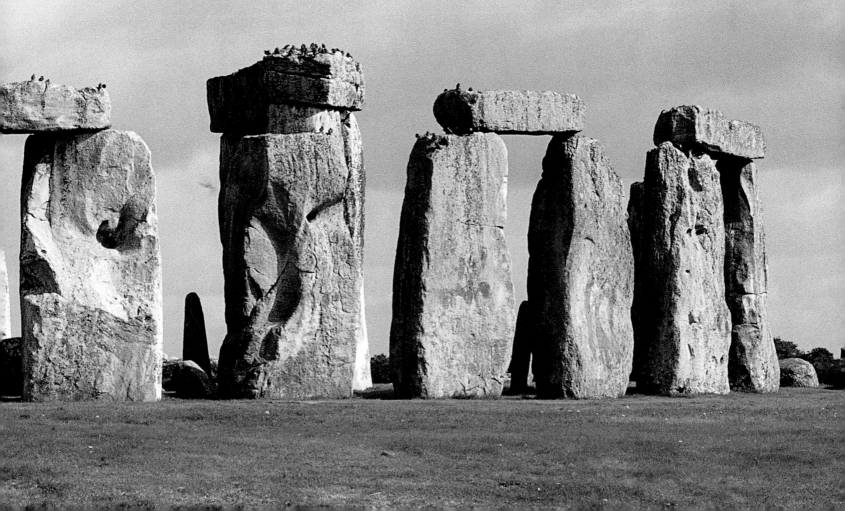

THE AGE OF THE PHARAOHS

The pharaoh has died. It is time for him to go among the gods, among the stars, into that other world from which he came through his father, the god who fashioned him on a lathe from a little silt of the river whose flood makes the plain fertile every year. It is true that the breath has left his body, but kings do not die—as the gods do not die. They pass through the gate that separates the two worlds. The body of the pharaoh will be kept, embalmed, mummified in bandages, sealed in a luxurious sarcophagus and protected in a strong room beneath an immense funerary palace—the pyramid. For all eternity, they thought.

Everything was prepared during the pharaoh's lifetime. Along with his royal architect, the pharaoh himself designed his new home. He chose the artists who would create his portraits, both painted and sculpted, on the walls of the chambers of his mortuary apartment. In very ancient times, his loved ones, servants, slaves, and the women of his harem would accompany him—so as not to leave him alone. But customs changed. Human sacrifices were no longer fashionable. Images were sufficient. This was the function of these paintings: they replaced human beings, symbolically representing those whom the king would need with him in the afterlife.

Egyptian art is essentially funerary art, originally marked by death, of which it is one of the ritual elements. It is a sacred art that celebrates a god incarnated in a man (because the pharaoh is divine) and the other gods who direct human lives. It is a secret art sealed in the darkness of tombs.

The puzzle of the pyramids has been greatly exaggerated. Like the Greeks who placed her on Oedipus' path to question the human condition, we have speculated endlessly about the Sphinx. Science, however, is less perplexed than some would like to believe. It teaches us much about ancient Egyptian life, the pharaohs, and the beliefs of a people who left many documents behind.

Of course, these documents remained a mystery until Jean-François Champollion deciphered them during Napoleon's campaigns in Egypt.

[1]

[1] The goddess Sekhmet. 18th Dynasty (c. 1450–1310 B.C.). Diorite, H: 1.78m (not including restored disk). Probably from the temple of Mut, Karnak. Paris, Musée du Louvre.

[2] Alley of sphinxes with rams' heads, Temple of Amon-Ra, Karnak. 19th Dynasty (c. 1310–1200 B.C.). Sandstone.

[3] Head of Nefertiti. 18th Dynasty (c. 1450–1310 B.C.). Limestone, H: 50cm. Berlin, Ägyptisches Museum.

[4] Pharaoh Psamtik II presenting Osiris. 26th Dynasty (c. 650–525 B.C.). Diorite, H: 28cm. Paris, Musée du Louvre.

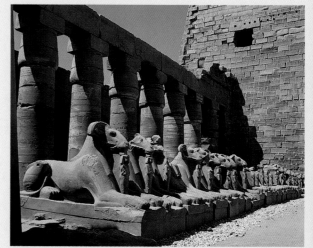

[2]

From Egypt to the Middle East

We are now able to consider with a little more objectivity a civilization whose principal characteristics remained unchanged for three millennia.

Such stability is unique in human history. Thus, Egypt's influence on the Assyrians, Babylonians, and Persians—and on the West by way of the Greeks, who conquered Egypt in the fourth century B.C. but often left the country as disciples—is not surprising. This is what makes ancient Egypt the first great chapter in the cultural history of the West. It was the mother of religion, philosophy, science, and arts that were relayed through history not only by Greece and Rome, but also by the Middle East.

In the course of ancient Egypt's three thousand years, there were few changes in the style of an art whose standard was high: a monumental, geometrically rigorous architecture, but one largely unaware of the circle or the vault; sculptures of great figurative precision, which multiplied to infinity the face of the pharaoh who reigned over a hieratic body, always represented regally, whether standing or sitting; graceful, decorative, highly colored narrative painting based on linear drawings that mixed head-on and profile views depending on the requirements of the image. (It is easier to draw a face or a foot in profile, as it is to draw a torso or shoulders head-on.)

To criticize the art of ancient Egypt for having repeated itself for so long would be to misunderstand its essential feature: the omnipotence of an artistic code that related more to eternity than to history and that was satisfied to cultivate what it considered to be perfection. The Egyptian artist was a civil servant within a political and religious hierarchy who served the pharaoh and answered to the high-ranking priest who was a master of the art. The god Ptah himself watched to see that the proper artistic order was respected. It should have lasted as long as the sun raced through the sky of day and through the waters of night. But the Egyptians would learn, at their expense and against all their beliefs, that civilizations are mortal. Even though theirs lived on in its influence on the West, less solid civilizations of the same period—such as Sumer and Babylon—did not.

[3]

[4]

THE DIVINE KING

The remains of the pharaoh, mummified and placed in a sarcophagus, were put in an immense tomb, a screen to the entrance of eternity. The pyramids are the spectacular testaments to this rite. Imhotep, in the service of King Djoser in the third dynasty, constructed the first of these pyramids at Saqqarah around 2600 B.C. Its sides mount in steps, while at Giza the pyramids of Khufu, Khafre, and Menkaure reach to the sky in pure geometric perfection. In these sanctuaries, splendid decorative art was condemned to secrecy, as it had been in the prehistoric caves.

> **The king was considered a divine being descended from heaven to reign on earth, and who would, when he left the earth, return to heaven.**
>
> Ernst Gombrich

[1] Palette of Narmer (Narmer, King of Upper Egypt, Triumph of the Peoples of the Delta). 1st Dynasty (c. 3100–2800 B.C.). Shale, H: 64cm; W: 42cm; D: 2.5cm. Cairo, Egyptian Museum.

[2] Pyramid of Djoser, Saqqarah. 3rd Dynasty (c. 2660 B.C.). Base: 109m×121m.

[3] The Sphinx and the Pyramid of Khafre, Giza. 4th Dynasty (c. 2600–2480 B.C.). Pyramid, H: 143.5m; Sphinx, H: 20m; L: 71m.

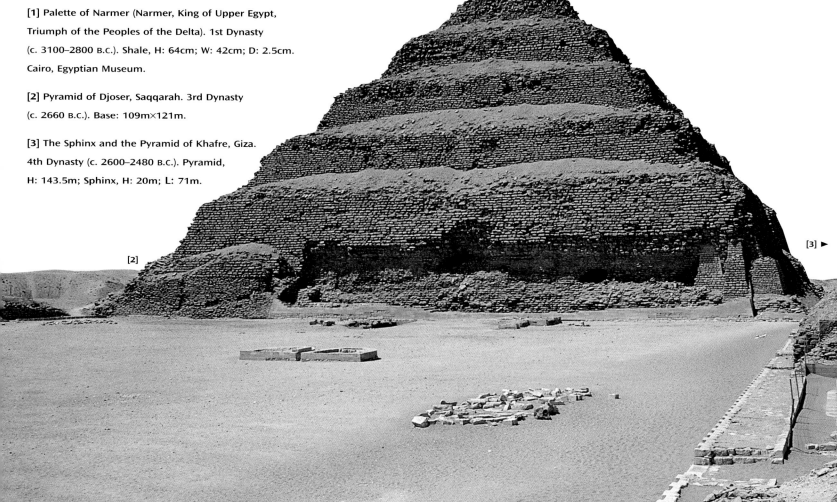

[3] ►

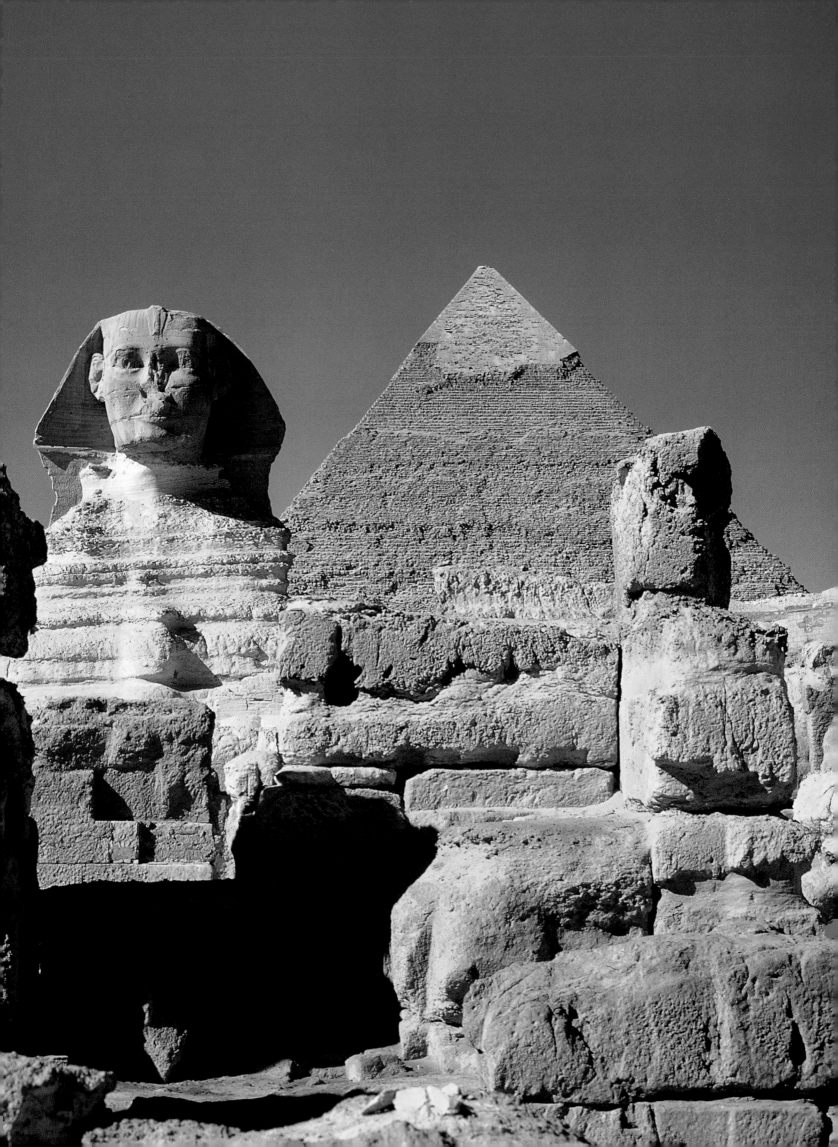

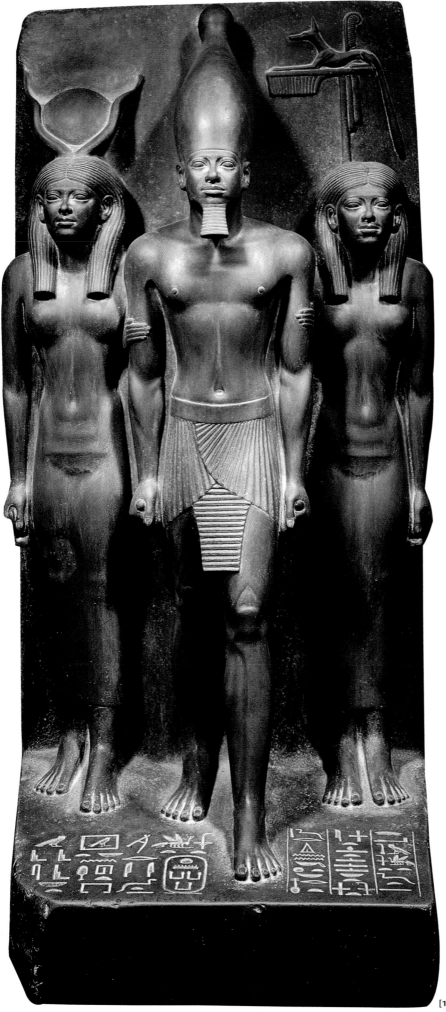

[1]

The Destiny of a Civilization

Thirty dynasties succeeded one another in Egypt. During the Old Kingdom (around 2660–2200 B.C.), the capital of Egypt was Memphis, and the sun god Ra was worshipped. Imhotep constructed the pyramid of Djoser at Saqqarah. The pyramids of Giza soon followed.

Following a civil war, power in the Middle Kingdom (2060–1720 B.C.) was held by the Theban monarchy. Classical art flourished, and trade expanded throughout the Middle East.

The New Kingdom (around 1580–1085 B.C.) was the period of Egypt's greatest power, when it dominated all the Near East. Karnak and Luxor were at the height of their splendor. The Valley of the Kings housed the remains of the monarchs.

In 671 B.C., the invasion of Egypt by the Assyrians marked the beginning of a period of decline and successive defeats. The country would be conquered by the Persians, the Greeks, the Romans, the Byzantines, and the Arabs.

[1] Triad of Menkaure (Menkaure between the goddess Hathor and the goddess protecting the "nome" [district] of Cynopolis). 4th Dynasty (c. 2600–2480 B.C.). Shale, H: 92.5cm; W: 43cm. Cairo, Egyptian Museum.

2700–2400 B.C.
Egyptian explorers go to Libya and Sudan.

Circa 2200 B.C.
Amon-Ra is the empire's chief god.

Circa 1700 B.C.
Egypt is invaded by the Hyksos.

GREAT ART

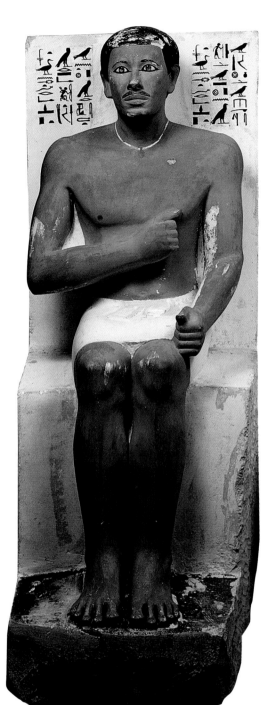

[2]

Painting and sculpture in Egypt were part of architecture: the massive and imposing sculptures themselves appear architectural. Sculpture was placed either inside the temples and pyramids, as elements of the building, or outside, as monuments to complete the structure. More simple and realistic sculptures, such as *The Seated Scribe*, featured people occupied with their daily work.

[2] Statues of Rahotep and Nofret. Beginning of the 4th Dynasty (c. 2600 B.C.). Painted limestone, H: 1.21m and 1.22 m. From the mastaba of Rahotep, Maydum. Cairo, Egyptian Museum.

[3] *The Seated Scribe*. 4th or 5th Dynasty (c. 2600–2350 B.C.). Painted limestone, H: 53.7cm; W: 44cm; D: 35cm. From Saqqarah. Paris, Musée du Louvre.

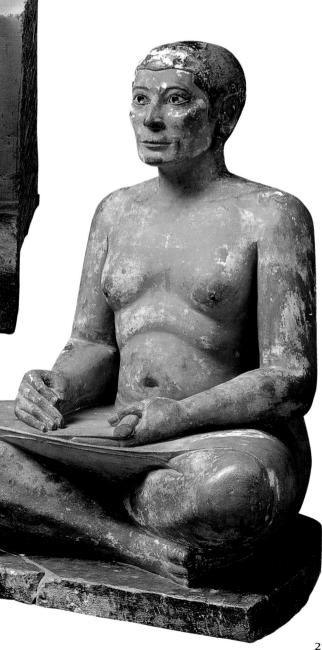

[3]

1580 B.C.
Amenhotep delivers Egypt
from its invaders.

1500 B.C.
Egypt dominates
the Middle East.

1417–1379 B.C.
Reign of Amenhotep III
and flourishing of the arts

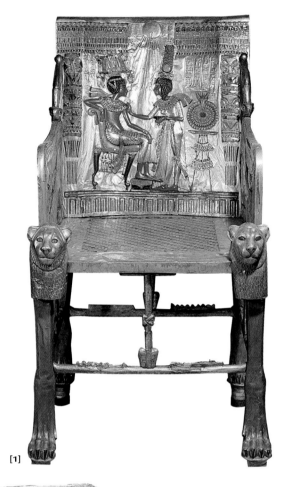

[1]

Amenhotep IV, who succeeded Amenhotep III in the mid-fourteenth century B.C., elected to call himself Akhenaton, because he worshipped Aton, a sun god who was more abstract than his animal-headed rivals. Abandoning Thebes, he established a new capital, Tell el-Amarna. He overthrew traditional artistic rules by having himself depicted in a realistic manner that did not flatter his unattractive physique. His wife, the beautiful Queen Nefertiti, would be the most prestigious sovereign of Egypt until Cleopatra. She bore Amenhotep four daughters and a son, Tutankhamen, who was the last of this unusual dynasty.

> *The Egyptian people looked continually upon death. They provided a spectacle without precedent—and one that would remain unequaled—of a people who, for twenty-four centuries, struggled to stop this universal movement.*
>
> Élie Faure

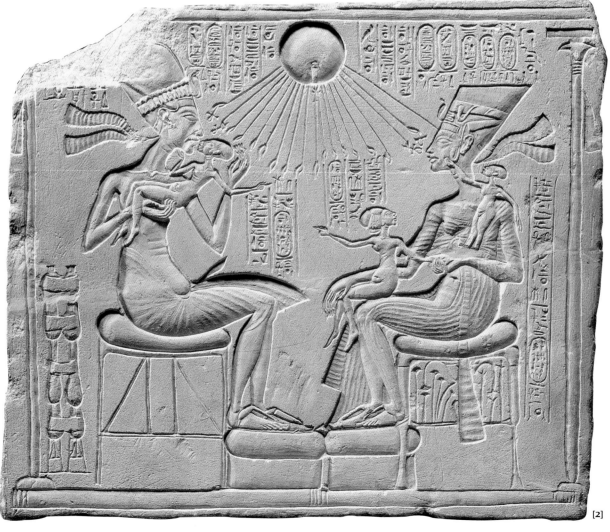

[2]

[1] Throne of Tutankhamen (Ankhesenamen oils the body of her spouse, Tutankhamen). 18th Dynasty (c. 1326 B.C.). Wood covered in gold leaf and inlaid with paste, semi-precious stones, and silver. From the tomb of Tutankhamen, Valley of the Kings, Thebes. Cairo, Egyptian Museum.

[2] Amenhotep IV, Nefertiti and three of their daughters. 18th Dynasty (c. 1340 B.C.). Domestic altar from a house in Amarna. Berlin, Ägyptisches Museum.

[3] *Scene Showing the Official Nebanum Hunting Birds.* 18th Dynasty (c. 1340 B.C.). Fresco. From the tomb of Nebanum, Drah Abu el-Neggah, Valley of the Nobles, Thebes-West. London, British Museum.

[3] ▶

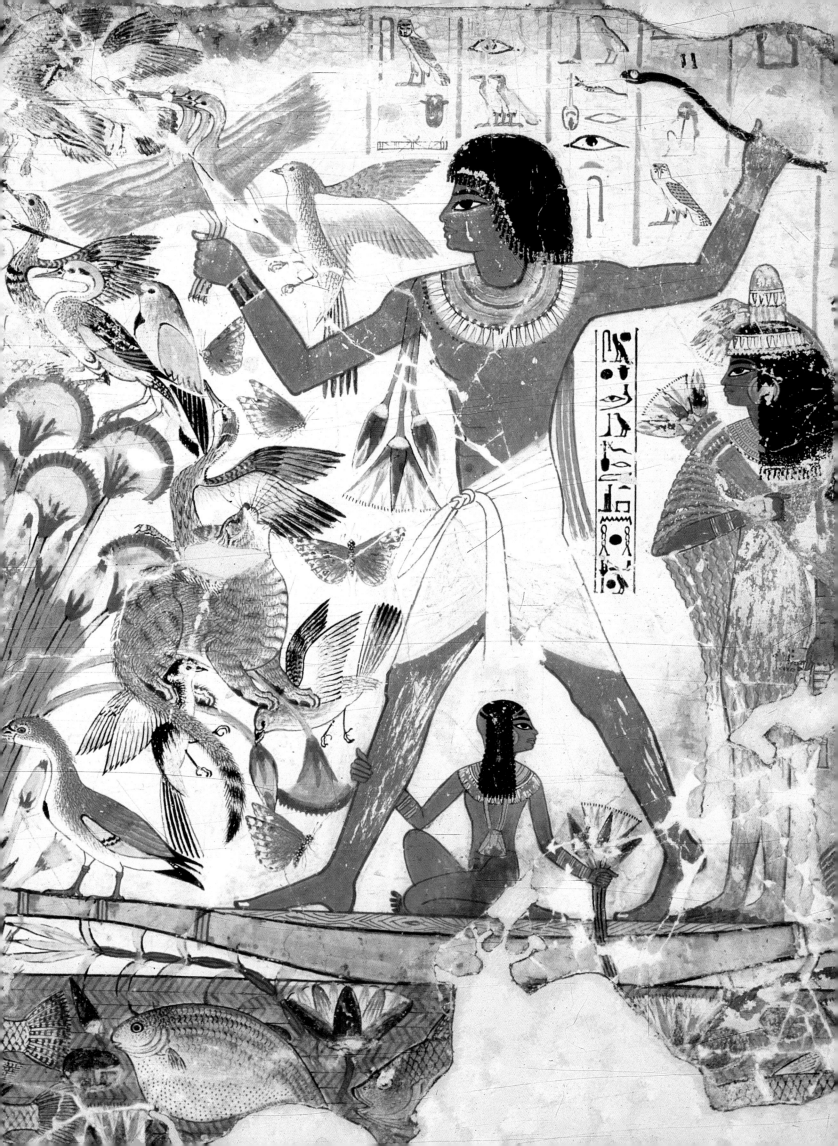

THE RAMESSIDES

1283 B.C.
Ramses II repels
the Assyrians.

1250 B.C.
Moses leads the
Hebrews out of Egypt.

1191 B.C.
Ramses III stops the
Hittites at the gates
of Egypt.

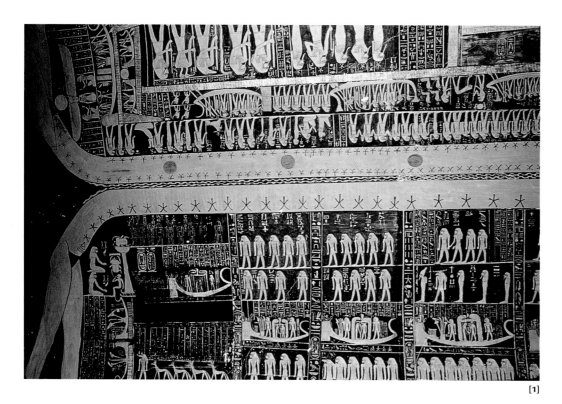

[1]

R amses II was the most important monarch of the nineteenth dynasty, that of the Ramessides. He gave a new impetus to Egyptian architecture with the great buildings at Luxor, Karnak and Abu Simbel. At Luxor—a sort of expansion of Thebes to the south that first experienced glory during the reign of Amenhotep III—Ramses II enlarged the temple of Amon, and had two obelisks erected in front. One of them would be taken to Paris by Louis-Philippe and placed in the Place de la Concorde. A sort of grandiloquent neoclassicism marked the era of the Ramessides, before Egyptian art lost its vigor following the decline of the pharaohs.

[1] Ceiling detail, hypogeum of Ramses VI (two buttressing goddesses representing the night sky and the daytime sky respectively). 20th Dynasty (c. 1140 B.C.). Valley of the Kings, Thebes-West.

[2] Temple of Amon, Luxor (papyrus-shaped columns of the peristyle court of Amenhotep III). 18th Dynasty (c. 1340 B.C.).

[3] Temple of Ramses II, Abu Simbel. 19th Dynasty (c. 1240 B.C.). Sandstone, H: 33m.

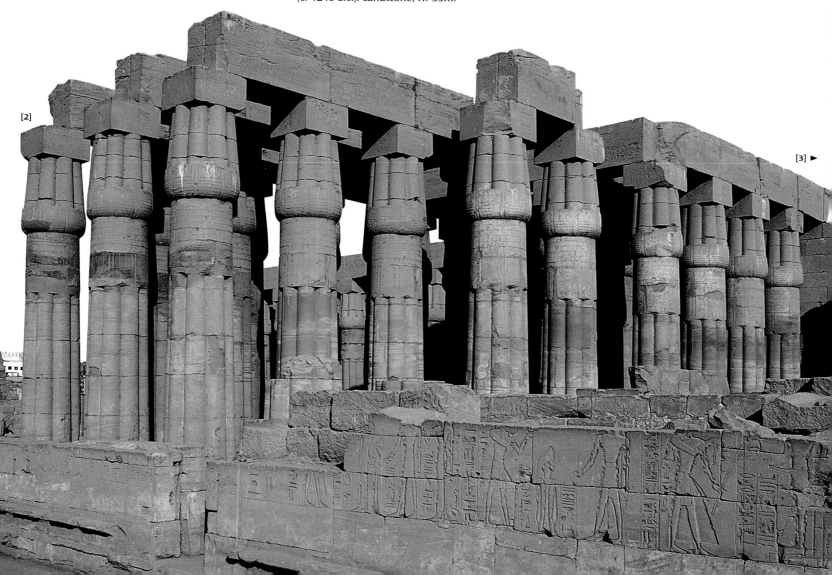

[2]

[3] ►

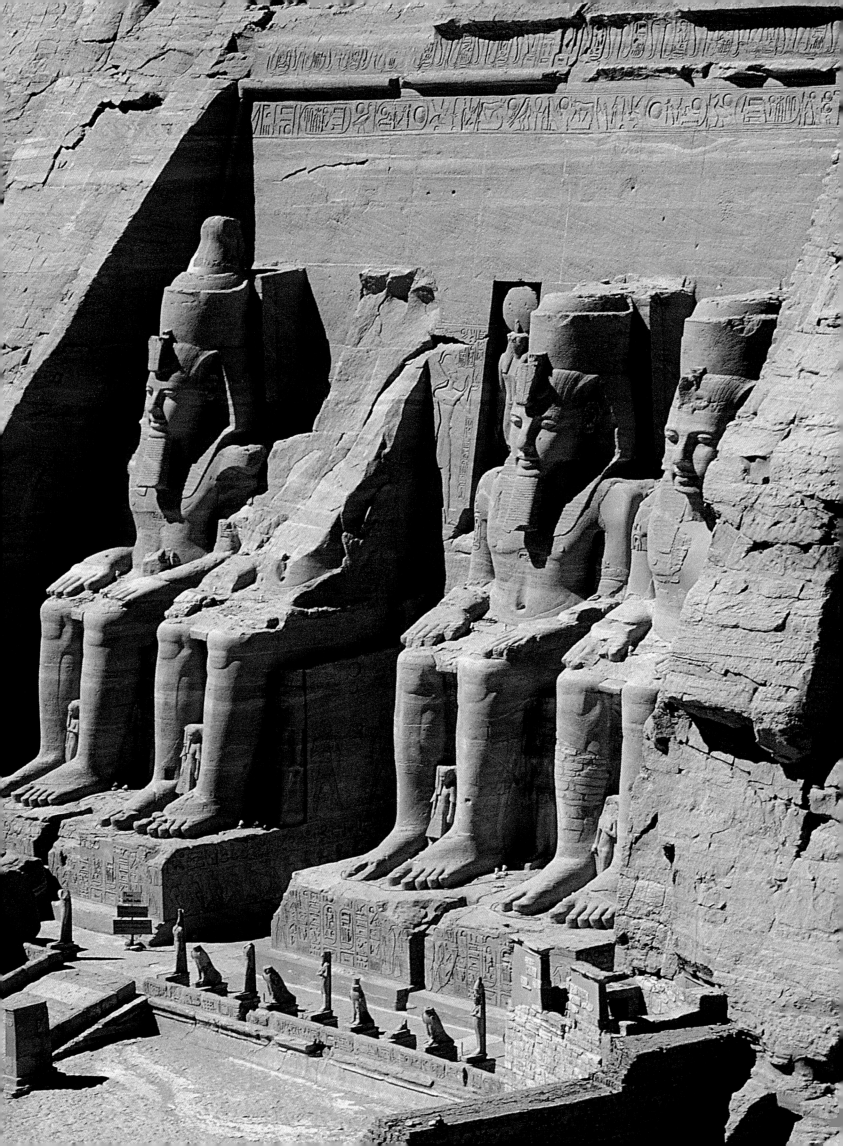

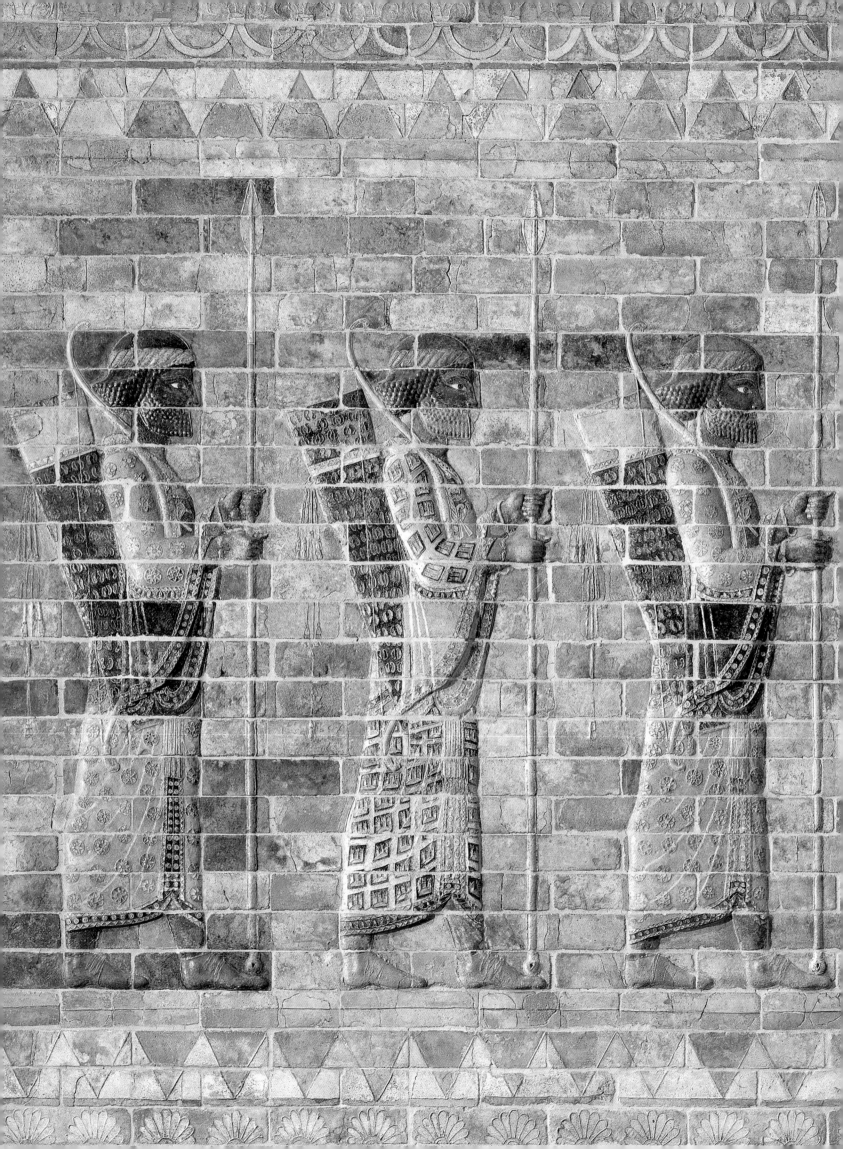

Circa **2600** B.C.
First dynasty of
Ur, Mesopotamia

Circa **1900** B.C.
Founding of Babylon

539 B.C.
The Persians
conquer Babylon.

THE ANCIENT MIDDLE EAST

[1] *The Archers of Darius.*
5th century B.C. Glazed
siliceous bricks, H: 1.83m.
From the Palace of
Darius, Susa. Paris,
Musée du Louvre.

[2] Statue of Gudea,
Prince of Lagash, c. 2150
B.C. Diorite, H: 46cm.
From Tello (formerly
Girsu). Paris, Musée
du Louvre.

[3] Standard of Ur
("peace" side), c. 2500 B.C.
Shells, limestone, and
lapis lazuli attached to
wooden core with tar,
H: 20cm; L: 47cm.
From Ur. London,
British Museum.

[2]

While Egypt flourished in the Nile Valley, another civilization was developing on the plains where the Tigris and the Euphrates flowed. The Sumerians (3000–2340 B.C.), the inventors of writing, constructed the ziggurats—temples with immense esplanades. Statuettes sculpted in limestone or modeled from clay display an early realism. Sumer, less firmly founded than Egypt, experienced many vicissitudes and left few great works to posterity. Around 1760 B.C., Hammurabi endowed Babylon with a might that would endure for only a century and a half. In the early first millennium B.C., the Assyrian empire dominated Mesopotamia and ruled from Lower Egypt to Armenia, until the Persians conquered Babylon. Mesopotamian art found its best expressions in bas-relief and decorative ceramics.

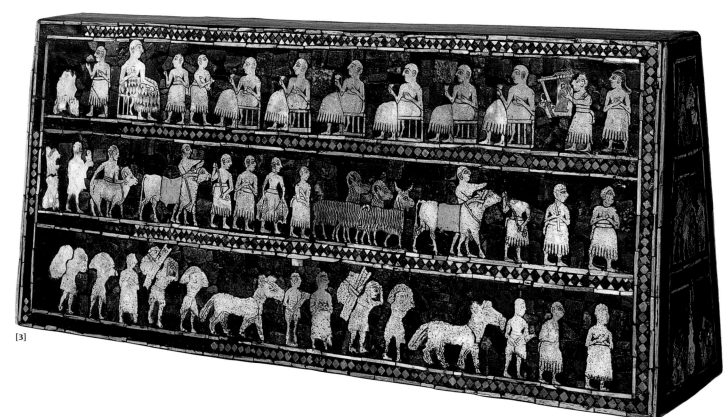

[3]

◄ [1]

LIGHT AND BEAUTY

Greece borrowed much from Egypt and the great Middle Eastern civilizations that flourished while it still faltered in prehistory. The eastern Mediterranean was, in fact, an area of cultural and commercial exchange, and its civilizations influenced one other. Thus Greece began before Greece: as early as 2000 B.C., several currents fueled its vitality. The art of the Cyclades was undoubtedly still prehistoric, but two centers of civilization were already noteworthy: the first in Crete, the second in Mycenae in the Peloponnese. Greek civilization was born in the first millennium B.C., a product of the mixture of the different peoples who had inhabited the region at various times.

[1]

[1] *La Parisienne.* 1600–1500 B.C. Fresco, H: 22cm. From the Palace of Knossos. Iráklion, Archeological Museum

[2] Death mask. 1600–1500 B.C. Embossed gold. From Mycenae. Athens, National Museum.

Greece acquired its grandeur and originality gradually, yet it took only four centuries for Greek culture to impose itself on the history of the world. This country that was not a country—ancient Greece was never anything but a collection of often rival city-states—long influenced the Mediterranean. More through commerce than through warfare, the Greeks radically changed the image human beings had of themselves and their place in the world. They instituted reason as the foundation of culture. They invented democracy. They identified beauty with truth. They made art a human activity, rather than one that owed all to the gods. They created the figure of the artist and that of the philosopher: two talented, lucid, inspired, and thoughtful men who worked for the happiness of the citizens and the greater glory of the city.

Works of art have not survived as well as have written texts. Literature has been transmitted through the centuries. We know Plato, Aristotle, Sophocles, and Euripides from their works, but we only know the painters who decorated temples and houses through references to them by certain writers—pioneers of art history and art criticism. Of Phidias and Praxiteles, only a few original sculptures and copies made by Roman admirers remain. The architecture exists, but in ruins; only the patience of archeologists has allowed us to have an even fragmentary idea of it. Because of decline, wars, and time, the treasures

[2]

[3] Painter of Brygos, detail of the central medallion of a red-figure vase, c. 490 B.C. Ceramic, diam: 32.5cm. Paris, Musée du Louvre.

[4] Apollo and a centaur. 470–460 B.C. Marble, H: 3m. From the west pediment of the Temple of Zeus, Olympia. Museum of Olympia.

of this culture have only come down to us in pieces; nevertheless, they are part of the foundations of our civilization.

Ancient Greece reached its zenith during the great era of Athens, in the fifth century B.C., when the city was governed by Pericles. Greece cultivated a humanist artistic ideal to which the human figure, albeit somewhat idealized, was essential. Man watched and studied himself. He observed and analyzed himself. He became a psychologist and an anatomist. In art, however, he did not limit himself to the observation of reality: he also idealized it. Human figures are not portraits, not objective images of individuals; they are images of ideal types, human beings as they should be. On the other hand, the figures of the gods are not symbolic, not imaginary beings; they are the figures of ideal human beings, perfect, governed by the mathematical reasoning that established what the Greeks considered to be the indisputable laws of harmony.

This was a revolution in the history of humanity, in the history of art. It started with the alliance, on the many vases exported all over the Mediterranean, of geometric decoration and human and animal figures painted on perfect forms. This instituted pottery as a separate art, independent of its function. It blossomed in sculpture that glorified man, whether carved in marble, the stone with the coldness of the ideal, or cast in bronze, the metal of eternity (or, at least, so it must have seemed). The revolution took place in religious architecture created to allow for the meeting of men and gods on earth. It displayed itself in the theaters, those splendid and simple buildings open to nature. In all these ways, this revolution became a model that continues to fascinate the world, and a reference point to which the continent continues to return—as if seeking the foundations of its identity after other currents have swept it away into more exotic adventures.

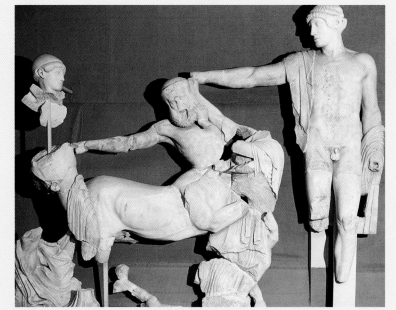

[4]

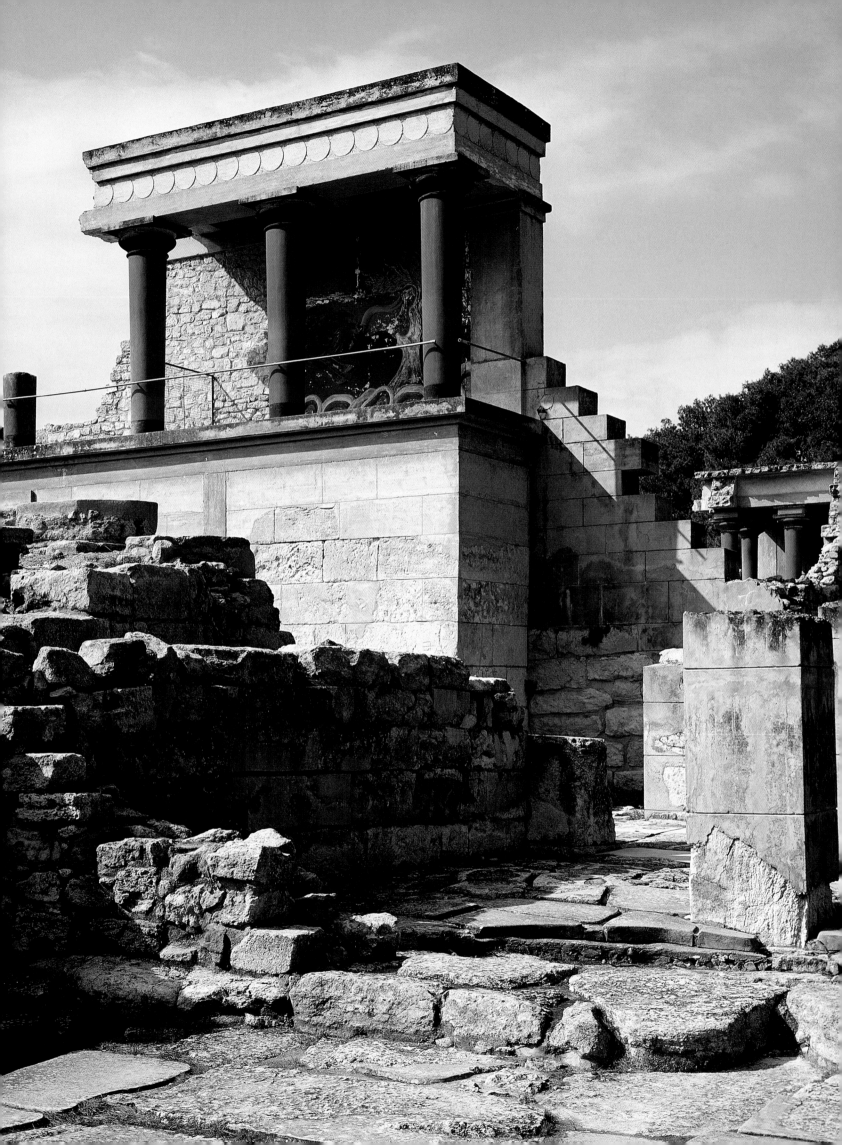

Circa **2000** B.C.
Appearance of the
domesticated horse
in Greece

Circa **1700** B.C.
Crete is ravaged by
an earthquake.

Circa **1400** B.C.
Beginning of Mycenaean
civilization

THE ORIGINS

The idols created in the Cyclades (a group of islands in the middle of the Aegean Sea) during the second millennium B.C. are products of a primitive society about which we know practically nothing, yet their pure beauty moves us. The palace of Knossos in Crete bears witness to an urban society that was sophisticated, powerful, centralized, and influenced by the Middle East; its frescoes reveal a joyously decorative art. In other works, we sense a greater uneasiness, more mystery, something archaic, that perhaps hints at the natural disposition of a people and a society that are also largely unknown to us.

[2]

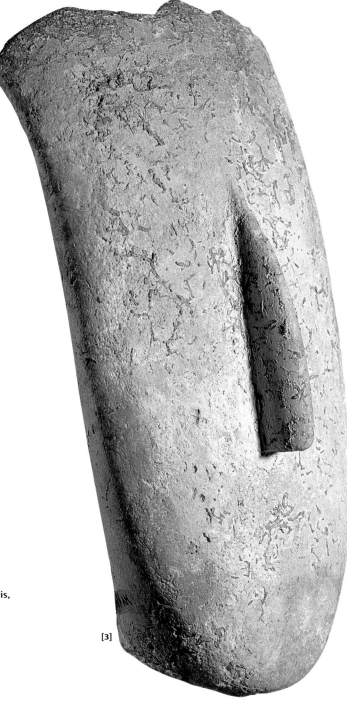

[1] Palace of Knossos,
north entrance
(reconstruction),
c. 1700 B.C.

[2] Snake goddess,
c. 1500 B.C. Earthenware,
H: 29.5cm. From the
Palace of Knossos.
Iráklion, Archeological
Museum.

[3] Head of a Cycladic
idol. 3200–2800 B.C.
Marble, H: 18.5cm. Paris,
Musée du Louvre.

[3]

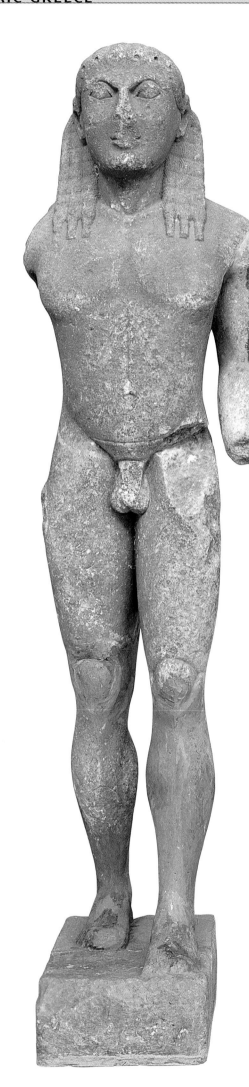

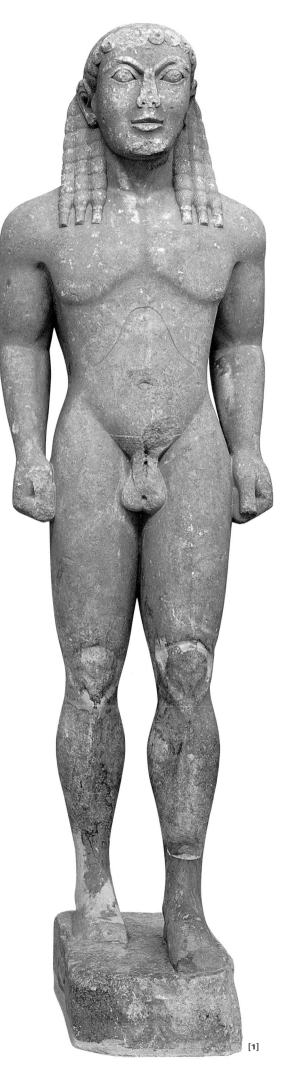

[1] Polymedes of Argos, the twins Cleobis and Biton (?), c. 580 B.C. Parian marble, H: 1.97m and 1.98m. Museum of Delphi.

[2] Attributed to the Analatos painter, red-figure loutrophoros (a ritual vase used in wedding ceremonies or funeral rites), c. 700–680 B.C. Terra-cotta, H: 81cm. Paris, Musée du Louvre.

[3] *Kore* dedicated by Cheramyes to Hera. 570–560 B.C. Marble, H: 1.92m. From the sanctuary of Hera, Samos. Paris, Musée du Louvre.

[1]

> "The main subject of Greek art was the human body, whether it was representing divinities or men, and this is in keeping with the conception of a single world, in which gods and mortals resembled each other sufficiently to behave similarly."
>
> C.M. Bowra

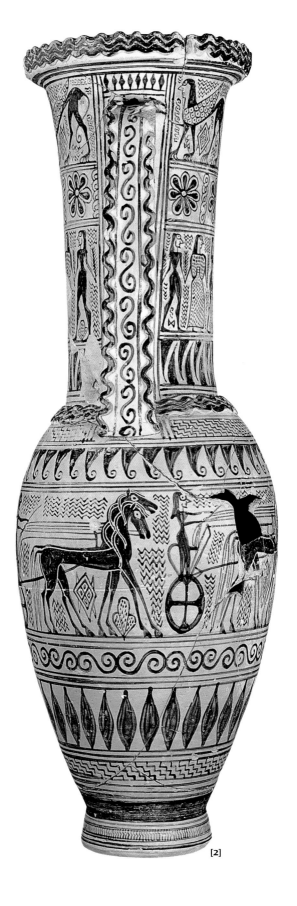

[2]

A s early as the eighth century B.C., pottery had attained a formal perfection and a refined decorative style that assured its commercial success on the shores of the Mediterranean. Geometric motifs were gradually replaced by narrative representation. Under the influence of Egypt, monumental sculpture developed in the seventh century B.C. with statues of naked young men and clothed young girls in stiff poses. These highly colored characters became progressively more natural.

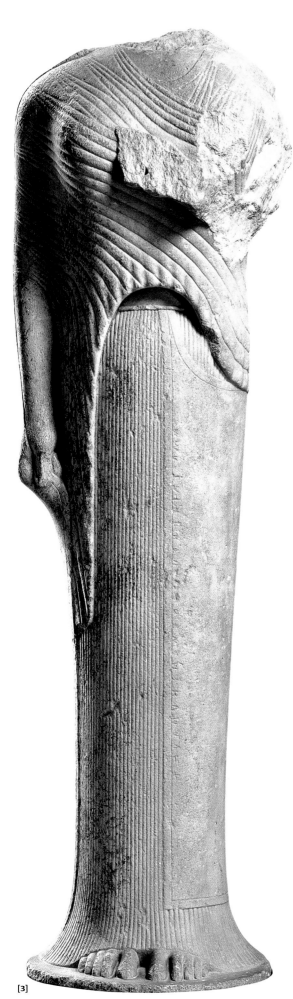

[3]

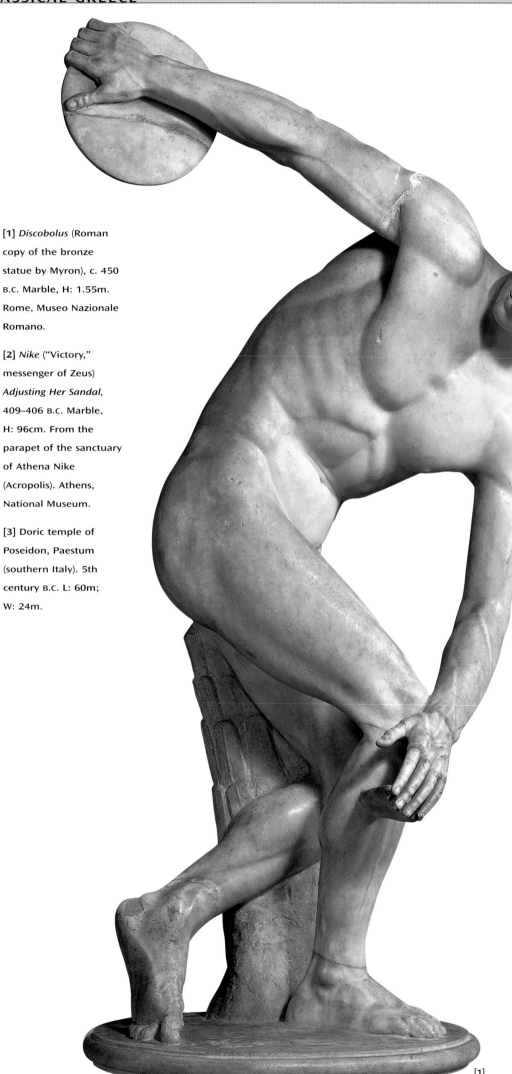

[1] *Discobolus* (Roman copy of the bronze statue by Myron), c. 450 B.C. Marble, H: 1.55m. Rome, Museo Nazionale Romano.

[2] *Nike* ("Victory," messenger of Zeus) *Adjusting Her Sandal*, 409–406 B.C. Marble, H: 96cm. From the parapet of the sanctuary of Athena Nike (Acropolis). Athens, National Museum.

[3] Doric temple of Poseidon, Paestum (southern Italy). 5th century B.C. L: 60m; W: 24m.

The Three Greek Orders

There are three styles, or "orders," in Greek architecture: Doric, Ionic, and Corinthian. The Doric order is characterized by fluted columns topped by a simple capital. The pediment rests on a bas-relief frieze between panels that are themselves fluted. In the Ionic order, the columns are more slender and more finely carved; they rest on a base and support a scrolled capital. The frieze is continuous. The Corinthian order is a more sophisticated version of the Ionic order, with capitals ornamented with acanthus leaves. The Doric and Ionic orders sometimes appear in the same building.

[1]

508–507 B.C.
Founding of
Athenian democracy

474 B.C.
The Greek cities defeat
the Etruscans at Cumae.

449 B.C.
Peace treaty between
the Greeks and the
Persians

CLASSICAL GREECE

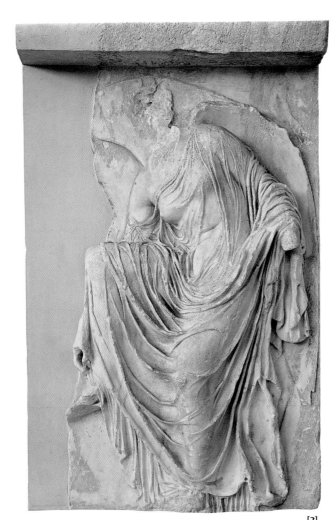

[2]

The Acropolis, overlooking Athens, has been a sacred site since ancient times. After the temples erected there were destroyed by the Persians in 480 B.C., Pericles (c. 495–429 B.C.) made the reconstruction of the temples the great project of his era. The Parthenon, a temple dedicated to the goddess Athena and built of marble over fifteen years, is a majestic example of the pure Doric style. It was partially destroyed in the seventeenth century when Turkish ammunition stored there exploded. The monumental entrance to the Propylaea, the Ionic sanctuary of the Erechtheion, the temple of Athena Nike, and the Parthenon constitute one of the most important monumental ensembles in the Western world. The sculptor Phidias was in charge of decorating the Parthenon, and what remains of the friezes, on site or in museums, reveals a supple and expressive art that represented a break with the archaic era.

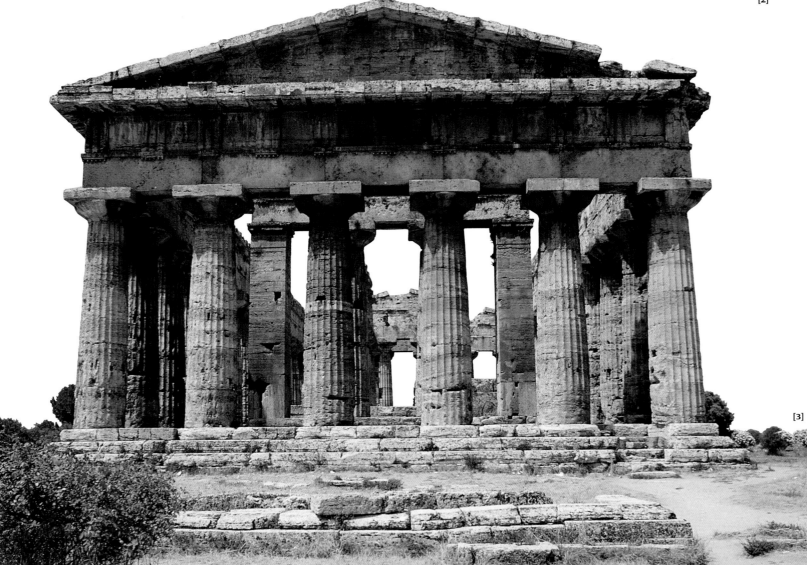

[3]

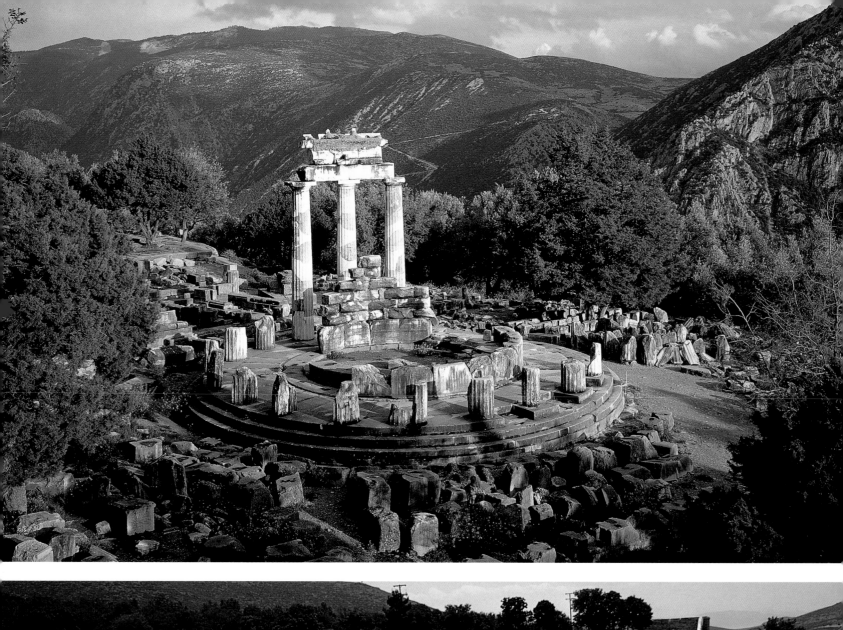
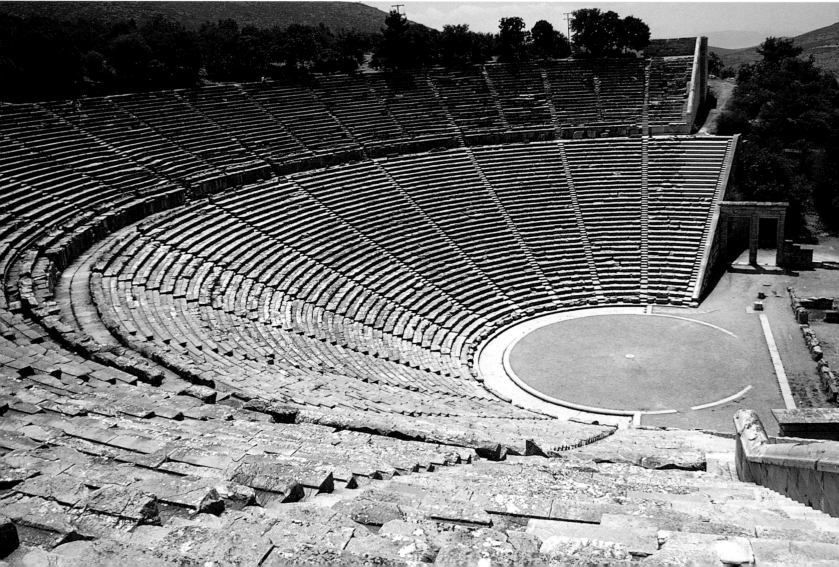

428 B.C.
Birth of Plato

404 B.C.
Athens surrenders
to the Spartans.

331 B.C.
Founding of Alexandria

CLASSICAL GREECE

> *"It is clear that we must consider happiness the greatest good that man can achieve."*
>
> Aristotle

[1] Circular temple ("tholos") of Delphi. Early 4th century B.C.

[2] Theater of Epidaurus. Last quarter, 4th century B.C.

[3] Praxiteles; *Hermes Holding the Infant Dionysus* (Greco-Roman copy), c. 340 B.C. Marble, H: 2.15m. From the temple of Hera, Olympia. Museum of Olympia.

[4] Athlete with strigil. Ceramic amphora. Vienna, Kunsthistorisches Museum.

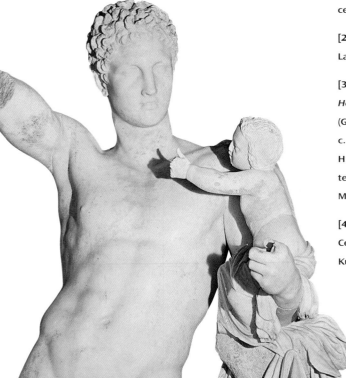

◄ [1]

◄ [2]

[3]

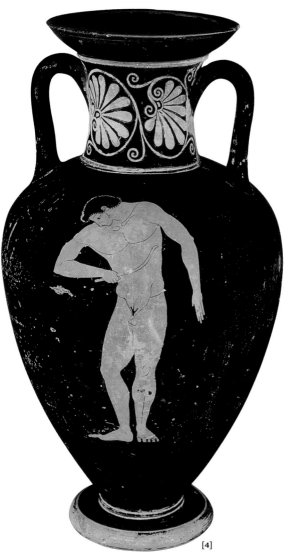

[4]

The Peloponnesian War, which ended with Athens' defeat by Sparta, closed a golden age. Fewer and less spectacular buildings were built, and yet the theater at Epidaurus was erected in the middle of the fourth century B.C. While the theaters that welcomed the work of the great tragic and comic dramatists of the fifth century B.C. (Aeschylus, Sophocles, Euripides, and Aristophanes) were simple rows of steps sloping down to the stage, the theater of Epidaurus is a miracle of circular harmony perfectly sited in a magnificent landscape. Nature became more and more important in Greek culture, as it gradually lost its religious focus. Similarly, the sculpture of the fourth century B.C. demonstrated a humanist realism; Praxiteles, who simultaneously developed the ideal of the classical proportions, was its greatest practitioner.

336–323 B.C.
Reign of Alexander
the Great

171–168 B.C.
Rome conquers
Macedonia.

146 B.C.
Corinth is destroyed
by the Romans.

[1]

Philip of Macedon conquered Greece at the end of the fourth century B.C., but left the cities their autonomy. The cities revolted against the leadership of Alexander the Great, who succeeded the assassinated sovereign. Although his reign only lasted thirteen years, he created an empire that extended Greek influence as far as the Caucasus. This was not enough to check the country's decline: Greece was almost invaded by the Celts and ended up succumbing to the power of Rome. Sculpture was its swan song. This art, whose hieratic perfection became progressively more animated, abandoned its traditional reticence when it discovered the art of portraiture and the dramatic expressions of characters who seem to manifest every nuance of human emotion.

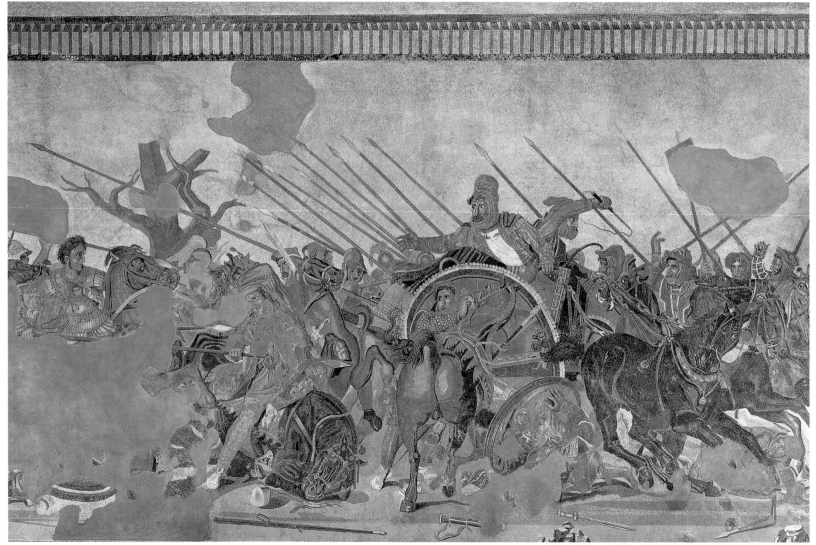

[2]

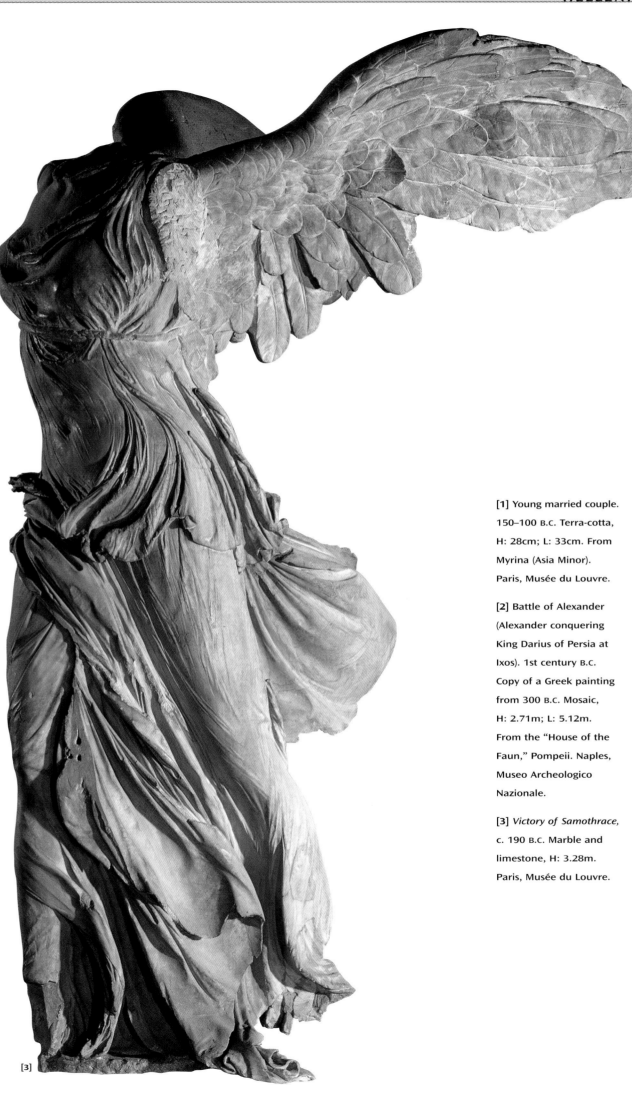

[1] Young married couple.
150–100 B.C. Terra-cotta,
H: 28cm; L: 33cm. From
Myrina (Asia Minor).
Paris, Musée du Louvre.

[2] Battle of Alexander
(Alexander conquering
King Darius of Persia at
Ixos). 1st century B.C.
Copy of a Greek painting
from 300 B.C. Mosaic,
H: 2.71m; L: 5.12m.
From the "House of the
Faun," Pompeii. Naples,
Museo Archeologico
Nazionale.

[3] *Victory of Samothrace*,
c. 190 B.C. Marble and
limestone, H: 3.28m.
Paris, Musée du Louvre.

[3]

THE CENTER OF THE WORLD

Rome is the daughter of the Etruscans and the Greeks. The Etruscans conquered what was then a barely settled village and, being good entrepreneurs, made it into a city. The Greeks, who had traveled widely in Italy and influenced the Etruscans, gave the Romans a good deal of their culture and the essence of their mythology. The Romans, however, fashioned something new out of what they took from Greek culture. In the second half of the first millennium B.C., an original civilization would be created on the Italian peninsula that would leave an indelible mark on Europe—and this not only through the transmission of Greek teachings.

The civilization of ancient Rome was characterized by an extraordinary degree of political, social,

[1]

and economic organization. These conquerors were shrewd colonizers who were able to impose the essence of their culture on the people they subjugated while remaining tolerant of local practices. They had no problems absorbing elements of foreign cultures. Because they had started from scratch, too young to be stubborn in their convictions, they built an original structure on a Greek foundation and added elements borrowed from the Etruscans, the Egyptians, and even the Persians. The first great artists working in Rome were Greek, and Roman art was largely made up of copies of Greek works. Thus, to a great degree, Rome's culture was Greek before it was truly Roman. The Etruscans, too, were influenced by Greek art, but the Romans adopted the Greek aesthetic and gave it a new character. While art in Greece became more expressive and lyrical, the Romans kept to a strict realism, to an unambiguous rationality. For them, portraiture became a preeminent genre, and we know the faces of their emperors thanks to a few insightful sculptors. Similarly, a need to celebrate, coupled with a desire for realism, led them to develop a wide-scale narrative art, albeit one that is difficult to read initially, because it spirals around commemorative columns.

It is to Rome that Europe owes one of its great myths: that of a colonial empire that civilizes the world. This missionary concept of civilization comes from Rome and rests on two elements. The

[1] *La Primavera*, 1st century A.D. Fresco, H: 39cm; W: 31cm. From the "Villa of Ariane," Stabiae. Naples, Museo Archeologico Nazionale.

[2] Roman noble holding the portraits of his ancestors (statue known as "Barberini"). Second half of the 1st century B.C. Marble, H: 1.65m. Rome, Palazzo dei Conservatori.

[3] Coliseum, Rome. A.D. 70–80. Diam: 188m.

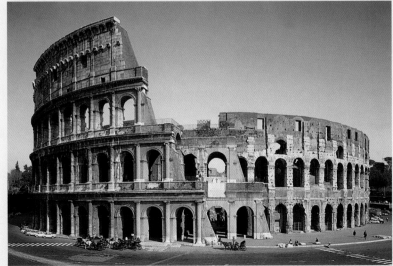

first is a certainty of possessing an absolute truth, the sharing of which can only be beneficial to others. The second element is a meticulously structured, centralized administration. Thus, more than signs or forms, it is the concept of the art of dominating that the Romans bequeathed to those who would conquer the world after them.

What the Romans brought to art seems slight compared with the contributions of the Egyptians and Greeks. The Romans preferred action to meditation or contemplation, so their culture never underwent an intoxicating artistic impetus. In fact, the Romans are known for their architecture and engineering, rather than for their art: their innovations would change the course of the art of construction.

Mastering the three Greek orders—with which the Etruscans were familiar as well— the Romans invented the arch. The triumphal arch—the emblematic Roman architectural structure—is a ceremonial monument that has no practical use. It seems to celebrate the arch itself, more than the hero whom its construction ostensibly glorifies. The arch introduced a hitherto unknown refinement to architecture: mathematics and the study of forces played a part in its design, and a new method of carving stones directed its production. Before the Romans, others, in the Middle East and Etruria, had already constructed rounded ceilings and porticoes, but on a smaller scale. The Romans took the use of arcature into monumental architecture and, throughout the Roman Empire, a profusion of public buildings affirmed the art of Roman architects as much as the power of the state.

Roman culture is more practical and less metaphysical than Greek culture. The Roman genius was for large-scale public works, endless roads, grand aqueducts, and monumental public baths. These left an indelible mark on the Mediterranean world at a time when, in the Middle East, under their rule, Jesus was born. From his life and teachings would arise another age of European culture and of other colonizing empires.

[2]

[3]

753 B.C.
Legendary date of
the founding of Rome

Circa 575 B.C.
The Etruscans take
Rome.

Circa 509 B.C.
Rome expels the
Etruscan kings.

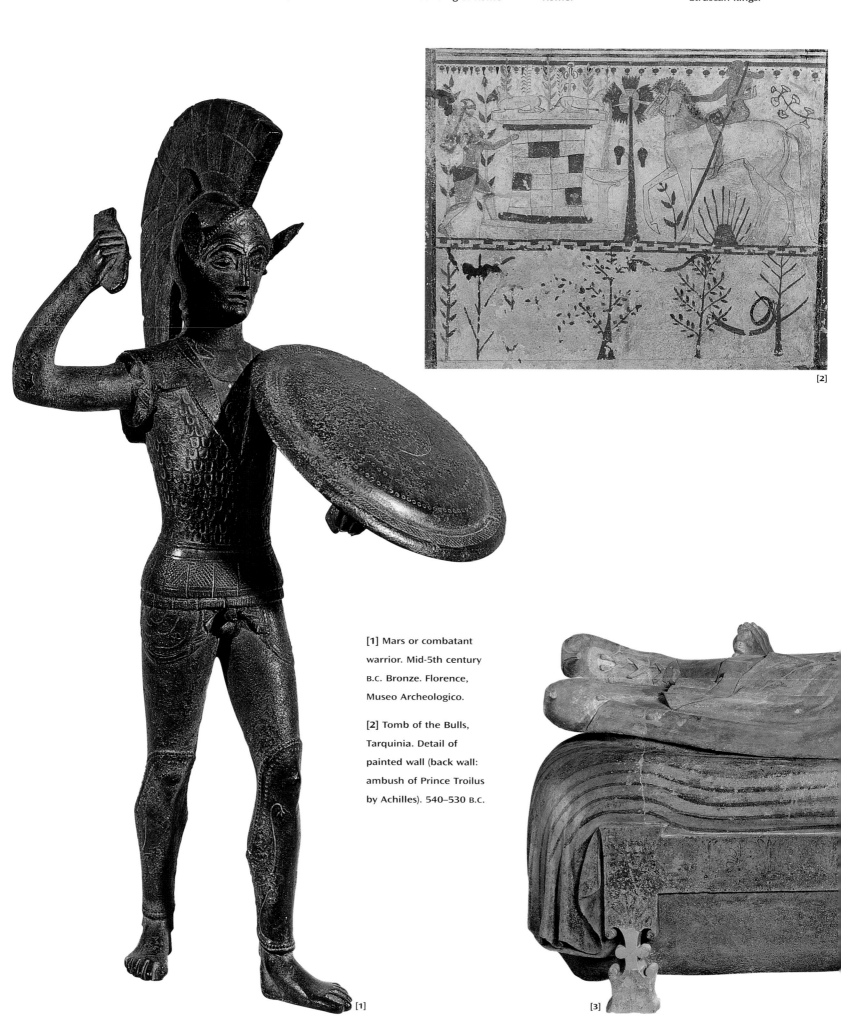

[1] Mars or combatant
warrior. Mid-5th century
B.C. Bronze. Florence,
Museo Archeologico.

[2] Tomb of the Bulls,
Tarquinia. Detail of
painted wall (back wall:
ambush of Prince Troilus
by Achilles). 540–530 B.C.

[1]

[2]

[3]

The history of Italy begins with the Etruscans, who are believed to have arrived from Asia Minor and settled between the Arno (which flows through Florence) and the Tiber (which crosses Rome). It was still the Bronze Age in this part of Europe, and it is difficult to understand how, in the eighth century B.C., an original civilization, about which we know practically nothing except through a few funerary monuments, sprang up in the region. Their tombs have conserved the urns, sarcophagi, and frescoes that made them pleasant underground homes for the dead—replicas, perhaps, of those the Etruscans inhabited during their lives. Wonderful terra-cotta figures represent couples who seem happy to be united for eternity: scenes painted on walls celebrate the pleasures of living, dancing, hunting, and fishing. Egypt and the Middle East also practiced this already well-developed art.

[3] Sarcophagus of the Spouses. Last quarter of the 6th century B.C. Polychrome terra-cotta. H: 1.11m; W: 1.94m; D: 0.69m. From Cerveteri. Paris, Musée du Louvre.

[1]

[2]

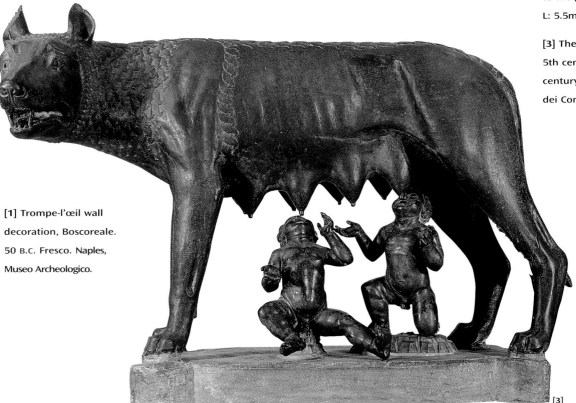

[2] Frieze from the Altar of Domitius Ahenobarbus (census episode: registration of citizens and sacrifice to the god Mars), c. 100 B.C. Marble, H: 0.78m; L: 5.5m. Paris, Musée du Louvre.

[3] The "Capitoline" she-wolf. First half of the 5th century B.C. (the twins date from the late 15th century). Bronze, H: 0.83m; L: 1.36m. Rome, Palazzo dei Conservatori.

[1] Trompe-l'œil wall decoration, Boscoreale. 50 B.C. Fresco. Naples, Museo Archeologico.

[3]

Gods and Heroes

The Romans borrowed most of their gods from the Greeks. Zeus became Jupiter, Aphrodite Venus, Herakles Hercules, and Athena Minerva. However, these gods could have just as easily lent their names to Latin or Etruscan gods dating from before the influence of Greece. But Rome invented another mythology, more political than religious, that to some extent made the Roman city sacred after its founding by Romulus and Remus. The civic pride of the Romans was, in fact, particularly strong and fueled their imperialistic dynamism. Hence, Roman art preferred heroes to gods.

According to legend, Rome was founded by twins whose mother had fled the ruins of Troy; the children would have been nursed by a she-wolf. Although their birth would seem to affirm the city's Greek origins, the emblematic she-wolf belonged to the Etruscans. The art of the first centuries of this new history left few traces, despite texts attesting to an abundance of heroic sculptures and paintings. The art of sculpted portraiture spread during the second century B.C., while the technique of handling monumental bronzes was perfectly mastered. The religious architecture was unambiguously Greek in style, following Rome's conquest of Greece. The oldest paintings found in the buried cities of Herculaneum and Pompeii were also influenced by Greece.

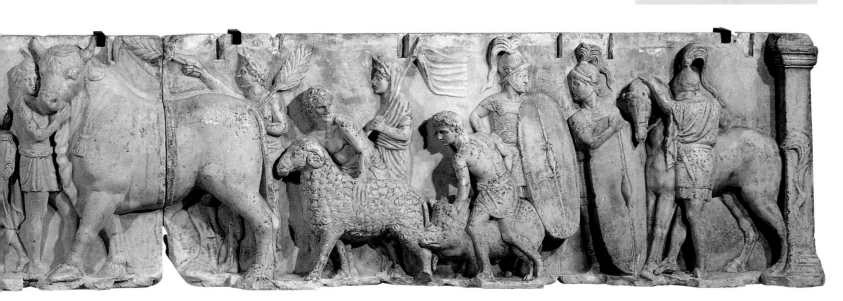

52 B.C.
Uprising in Gaul

44 B.C.
Assassination of
Julius Caesar

27 B.C.
Octavius becomes the Emperor
Augustus after defeating
his rival, Mark Anthony.

Even more than Caesar—the general-turned-dictator who built a forum in his own honor—the Emperor Augustus, first in a long series, was a builder. Desiring to restore the grandeur of a Rome eaten away by racketeering and civil wars, he built several monuments in the city, renovated others, and encouraged his representatives to follow his example throughout the empire. A new forum and temples dedicated to Mars and Apollo were built in the capital; in Gaul, Nîmes saw a Maison Carrée constructed, while in Orange a handsome triumphal arch and the Pont du Gard bore the imperial stamp. Augustus' successors continued his work until Nero, who rejoiced in the blaze that would allow him to reconstruct Rome the way he wanted.

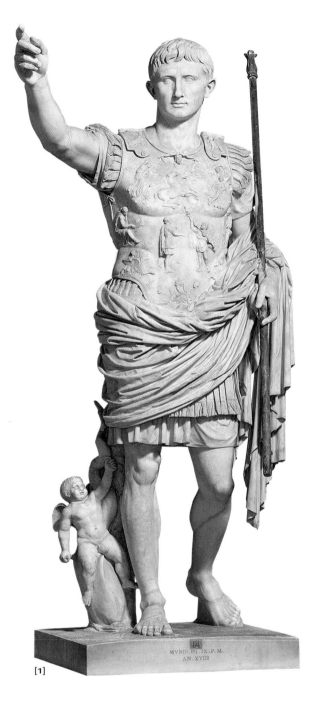

[1]

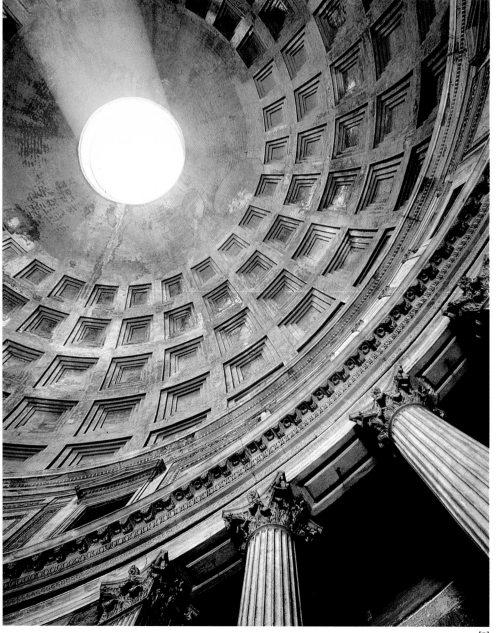

[2]

[1] Statue of Emperor Augustus, c. 20 B.C. Marble, H: 2.06m. From Livia's Villa, Prima Porta, north of Rome. Rome, Musei Vaticani.

[2] Interior of the Pantheon, Rome. Erected in 17 B.C., destroyed by fire in A.D. 80 and reconstructed by Hadrian in A.D. 123. Diam: 43m; H: 43m.

[3] Forum, Rome (arch of Septimius Severus in the background, erected in A.D. 203).

[3] ►

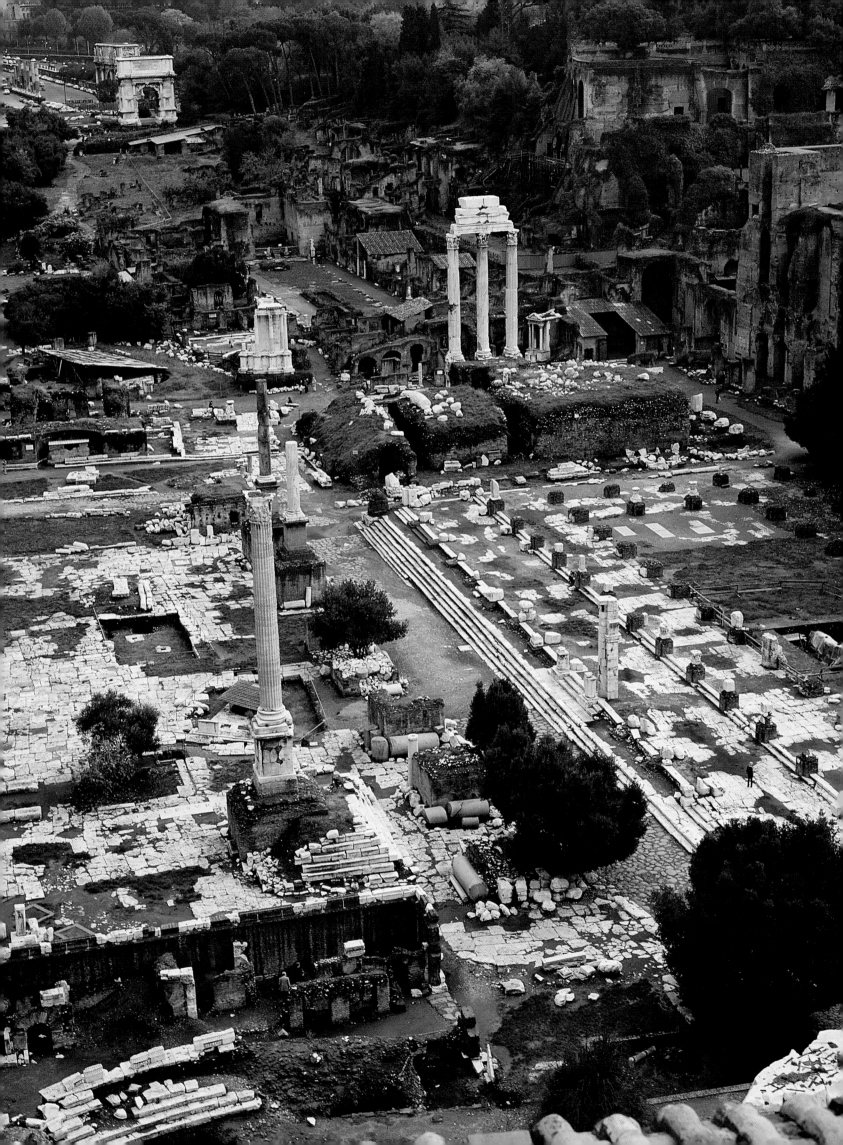

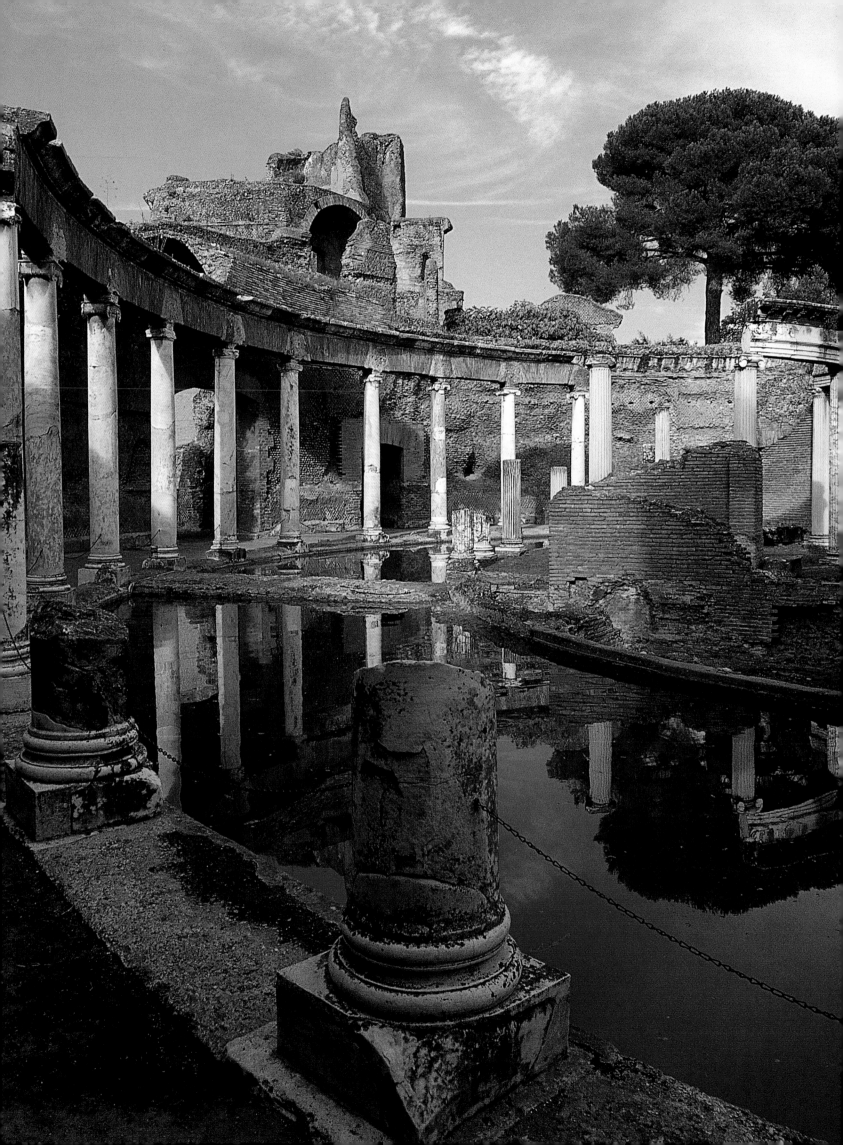

49 **54** **107** **CLASSICAL ROME**

The Jews are expelled Nero is emperor. Dacia (present-day Romania)
from Rome. becomes an imperial province.

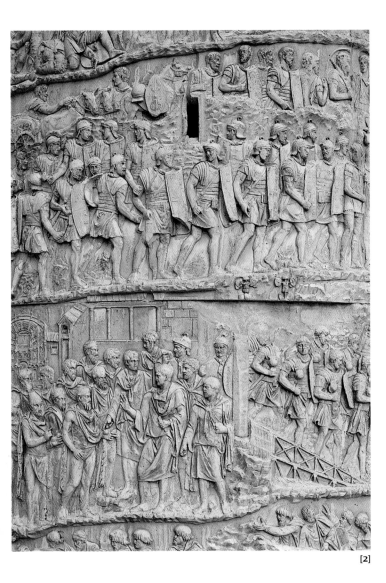

> **❝**When Rome started becoming the master of
> the known universe, it was deeply aware
> of the necessity of using art as a language
> that would be intelligible everywhere.**❞**
>
> René Huyghe

[1] Villa of the Emperor Hadrian at Tivoli. A.D. 117–134.

[2]] Detail of Trajan's Column. A.D. 107–113. Marble, total H: 42m; diam: 2.5m.

[3] Aqueduct of Segovia (Spain) A.D. 117–134.

[2]

After Nero, the power of the emperors passed from the hands of the aristocracy into those of a bourgeoisie that was less infatuated with Greek culture. In sculpture, the realistic tendency in Roman art was reinforced by the blossoming of what was called "plebeian" art—more populist and less idealistic than traditional art. A third movement, called "pathetic" (because it was more expressive) emerged and took root during the reign of Emperor Marcus Aurelius in the second half of the second century. Architecture, less affected by changes in the mood of society, retained all of its grandeur in civil engineering (fortifications, ports, markets, aqueducts) and the construction of spectacular public places (theaters and, especially, monumental thermal baths).

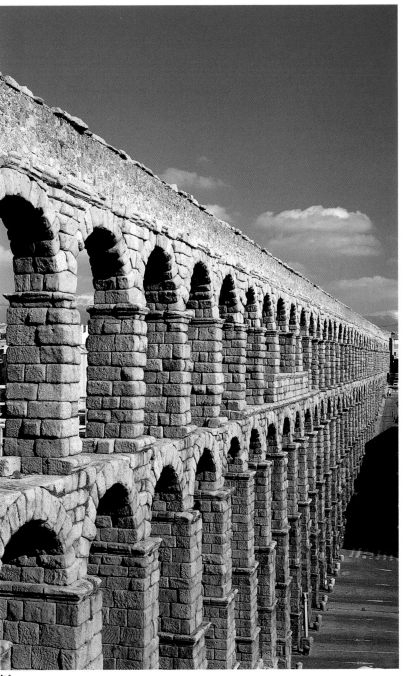

[3]

◄ [1]

122–127
Hadrian's Wall is
constructed in England.

200–202
Septimius Severus
conquers
Upper Mesopotamia.

212
Citizenship is accorded
to all the inhabitants
of the Roman Empire.

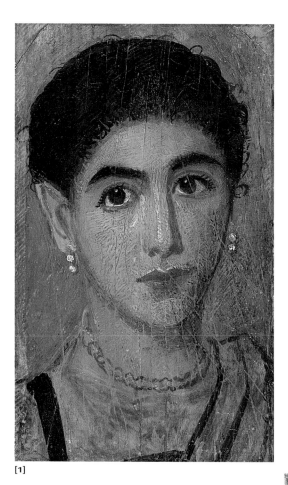

[1]

Rome was soon no longer confined to Rome. The Greek example, already eroding, disintegrated. Columns and pediments tended to become a facade attached to a building, rather than remain as structural components. The emperors no longer affirmed their architectural power except in the construction of thermal baths, while distant provinces rediscovered their personalities. The Middle East asserted its differences and provided renewed inspiration for an art that was otherwise becoming rigidly conventional. A hitherto unknown playful aspect emerged in Roman art. In Split (Croatia), Baalbek (Lebanon), Palmyra (Syria), and Antioch (Turkey), majestic structures were erected. In Egypt, an original funerary art—beautiful examples of which were found in El-Fayoum—was born of the marriage between a local tradition of sculpted portraits and a pictorial technique imported from Italy by a sizable Roman community.

[1] Funerary portrait
of a young woman,
c. A.D. 161–180. Encaustic
on panel. H: 33cm;
W: 20cm. From Faiyum
(Egypt). Paris, Musée du
Louvre.

[2] *Judgement of Paris*,
c. A.D. 115. Mosaic,
H: 1.86m; W: 1.86m.
From Antioch (Turkey).
Paris, Musée du Louvre.

[3] Monumental arch,
Palmyra (Syria). 3rd
century A.D.

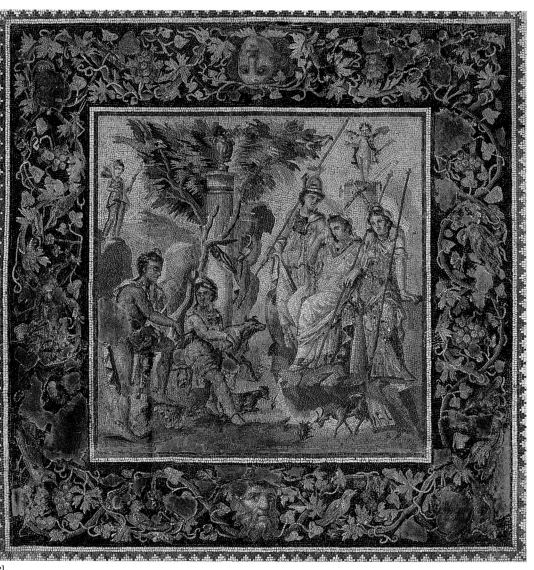

[2]

[3] ►

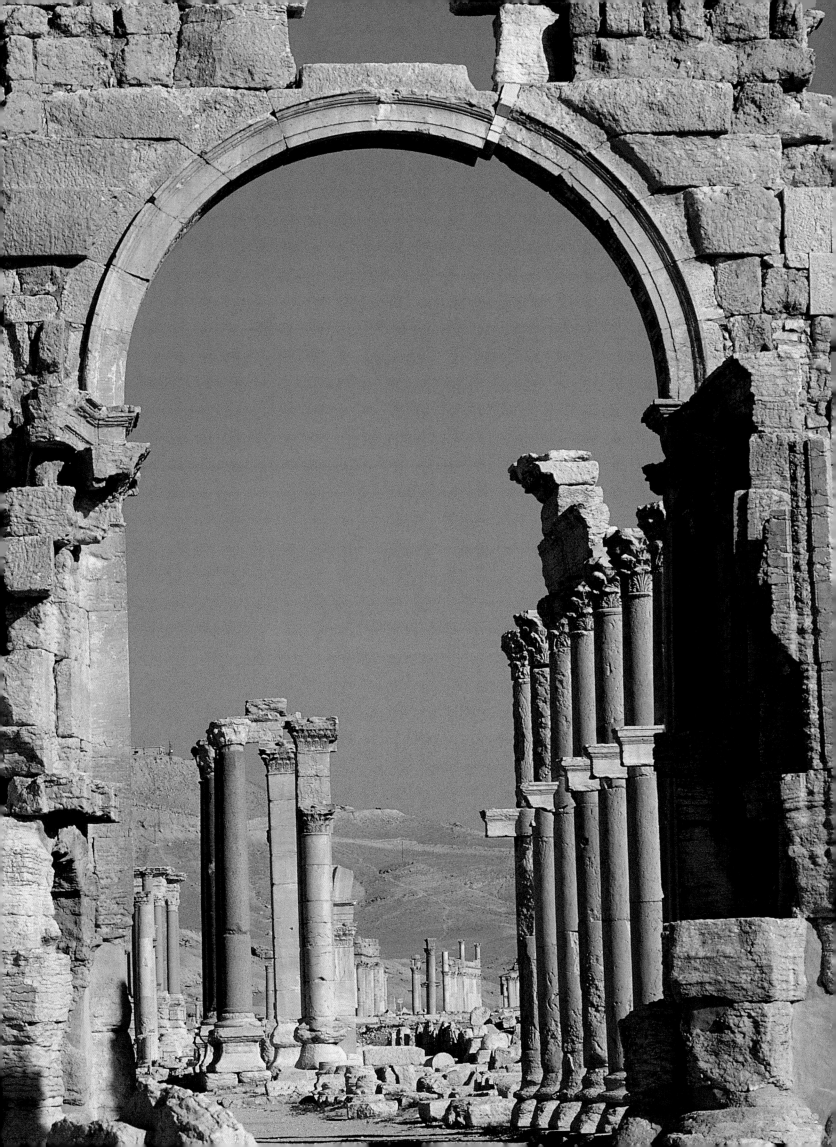

FROM ROME TO BYZANTIUM

onstantine was emperor, but he did not reign alone at first. In the early fourth century, Rome was divided among several squabbling masters. For almost a century, Rome had been in decline, losing its grasp on a distintegrating empire. Proclaimed "august" by his soldiers, the young general who governed Gaul, Britain, and Spain got rid of a father-in-law, a brother-in-law, and a few other rivals in order to become the sole ruler. Just outside Rome, he had a vision. No less than the sign of Christ, it gave him the confidence to take a bridge he needed to win, and was enough to make him convert. This is undoubtedly a legend, nevertheless the now-confident Constantine reunified the empire, closed the pagan temples and declared himself the defender of Christianity, to which he gave a city. That city would become Constantinople, which he founded on the site of an ancient Greek colony on the Bosphorus: Byzantium, a city that had only been Roman for little more than a century, and whose fortifications he had razed to the ground when it sided with one of his rivals. He was now the only emperor of an empire with two capitals, one in decline, the other destined to impose itself on the eastern Mediterranean and then on the Slavic world for over ten centuries.

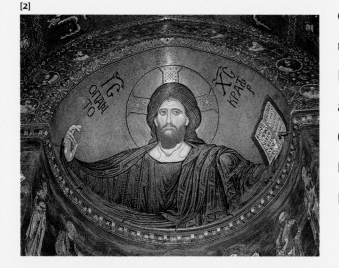

[1]

Christianity had really only been spread throughout the empire for a century, and in a relatively clandestine manner. In the catacombs, the subterranean necropolises, a naive folk art developed. The art that would be called "paleo-christian" took shape in Rome and the eastern provinces where the adepts of the new religion lived—in Alexandria, for example, then in Constantinople. For Byzantine art, which is the art not of Byzantium, but of Constantinople (the city of Constantine, to distinguish itself from Rome, proclaimed itself proud of its Greek ancestry and called itself Byzantine), would

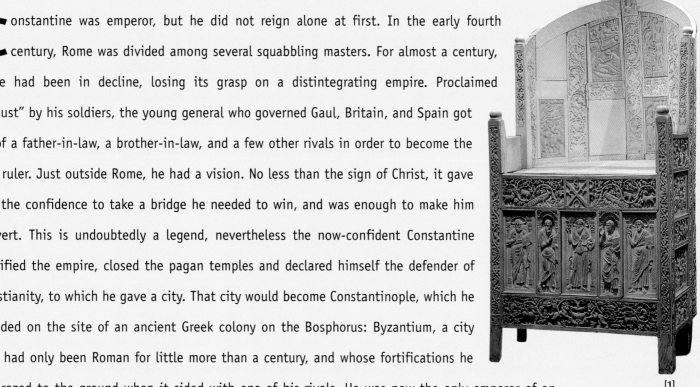

[2]

only become a major style two centuries later, during the reign of Justinian.

In Rome, Constantine was still a classical Latin builder, and the monuments he had built were faithful to tradition. Constantinople, inaugurated in 330, was initially in the Roman style, designed in the image of the older city. From the beginning, therefore, pomp was natural to it.

[1] Chair of Bishop Maximien, Constantinople. Mid-6th century. Ivory, H: 1.5m; W: 0.6m. Ravenna, Museo Arcivescovile.

[2] *Christ Pantocrator*, c. 1180–1194. Mosaic. Apse of the cathedral of Monreale (Sicily).

The Birth of Christian Art

It was also a Christian city, the first great Christian city in the history of the world, its churches built following the plan of the Roman basilicas: vast public meeting places erected on two rows of columns.

When civil war destroyed the city at the beginning of the sixth century, the Emperor Justinian took the opportunity to rebuild it magnificently in the new style that had matured for over two centuries in the Eastern Empire—the apotheosis of which is the cathedral of Hagia Sophia. This was the first golden age of Byzantine art, whose features were codified rigorously enough to be perpetuated, after the fall of the city to the Turks, throughout the Orthodox Greek and Slavic world. Cruciform plans, lighter domes, and lavish mosaic decorations: the new architecture of a religion that proclaims the divine splendor and compares the power of the emperor to the glory of Christ.

In the early eighth century, Emperor Leo III supported the iconoclasts who, in the name of the biblical tradition forbidding idols, opposed all forms of religious imagery. Paintings and mosaics were destroyed. Fortunately, the Italian city of Ravenna, a Byzantine fortress, was spared the fury of these fundamentalists, and we can today admire the quintessence of Byzantine art in all its beauty. In 843, the Empress Regent Theodora restored the right of art to depict Christ, the Virgin, and the saints. This event is known as the "victory of Orthodoxy."

Hagia Sophia was redecorated, and Byzantine art was renewed, spreading throughout Constantinople's sphere of influence—from Sicily to Asia Minor. Far removed from the idealized realism of Roman art, mosaics, icons, and illuminated manuscripts bore witness to the new rules of representation whose goal was less to depict reality than to express the spiritual power of the new faith: figures looking straight ahead, lack of perspective, simplified forms, intense colors, and a marked contrast between light and shade. It was a sacred art that left little room for individual interpretation, but that would produce a few great artists, of whom the Russian Andrey Rublyov (around 1360–1430) is the best example.

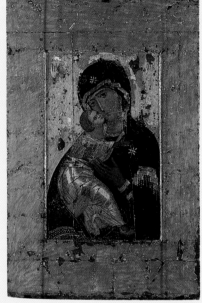

[4]

[3] Detail of the Pala d'Oro (the archangel Michael). Early 12th century. Gold, enamel, and gemstones. Venice, Basilica of Saint Mark.

[4] Icon of the Virgin of Saint Vladimir. 12th–13th century. Tempera on panel, H: 1.13m; W: 0.68m. Moscow, Tretiakov Gallery.

[3]

202
Judaism and Christianity
are forced underground
in Rome.

253
The Roman Empire
is divided into
east and west.

330
Constantinople becomes
the center of
the Roman Empire.

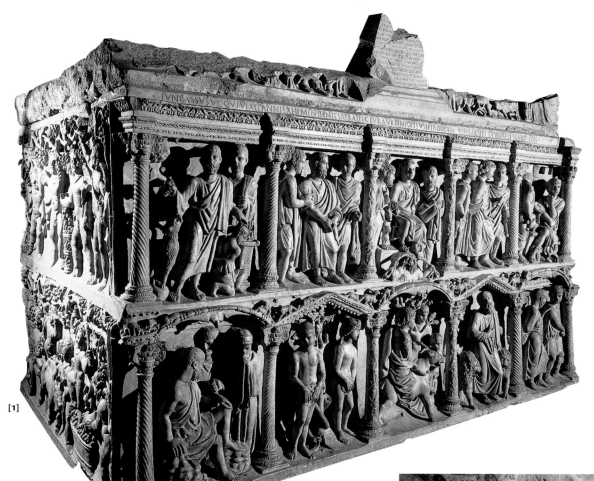

[1]

[1] Sarcophagus of
Junius Bassus, c. A.D. 389.
Marble. Rome, Grotte
Vaticane.

[2] Catacombs of the
Via Latina, Rome (view
from a *cubiculum*, north
room: Alcestis before
Hercules and Cerberus).
4th century.

[3] Church of Santa
Constanza, Rome
(mausoleum of Helen
and Constantia,
daughters of
Constantine).
4th century.

For a brief span of time, the Christian faith moved from the gloom of the catacombs to imperial recognition. Two centuries after the coming of their Messiah, Diocletian severely repressed the Christians, who had previously enjoyed relative tolerance. By according them his protection in the fourth century, Constantine made Christianity the official religion of the Roman Empire. Once tentative, the artistic expression of the new monotheistic faith could now flourish. The paintings of the catacombs, the sculpted sarcophagi, and the first churches were expressions of Roman art, but Christianity did not forget that it was born in the Middle East. A new set of themes appeared in ancient forms (the figure of the shepherd became the Good Shepherd), then a new style developed, renewing Greco-Roman tradition with the Middle Eastern inspiration that was brought by the Jewish people.

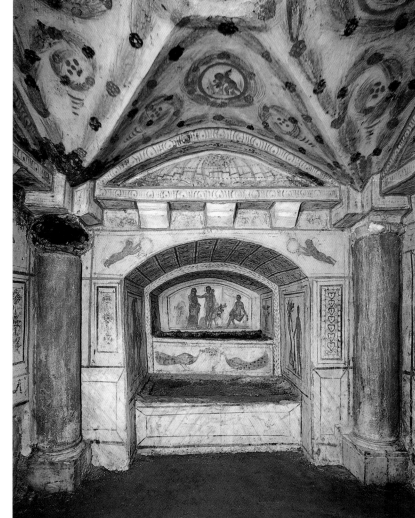

[2]

[3] ▶

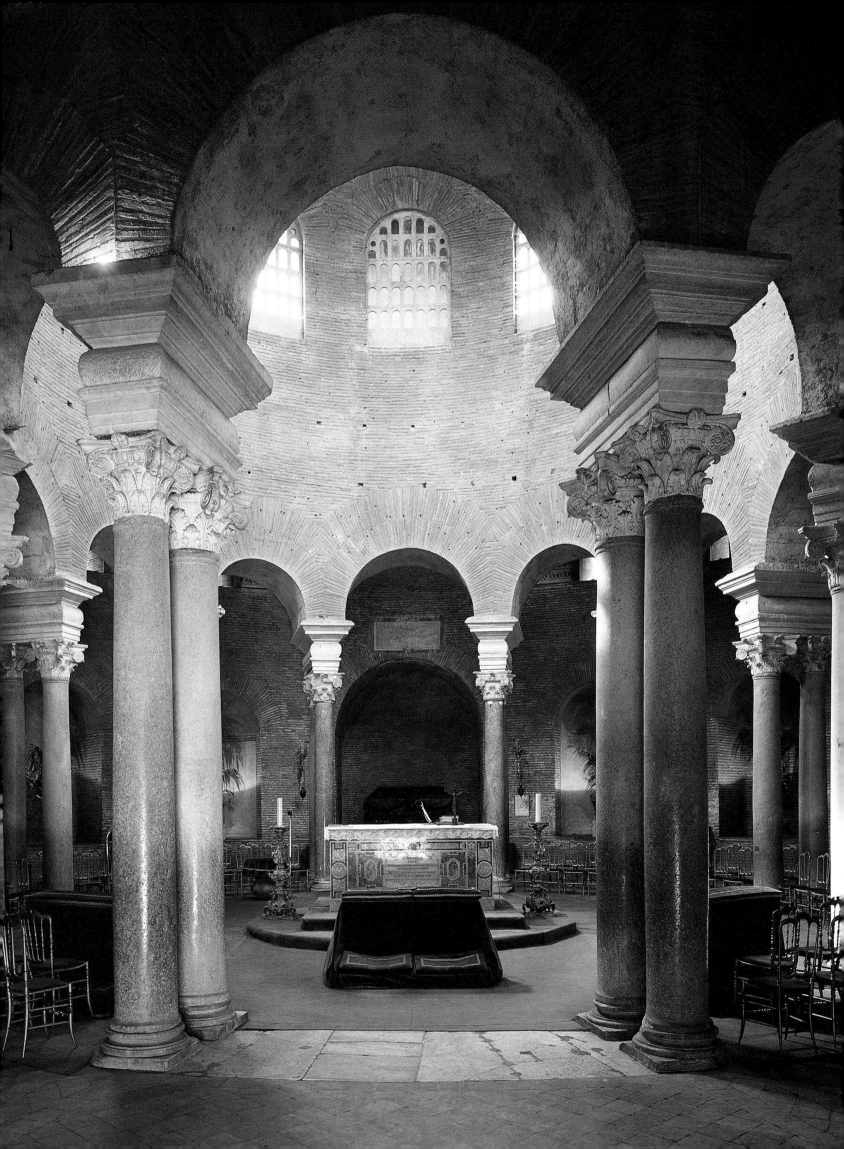

THE FIRST BYZANTINE GOLDEN AGE

410	537	723
The Visigoths take Rome.	Inauguration of Hagia Sophia	Emperor Leo III forbids religious images.

Byzantine art triumphed in Constantinople's Hagia Sophia (532–537). Two architects from Asia Minor, Anthemius of Tralles and Isidorus of Miletus, were putting into practice a revolutionary principle when, in order to raise domes higher, they placed them on four arches. They also freed the light to play over the gold-backed mosaics (which have since disappeared) and on the finely chiseled capitals. In the Church of San Vitale in Ravenna, which is smaller but equally opulent, two large, well-preserved mosaics depict the imperial couple Justinian and Theodora in a setting that rejects perspective for a flat construction in which figures seem fixed for eternity. The features on faces are strongly delineated around large black eyes in a manner that would forever characterize Byzantine art.

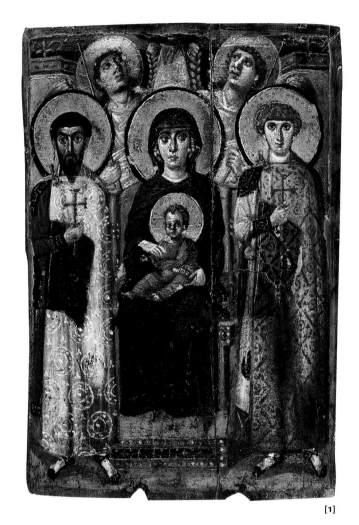

[1]

The Art of the Icon

The icon (from the Greek *eikonion*, or "small image") is a painting on wood using tempera or encaustic (seen in the portraits of Faiyum) that plays a very important role in the Orthodox faith. It is placed on a church's iconostasis, the wall in front of the altar. Beginning in the ninth century, after the defeat of the iconoclasts who destroyed the first icons, this sacred art spread throughout the Greek world, then to the Slavic peoples who converted to Orthodoxy. Very early on, the conventions of the style—whose raison d'être lay in a strict religious symbolism—were established. Despite this constraint, the art of the icon remained active and, in the fifteenth century, the Russian painter Andrey Rublyov was a sublime practitioner of the form.

[3] ►

[1] Icon of the Virgin and Child (with Saint Theodore and Saint George). 6th century. Encaustic on panel. Monastery of Saint Catherine, Mount Sinai (Egypt).

[2] Hagia Sophia, Istanbul. Second third of the 6th century (minarets from the Ottoman period).

[3] Empress Theodora and her court. Mid-6th century. Mosaic detail. Church of San Vitale, Ravenna.

[2]

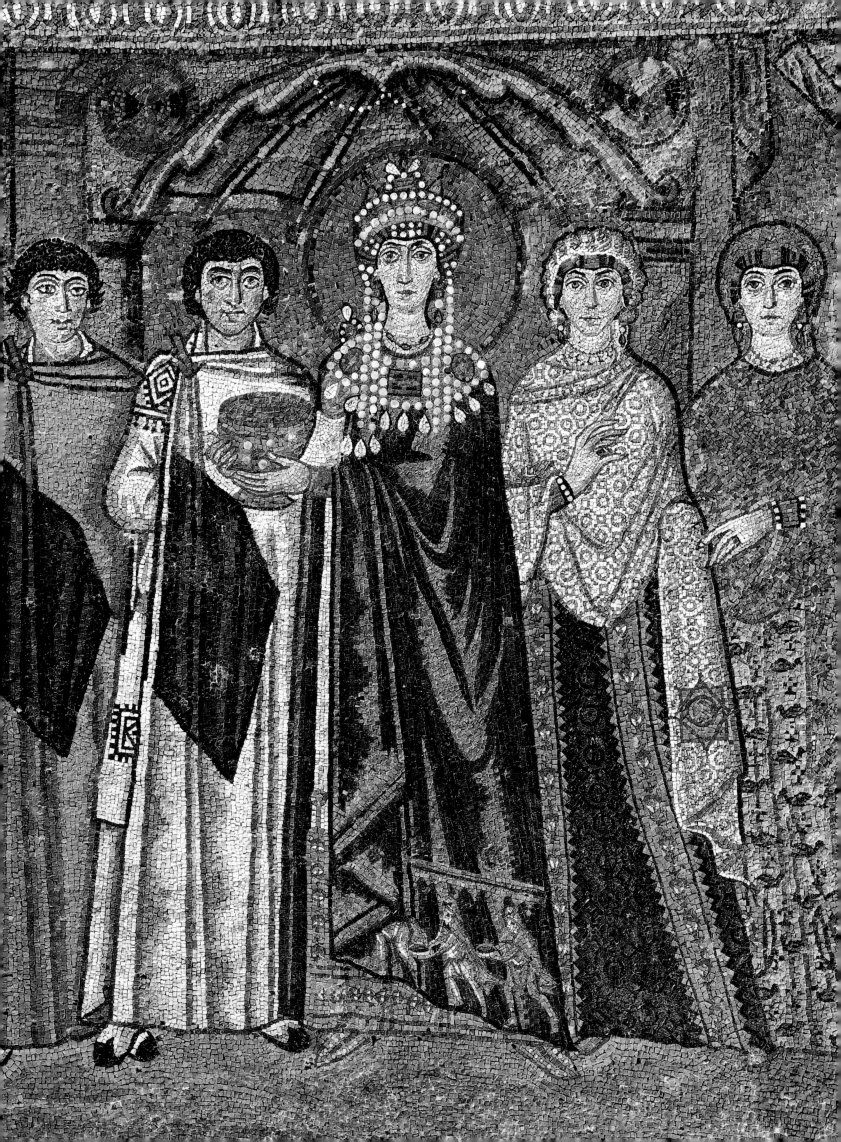

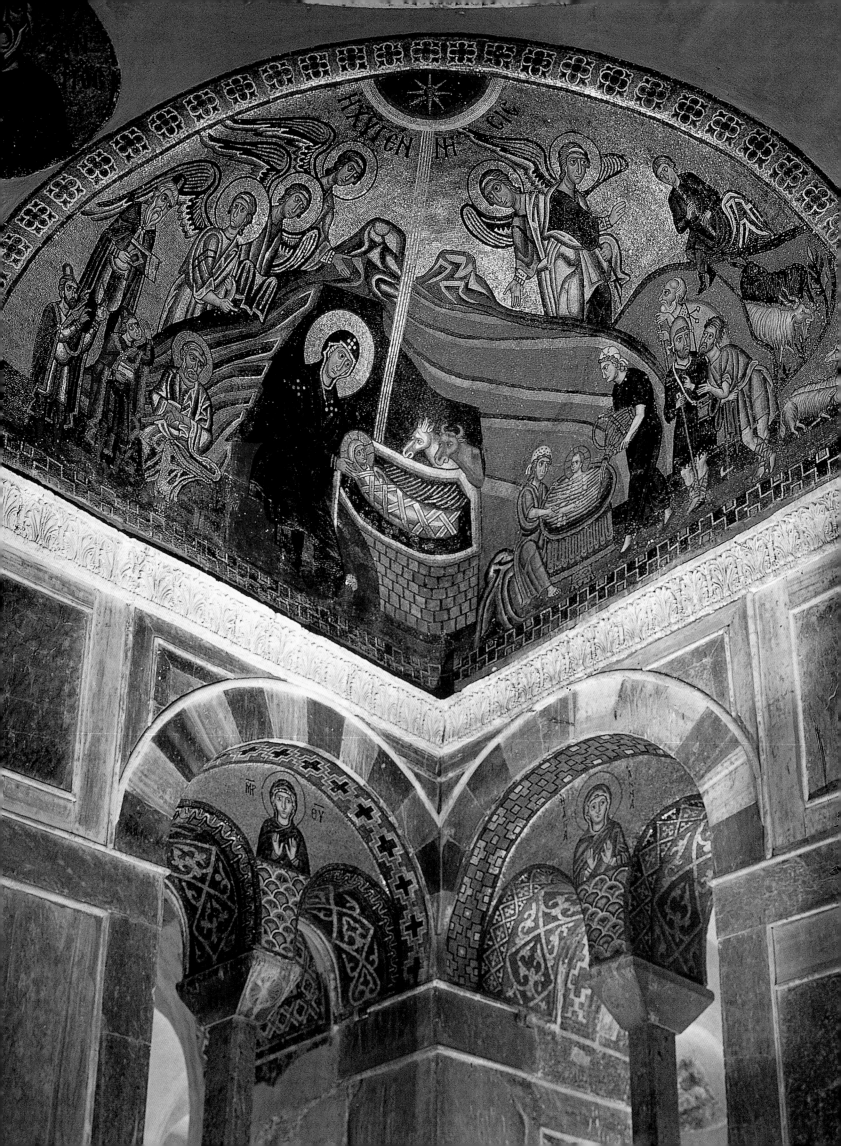

843
A synod held at Hagia Sophia reestablishes the right to venerate images.

963
The first monks inhabit Mount Athos.

1054
Schism between Rome and Constantinople

THE SECOND BYZANTINE GOLDEN AGE

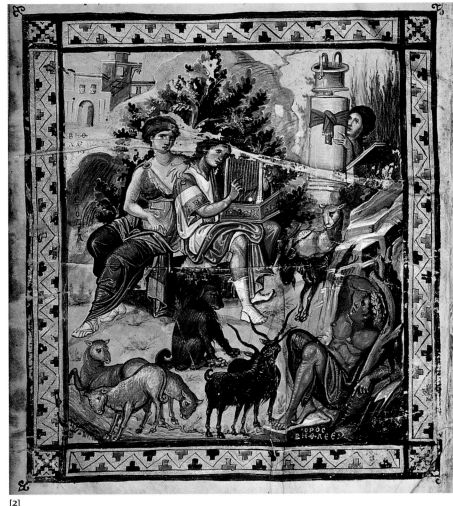

[2]

The golden age of Justinian followed troubled centuries during which Constantinople barely maintained its imperial grandeur. Internal conflicts and external threats (the barbarians, who had already sacked Rome, were surging across Europe) attacked the splendor of this new civilization. From the ninth to the eleventh century, following the period of the iconoclasts, a new golden age animated Byzantine art. Many beautiful sanctuaries, especially monasteries, were built throughout the empire. In the eleventh century, the Church of Saint Mark in Venice was the crown jewel of Byzantine Italy, even though the schism with Rome had just taken effect. Ornamented with luxurious gold, marble, mosaics and marquetry, it demonstrated the glory of the East in a West that was searching for its own identity.

[1] *Nativity*, 11th century. Mosaic. Monastery of Hosios Loukas (Greece).

[2] Psalter of Paris (David and his flock). 10th century. Paint on parchment, H: 21cm; W: 19cm. From Constantinople. Ms Grec 139, folio 1v. Paris, Bibliothèque nationale de France.

[3] *Christ Praying at Gethsemane*. 1215–1220. Mosaic detail. Venice, Basilica of Saint Mark.

[3]

◄ [1]

THE RISE OF EUROPE

The Middle Ages was a time of chaos, when Europe, overwhelmed by "barbarians" who took advantage of the decline of the Roman Empire, witnessed the creation of a new civilization. Peoples from the north and east, bringing other traditions and other dreams, collided with those influenced by Roman culture but no longer defended by the Roman legions. Bloodlines and ideas were mixed. New kingdoms were founded, with different customs, but the invaders became Christians and were thus affiliated to Rome, renewing the bonds of European unity. The Church was the new empire, now powererful and secure enough for Charlemagne, the emperor, to found the glory of the West and make Europe a great historical vision.

In the north, where the Celts had successfully resisted their enemies (the Romans never invaded Ireland), the Vikings and Normans took a share of Europe. In the early eighth century, the Arabs conquered northern Africa, part of Spain and the south of France. Another religion, which, like Christianity, claimed to be universal, drove them, but they brought with them the learning and techniques conceived in the Middle East and Greece and forgotten in the West. The Moors were not barbarians, though they were called so at the time. Mathematics, philosophy, and medicine thrived once more in much of the Mediterranean thanks to them. Nevertheless, although Europe absorbed the most exotic of foreigners, it rejected Islam. The differences between those who believed in Christ and those who believed in Mohammed were irreconcilable. Europe, inventing the religious war, launched the Crusades (eleventh–twelfth centuries) to reconquer Jerusalem, which had fallen into the hands of the "infidels." The Christian faith moved mountains of boldness, inspired prodigious adventures and erected cathedrals that bore witness to a new architectural and spiritual grandeur. The West, intoxicated with God, believed itself destined to rule the world once more. The soldiers of Christ wanted to subject the world to their God, and their armies advanced throughout the world while audacious vaults, built by architects to gather souls together in a common prayer, rose toward the sky.

[1] Fibulas shaped like eagles (Visigoth art). 6th century. Gold-plated bronze, colored stones, rock crystal. From Tierra de Barros (Spain). Baltimore, Walters Art Gallery.

[2] Detail from the tapestry known as "The Bayeux Tapestry" (William, Duke of Normandy, haranguing his troops), c. 1070–1080. Woolen thread on linen, H: 50cm. Bayeux, Musée de la Tapisserie.

From the 6th to the 12th Century

[3]

Romanesque art was the first great style to spread throughout Europe after the art of the ancients. This means that it took a thousand years for Christianity to establish its aesthetic rule in Western Europe. Furthermore, it was long opined that the Middle Ages did not flourish until the advent of Gothic art, of which Romanesque art was considered to be only the precursor. It was only after the millennial frenzy, when the Apocalypse was expected, that Europe blossomed again, rediscovering its military might, commercial dynamism and economic growth. It covered the earth in churches in the shape of the Latin cross (a long nave and shorter transept with a triumphal entrance and an apse behind the altar). Architects were obliged to devise technical innovations so that churches could be even taller and thus closer to God. After long employing curved vaults, they invented the pointed arch, which gave stone more lightness.

Architecture regained the primacy and prestige it had enjoyed in Egypt, Greece, Rome, and Constantinople. Painting and sculpture, too, regained the momentum they had lost for several centuries. Nothing was too beautiful for God. Everything could serve to instruct Christians: artists illustrated stories from the Bible and the Gospels. They portrayed a fragile humanity in the grip of a destiny that would send them either to heaven or to hell. Feeling dominated reason. The human drama showed itself unblushingly, and only Christ, whose serene triumph was displayed over church porches, was the measure of the ideal.

The Romanesque age was the period when Europe found its identity as the heir to ancient Rome and the descendant of Christian Rome. In Constantinople, the Roman Empire had become Christian, but had lost its Latin spirit. In the West a new civilization, inspired by the Byzantine example, was born from the amazing cultural sleight of hand that rooted Christianity—a Middle Eastern religion—in the city of the Caesars. The spiritual momentum of the former and the dominating imperialism of the latter united to change the face of the world. The tall vessels of stone that were the new cathedrals were the outward signs of this new Europe.

[3] Gislebertus; *Eve*, c. 1130. Stone, L: 1.32m. From the lintel of the side portal, Cathedral of Saint-Lazare, Autun (France). Autun, Musée Rolin.

[4] The church of Notre-Dame, Paray-le-Monial (Saône-et-Loire, France). Former abbey church, early 12th century.

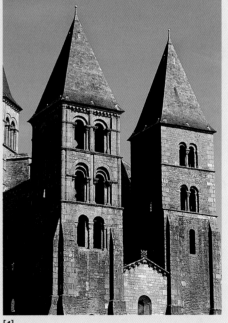

[4]

"BARBARIAN" ART

622
Year 1 of the
Islamic calendar

845
The Vikings occupy
Paris.

955
The battle of Lechfeld
puts an end to the
invasions of the Huns.

[1] Grip of Viking processional cudgel. 9th century.
Wood. Oslo, Universitets Oldsaksamling.

[2] Chalice. 8th century. Silver, gold-plated bronze,
enamel and paste, diam: 23cm. From Ardagh
(Ireland). Dublin, National Museum of Ireland.

[3] Page from the collection of Gospels known
as the "Lindisfarne Gospels" (northeast
England), c. 698–700. Paint on
parchment. London,
British Museum.

Barbarians are "other." They are those who did not enter into the order of imperial
civilization—like the Celts of Ireland, who did not allow the Roman legions onto
their island; or who, like the easternmost Germans, were not seduced by a colonization
that had less momentum on the frontiers of the empire than nearer its heart. These
peoples, who seemed to have barely emerged from prehistory, nevertheless had a rich
culture, a great oral tradition, and a fertile mythology. Their vigor and profoundly
symbolic art commingled with the classical tradition and with the Eastern influences
that characterize early Christianity.

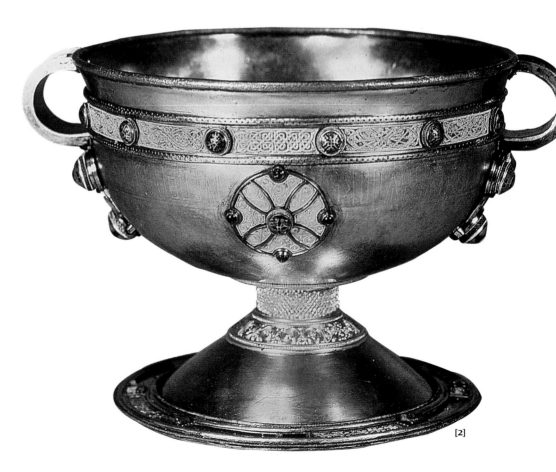

[1]

[2]

910
Founding of the
Abbey of Cluny

1095–1099
First Crusade

1108–1137
Reign of Louis VI and the
beginning of the unification
of the kingdom of France

ROMANESQUE FRANCE

Faith is wonder, not reason. In Cluny and Burgundy, in France, the monastic order of Saint Benedict began a spiritual revolution that would shake Christianity. The liturgy, which is the praise of God, adopted a new aesthetic, which broke with the secular reasoning of classical culture. By decreeing that every work of art had to be an offering to God, the Benedictines made a mystical breach in the feudal world. For their monasteries they built large churches, a noble and austere architecture filled with gold, paintings, stained-glass windows, and sculptures.

◄ [1]

◄ [2]

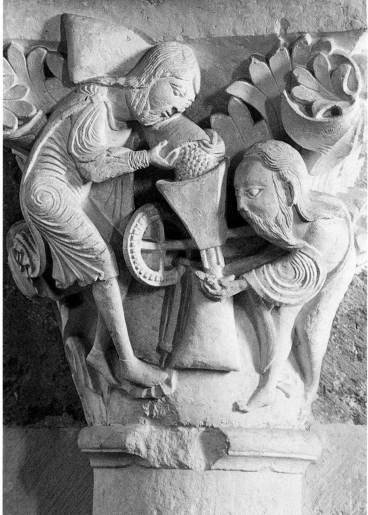

[3]

The Benedictine Order

Saint Benedict of Norcia founded the Benedictine order in the sixth century to reinvigorate a Church that was weakened by feudal rivalries. The rule of this order recalled those of the knights: a group of brothers, united under the authority of a father, was constituted as a spiritual militia to propagate the teachings of Christ. These monks did not fear manual labor and were able to resist the lords who eyed their possessions. Founded at the beginning of the tenth century, the monastery of Cluny, whose abbot was elected, rejected all authority except that of the Pope. In a life consecrated to God, the monks also devoted themselves to study. This intellectual reform broke with pagan culture while restoring Latin as the language of the Scriptures.

[1] Sénanque Abbey (Vaucluse, France). 12th century.

[2] Gallery of the cloister of the abbey church Saint-Pierre de Moissac (Tarn-et-Garonne, France). Late 12th century.

[3] *The Mystic Mill.* (Moses emptying a sack of grain and Saint Paul gathering the flour). Capital, central nave, Church of the Madeleine, Vézelay (France), c. 1120–1140.

[4] Detail from the fresco (Apocalypse scene) in the porch of the abbey church of Saint-Savin-sur-Gartempe, Vienne (France), c. 1100.

[4]

IN NORTHERN EUROPE

1066	Circa 1150	1154
William the Conqueror defeats the English at Hastings.	Creation of the Northern Hanseatic League, league of German merchants	Beginning of the Plantagenet dynasty

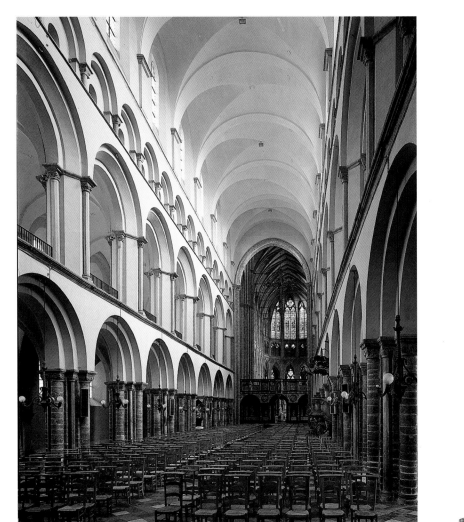

[1]

The German Empire came only slowly to Romanesque art. In this forested region, carpentry did not cede easily to stone vaults. At the end of the eleventh century, the Rhineland was the first region to take this direction, followed by Flanders, in present-day Belgium. The Normans turned the Romanesque style to their advantage, in their own region, as well as in England, which they had just conquered. They built Durham Cathedral, the first triumph of the intersecting ribs, and the harbinger of the mutation of Romanesque art into the great style it engendered: the Gothic.

[1] Central nave, Cathedral of Tournai (Belgium). Second quarter of the 12th century.

[2] Castle of the counts of Flanders, 's Gravensteen, near Ghent (Belgium), c. 1180.

[3] Eastern apse, Cathedral of Spire (Rhineland, Germany). Late 11th–early 12th century.

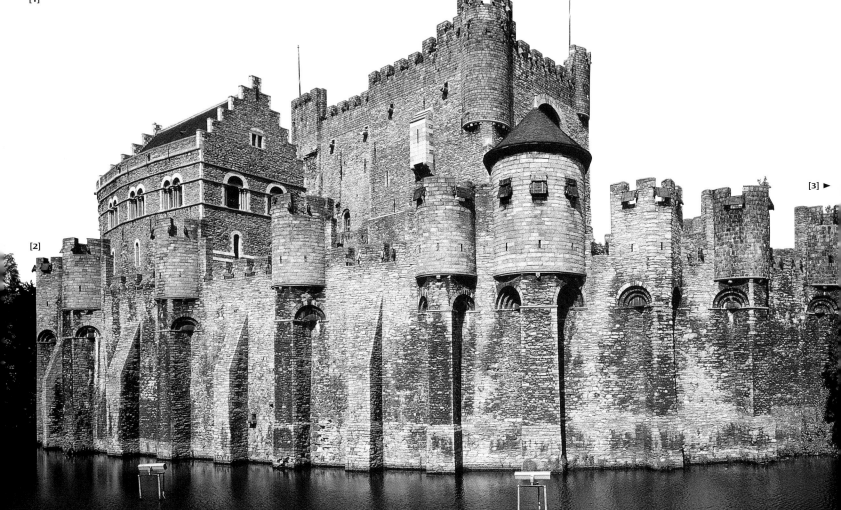

[2]

[3] ►

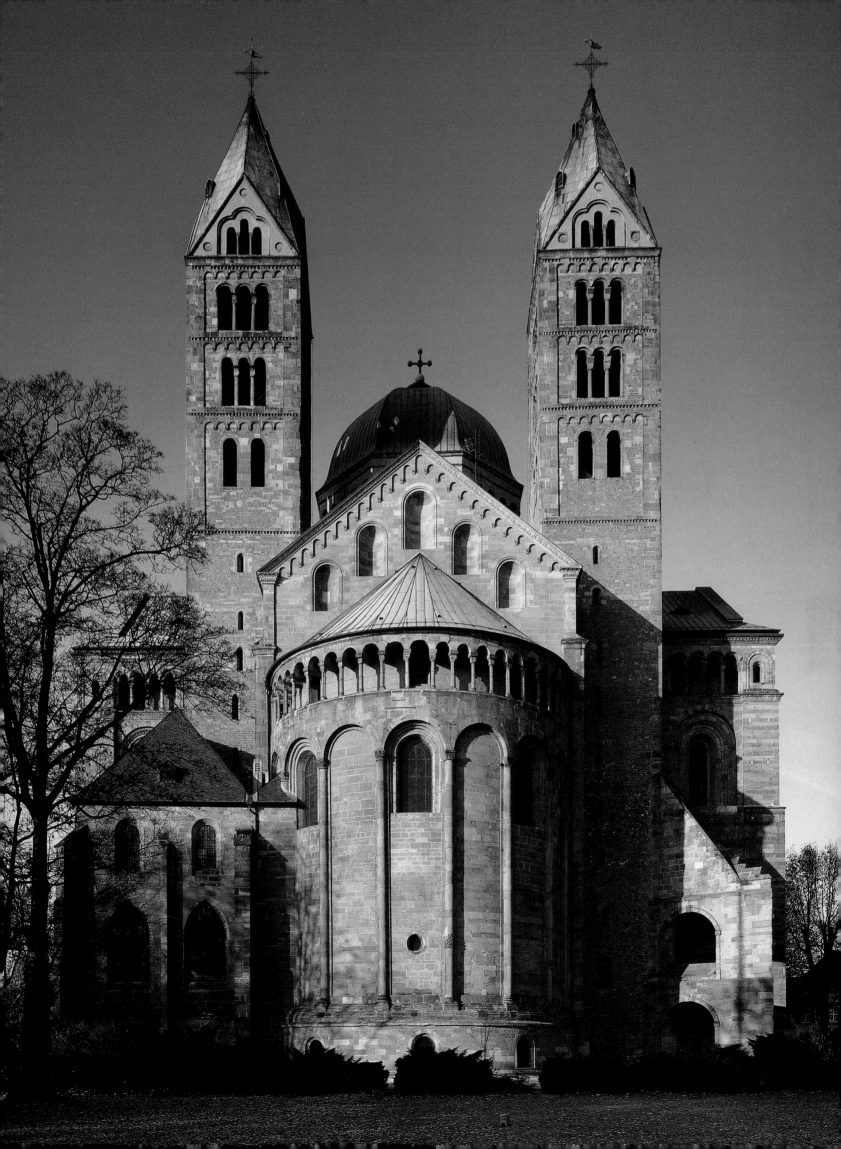

1085
Alphonse VI conquers
the Muslim kingdom
of Toledo.

1145
Frederick Barbarossa
takes Rome.

c. 1200
The Commune movement
spreads in Italy.

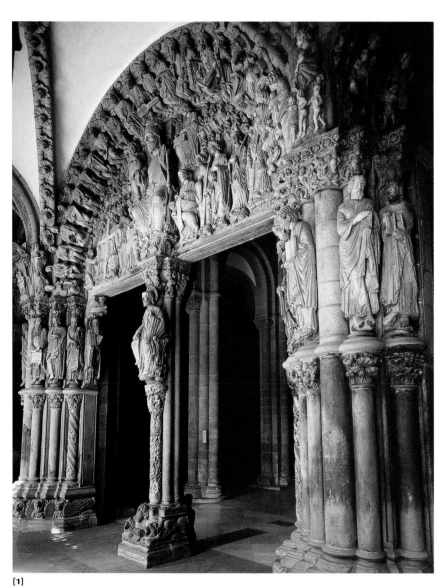

[1]

The Normans brought Romanesque art to Lombardy, where Ravenna's lessons endured. Tuscany's interpretation of the Romanesque code was much more original (and closer to Rome). In Pisa, the complex comprising the cathedral, its leaning campanile (the famous tower—the result of an error in construction) and the round baptistry that accompanies them, is one of the masterpieces of European art. The roof is not covered in stone, while the marble facade gives the monuments a classical air that is in harmony with the elegance of the delicate arches. In Spain, the cathedral of Santiago de Compostela is one of the most rigorous examples of the architectural orthodoxy of the monks of Cluny.

[3] ►

[4] ►

[1] Facade, Church of
Santiago de Compostela
(the Porch of Glory).
1188–1200.

[2] Interior, Baptistery of
Parma. 1196–1260.

[3] The Campo of Pisa
(in the foreground, the
baptistery, 1153–14th
century; cathedral,
1063–13th century;
campanile, 1173–1350).

[4]] View of the apse,
Church of Saints Mary
and Donatus, Murano
(Veneto, Italy). 12th
century.

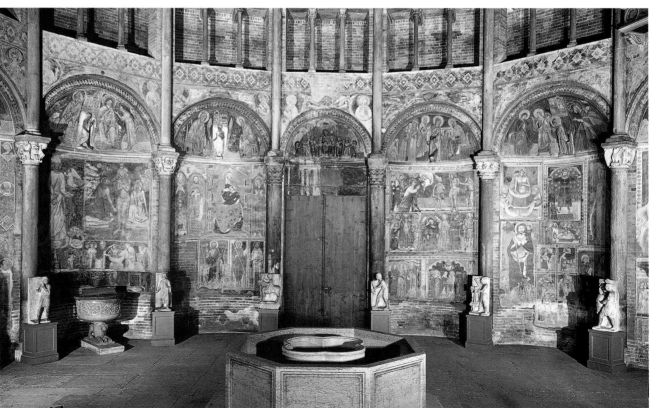

[2]

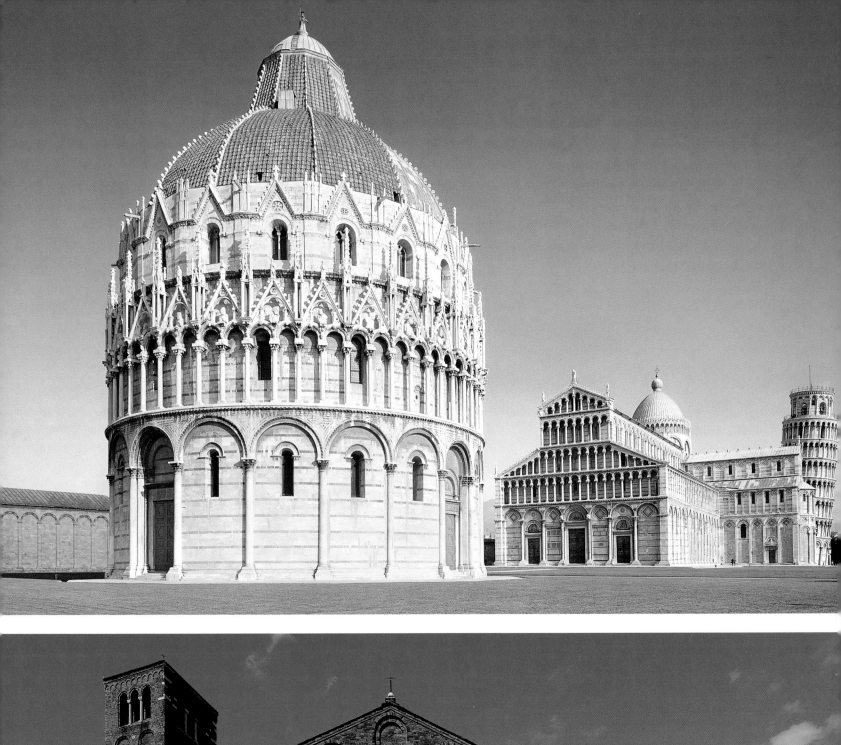

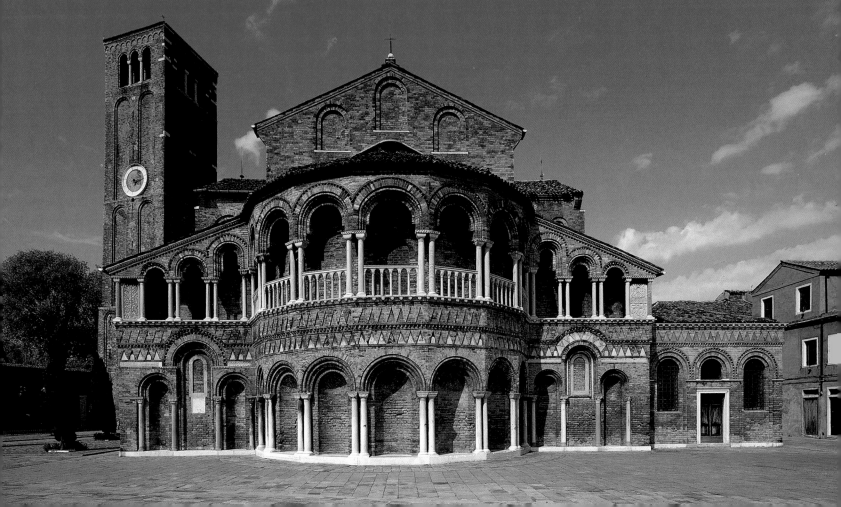

THE TRIUMPH OF THE CHURCH

In the early twelfth century, Abbé Suger, a man of intelligence and culture, was the counselor of the French kings Louis VI and Louis VII. He worked for the glory of his monarchs, his country, and his people—all of which, according to the beliefs of his time, were subsumed into the glory of the Church. For this Benedictine, the church of the kings of France must be a monument that symbolically unites royalty and God. Transforming himself into a contractor, he built, just north of Paris in Saint-Denis, a sumptuous abbey church that he designed according to a theological principle: God is light. God is radiant and illuminates the world. God shows Himself to man through light, and man can follow the beam of light back to its source, which is God.

At Saint-Denis, Suger invented an architecture of light. More than an inventor, however, he was the interpreter of a movement with diverse origins to which he gave the clearest form. This movement flourished at Sens, Notre-Dame de Paris, Chartres, Bourges, and Amiens, and rapidly conquered Europe—from England to Italy, from Spain to Poland. The Gothic cathedral differed from its Romanesque ancestor due to a new architectural design: the systematic use of intersecting ribs, which replaced the rounded vault, allowing for a better distribution of distribution of weight over the columns, thereby freeing the walls from their weight-bearing functions and opening the space up to light.

[1] Duccio di Buoninsegna, c. 1260–1318/1319; *Madonna and Child with Saints*. Obverse of the reredos for the main altar, Cathedral of Siena. 1398–1311. Tempera on panel, H: 3.7m; L: 4.5m. Siena, Museo della Metropolitana.

Flying buttresses, which often made the building resemble a large insect, further improved the distribution of weight.

It was during the Renaissance that the name "Gothic" was used pejoratively to name the art of the closing centuries of the Middle Ages. It also designated the culture of the period, a culture supported by the great vessel of the new cathedral whose audacious architecture plays with an interior void that is high and spacious, light, and luminous. For three centuries, religious architecture followed the model established by Suger, becoming ever bolder, taking the experiment further by reducing it to its quintessence, as in Cistercian austerity, or by toying with forms, as in the decorative mannerism of the late Gothic known as "flamboyant."

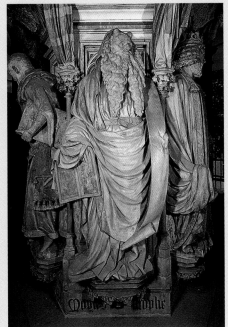

[2]

Gothic spirituality was also intellectually vigorous: God was also reason. During this period, Paris became the intellectual capital of a Europe that was politically and administratively divided, but where ideas circulated quickly. Teaching was no longer confined to the monasteries; it came to the cities around the cathedrals, to the secular clergy, even to laymen. The art of the *disputatio*, or discussion, followed in the footsteps of Aristotle, then Thomas Aquinas, who, in the thirteenth century, made a case that philosophy should enjoy a certain autonomy with respect to religion. The Gothic cathedral acted as a model in this intellectual expansion: its form both rational and sacred.

These centuries obsessed with unity—the Incarnation united man and God, Scholasticism united the intellectual and the spiritual—saw the construction of immense cathedrals that link heaven and earth, stone and light, the void and form, in the mathematical declension of the bay, its fundamental element. The cathedrals incorporated painting, sculpture, goldsmithery, and stained glass into architecture. It was a great dream that concealed a reality composed of divergent movements. For the intellectual impetus provoked reactions: both an entrenchment of the conservatives in the Church, who closed ranks around the papacy, and the ecstasy of the secular clergy. Mysticism was in fashion, inside the Church with the Cistercians of Saint Bernard, the Franciscans of Saint Francis, and the Dominicans of Saint Dominic. Outside the Church, mysticism fueled widespread popular trends that challenged the ecclesiastical hierarchy and were condemned by the Church; these included the Waldenses and the Albigensians (or Cathars)—the latter eliminated in 1244 at the end of a crusade that was nearly a civil war.

The omnipotence of the Church was further eroded by profane powers, crystalized in courtly love, an original erotic ritual and the last manifestation of the spirit of chivalry. In the shadows of the cathedrals, a large part of the culture was already outside the reach of the Church.

[2] Claus Sluter (c.1350–1406); *The Well of Moses*, c. 1400. Dado, Way of the Cross, cloister, Charterhouse of Champmol, near Dijon.

[3] The Church of Santa Croce, Florence. 1295–1413.

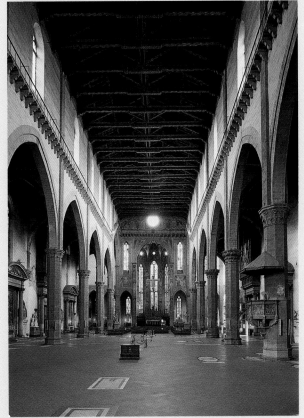

[3]

1144–1146
Famine in Europe

1179
Philip Augustus
is king of France.

1209–1244
Crusade against
the Albigensians

[1]

Born of Abbé Suger's experiments at Saint-Denis, Notre-Dame de Paris is the first masterpiece of Gothic art. Its size, the perfect balance of its facade, the elegance of its flying buttresses, and the perfection of its stained-glass windows fully justify its reputation as the most famous church in France. With variations specific to each cathedral, the same features may be found at Chartres, with its two high towers and magnificent stained glass, and at Sens, Bourges, Reims, and Amiens. It is no exaggeration to state that France (*that* France, smaller than today's) was the birthplace of Gothic art.

> ❝*The cathedral developed—in a persuasive trick of the intelligence—a vertical geometry woven of light.*❞
>
> **Georges Duby**

[1] Stained-glass window,
Chartres Cathedral,
c. 1220–1230.

[2] The Cathedral of
Notre-Dame de Paris.
1163–early 14th century.

[3] Nave, Cathedral of
Amiens, c. 1220–1250.

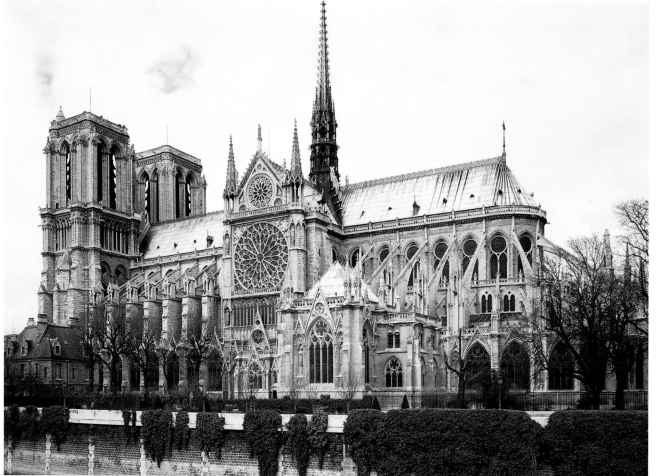

[2]

[3] ▶

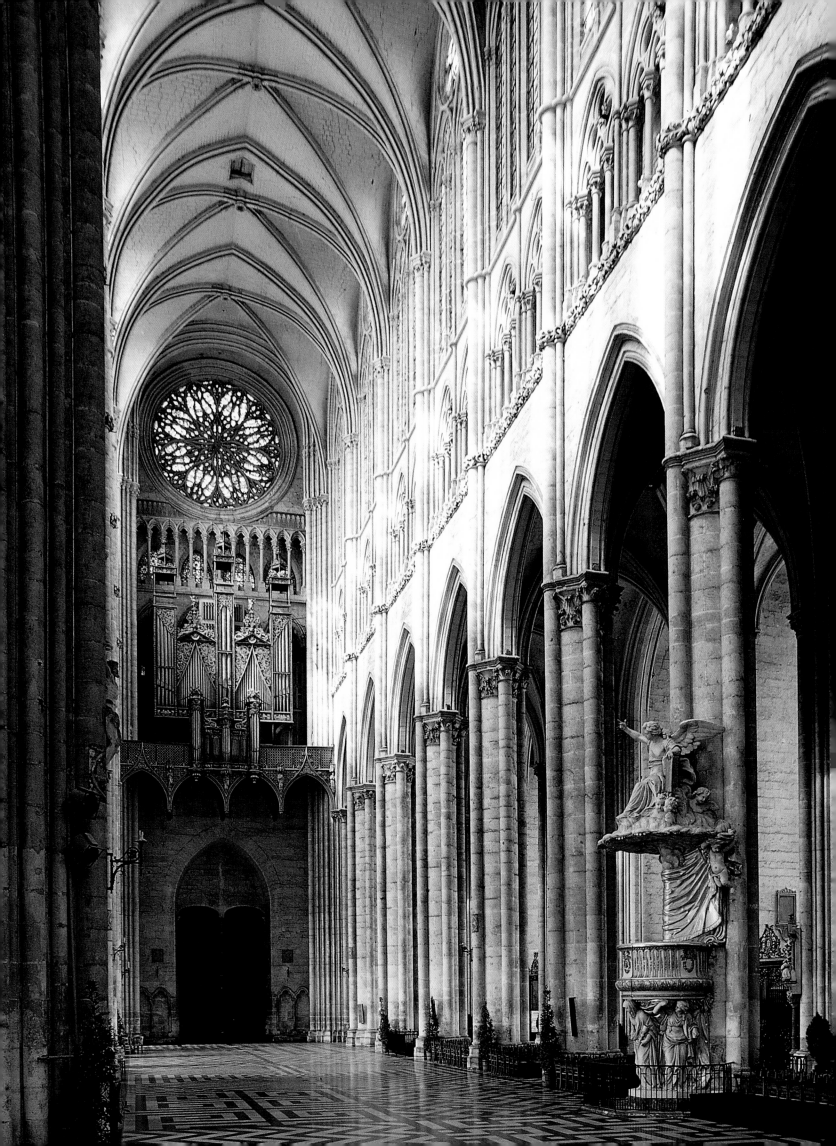

1304
Division of Flanders,
part of which is
annexed by France

1309
Pope Clement V
moves the papacy
to Avignon.

1429
Joan of Arc
delivers Orléans.

Gothic art was equally handsome in its secular manifestations: in elegant constructions that demonstrated that, setting aside the consecrated grandeur of the cathedrals, it could be adapted to buildings with very different functions. This took some time, however. In Avignon, the palace to which the popes removed was built in two stages (but in less than twenty years) in the mid-fourteenth century: first with a beautiful Cistercian austerity, in the spirit of fortresses, then with the decorative profusion of the late Gothic. The home of Jacques Coeur in Bourges is another splendid example of late Gothic architecture.

[1] Entrance of the "Palais-Neuf," Palais des Papes, Avignon. Early 14th century.

[2] House of Jacques Coeur (financial advisor to Charles VII). Bourges, France. 1443–1451.

[3] Hôtel-Dieu, Beaune (Côte-d'Or, France). Hospital founded by Nicolas Rolin, chancellor of the Duke of Burgundy, c. 1443.

[2]

[3]

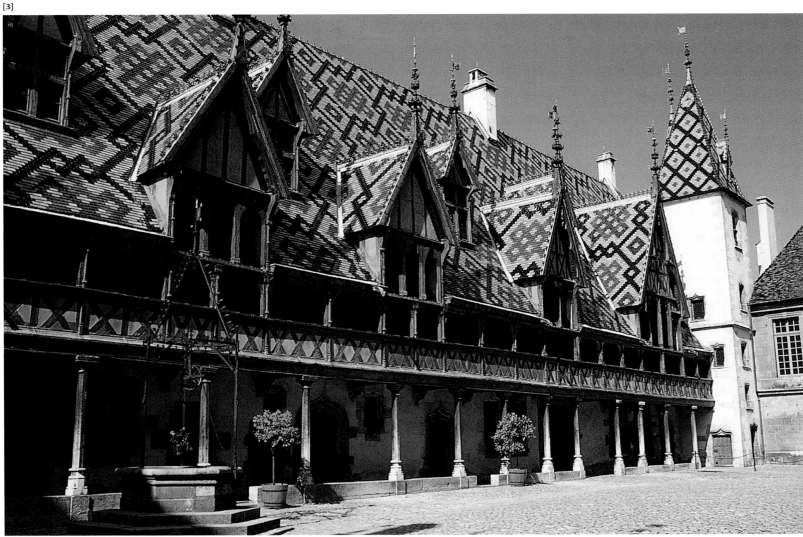

1198
The Teutonic Order
is founded
in Jerusalem.

1347–1351
The Black Plague

1356
The Golden Bull puts an
end to papal interference
in the German Empire.

[1]

> *"At the very moment when peoples became self-aware and when national languages were in full bloom, the Gothic became a common language for all of Europe."*
>
> **Friedrich Heer**

In Germany, the Romanesque and Gothic remained closely linked for a long time, and it was not until the thirteenth century that the Gothic trend was truly adopted. Cologne Cathedral, begun in the mid-thirteenth century and still unfinished, is a fine example of Gothic art. Strasbourg Cathedral, which never did get the two spires promised to it, but which is embellished by delicate stone carvings, belongs to the same lineage. But it is in sculpture, above all, that Gothic Germany demonstrated its originality by radically separating this art from architecture with an expressionist force unusual for its time. In Flanders, secular architecture flourished in the cities of Bruges, Tournai, Ypres, and Ghent.

[1] *The Dormition of the Virgin.* 1220–1230. Tympanum, Strasbourg Cathedral, portal of the south transept.

[2] *Bonn Pietà,* c. 1300. Wood. Cologne, Rheinisches Landesmuseum.

[3] Vaults, Cologne Cathedral. 1248–1322.

[2]

[3] ▶

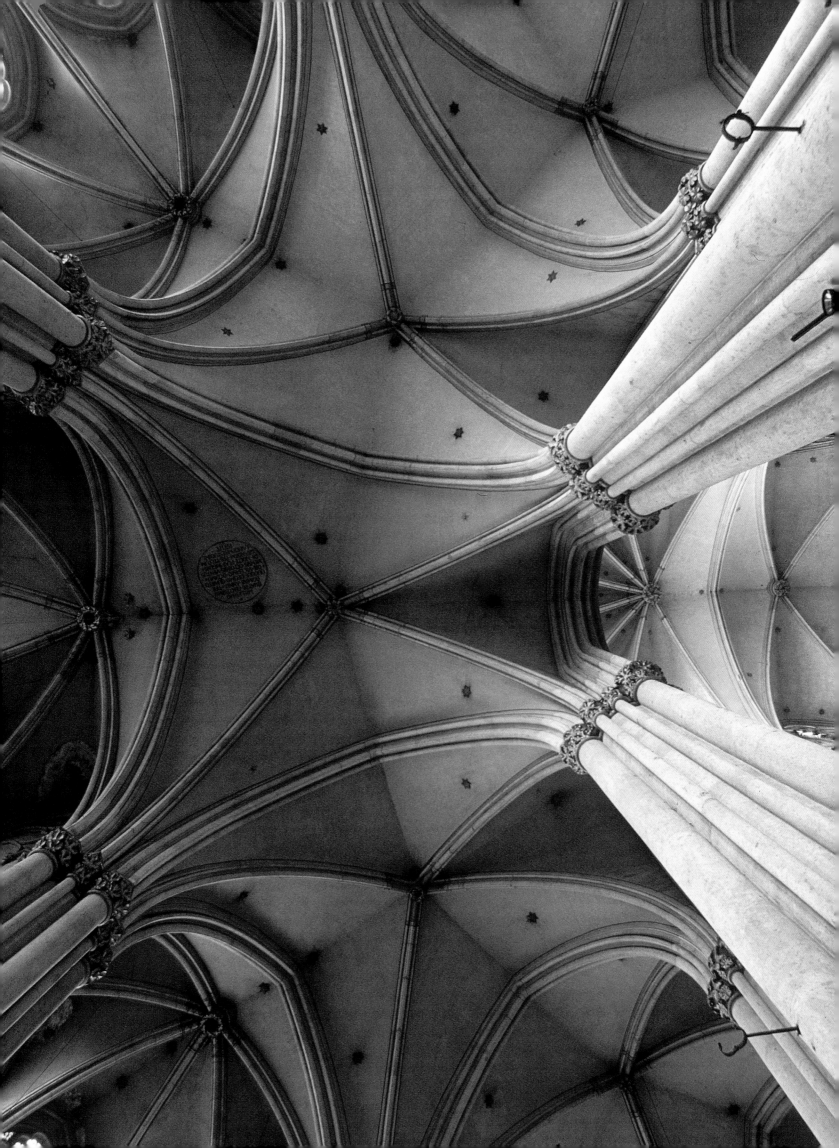

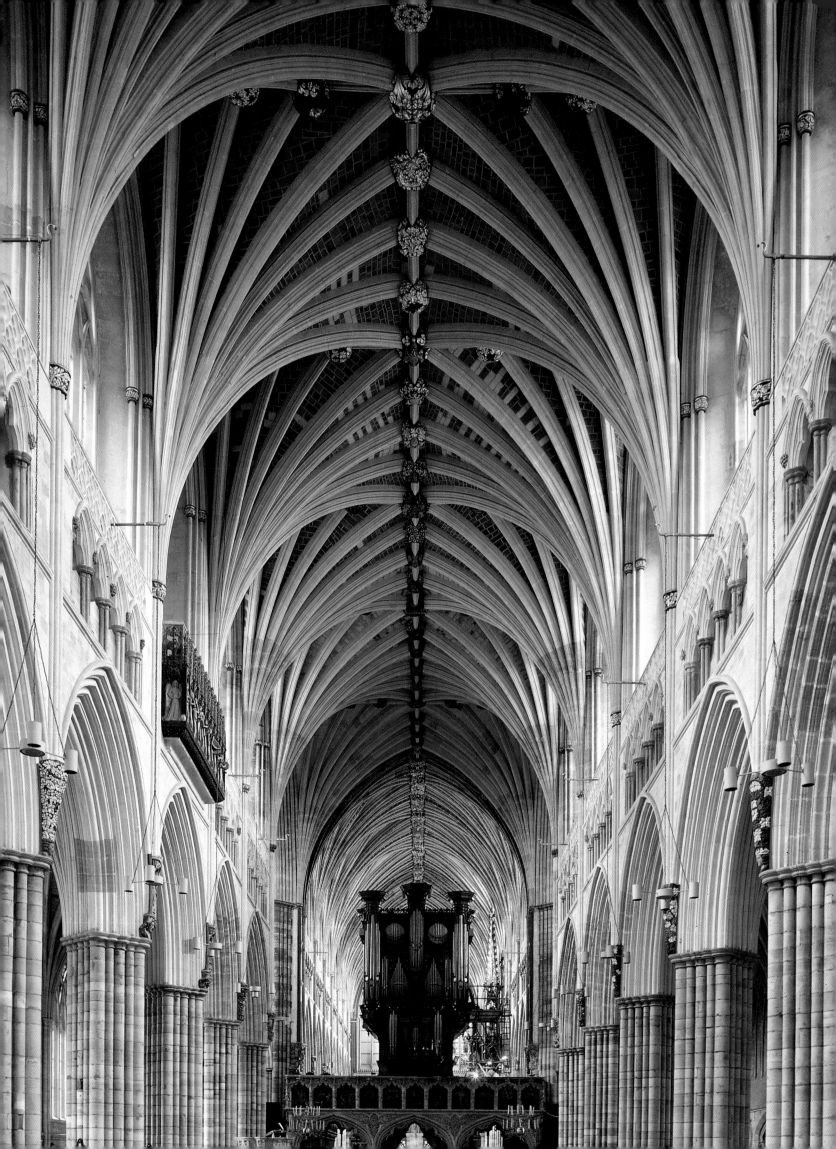

1154
Henry II Plantagenet
is king of England.

1189
Richard the Lion-Hearted
is king of England.

1356
The English hold John II,
king of France, prisoner.

[1] Vaults of the nave, Exeter Cathedral, c.1280–1290.

[2] Detail of a stained-glass window, Canterbury Cathedral, c. 1180–1220.

[3] Richard II. 1377. Tempera on panel. London, Westminster Abbey.

[2]

England was quick to adopt the Gothic style. The English version was original in that it emphasized length rather than height, taking a fancy to heavy masses before developing the ornamental exuberance that characterizes what would be called the "decorated style." This style emerged in the first half of the fourteenth century with ornamentation inspired more by the goldsmith's art and manuscript illumination than by architectural pragmatism. The lantern tower rising from the middle of the building is entirely in the Anglo-Norman tradition.

[1] Vaults of the nave, Exeter Cathedral, c.1280–1290.

[2] Detail of a stained-glass window, Canterbury Cathedral, c. 1180–1220.

[3] Richard II. 1377. Tempera on panel. London, Westminster Abbey.

[3]

◄ [1]

1268
Charles of Anjou
conquers Sicily.

1271
Marco Polo sets off
on the Silk Road.

1284
Genoa defeats Pisa
at the Battle of Meloria.

[1]

In Italy, the Gothic movement of the early thirteenth century was Cistercian in origin. It then deferred to Franciscan simplicity—still faithful to its wooden ceiling, but luminous and rich with frescoes and stained-glass windows. In Orientalizing Venice, the Doges' Palace is a very pure fourteenth-century interpretation of the Gothic. During this period, Italy held the primacy in painting, with Duccio, Cimabue, Simone Martini, and, above all, the great Giotto. It is to Giotto that we owe a more humanistic vision of the sacred stories, as well as a sense of space that gives the illusion of a third dimension. He was the first master of the Christian era, raising the stature of painting to equal that of sculpture, until then the reigning art.

[1] Simone Martini (1284–1344); *Guidoriccio da Fogliano*, c. 1330. Fresco, Palazzo Pubblico, Siena, Sala del Mappamondo.

[2] Doges' Palace, Venice. 14th–15th century (facade on the jetty, 14th century; balcony, 1404; facade on the Piazzetta, 1424–1442).

[3] Giotto di Bondone (1266–1337); *The Dream of Innocent III*, late 13th century. Fresco, upper chapel, Basilica of Saint Francis, Assisi.

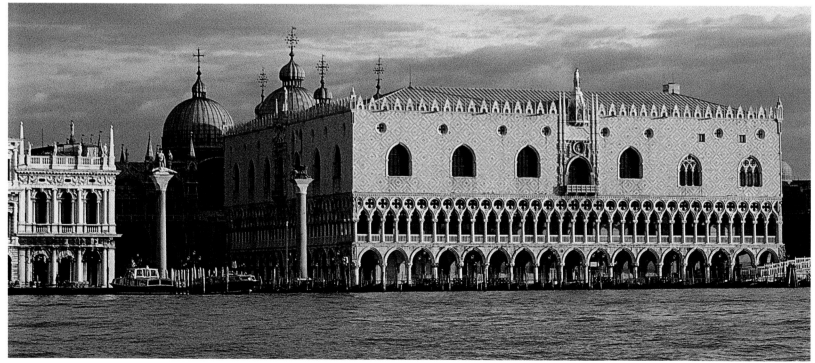

[2]

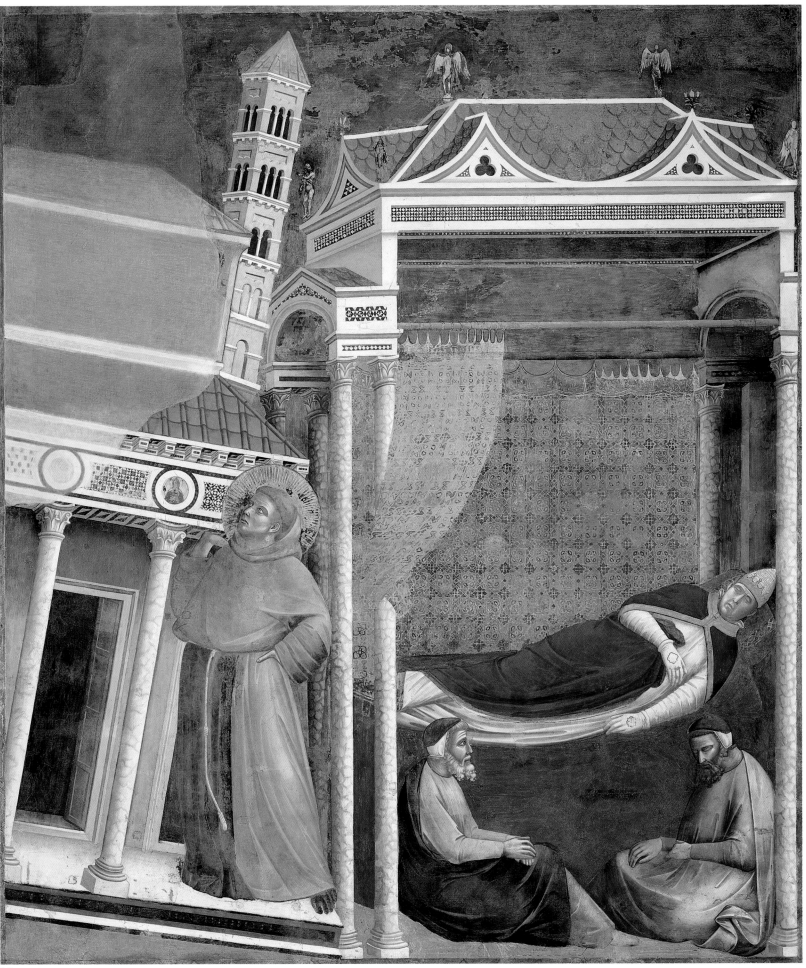

[3]

1226
The Moors lose Cadiz.

1252
Pope Innocent IV
authorizes the Inquisition
to use torture.

1492
The Spanish win
Grenada back from
the Moors.

In Spain, the Moorish colonization was only gradually driven back towards the south. Seville was taken back in 1248, but Granada remained Arab until 1492. The north, on the pilgrims' route to Santiago de Compostela, is full of imposing monuments that affirmed the Christian presence in the face of the "infidels." In the south, Castille and Andalusia saw the development of a hybrid art that combined Christian and Mudejar art, an Arab form that persisted after the Reconquista. The transformation of mosques and synagogues into churches grafted bold influences onto Spanish religious architecture. The architecture of Granada's Alhambra Palace, constructed in the fourteenth century in a kingdom that was still Muslim, is open to nature and made for the pleasure of living. A certain profusion of ornamentation is similar to that of the late Gothic period.

[1]

[1] The Court of the Lions, the Alhambra, Granada, Spain. Second half of the 14th century.

[2] Interior, Great Mosque of Cordoba. Late 10th century.

[3] The Cathedral of Burgos. 1221–1260 (upper portion and bell tower, 15th century).

Islamic Art

Architecture came to the Arabs with Islam. It was only after Mohammed that these nomads settled, and their monarchs built palaces and mosques. In the eighth century, the influences were Persian, Hellenistic, and Byzantine, but an original artistic style quickly took shape. The mosque of Cordoba, constructed in three stages over two centuries, is characterized by its profuse arcature and slender columns. The Moorish style blossomed at the Alhambra in Granada, which is very elegant with a refined calligraphic decoration. To combat any temptation to idolatry, Islamic art forbade the representation of any religious images.

[2]

[3] ►

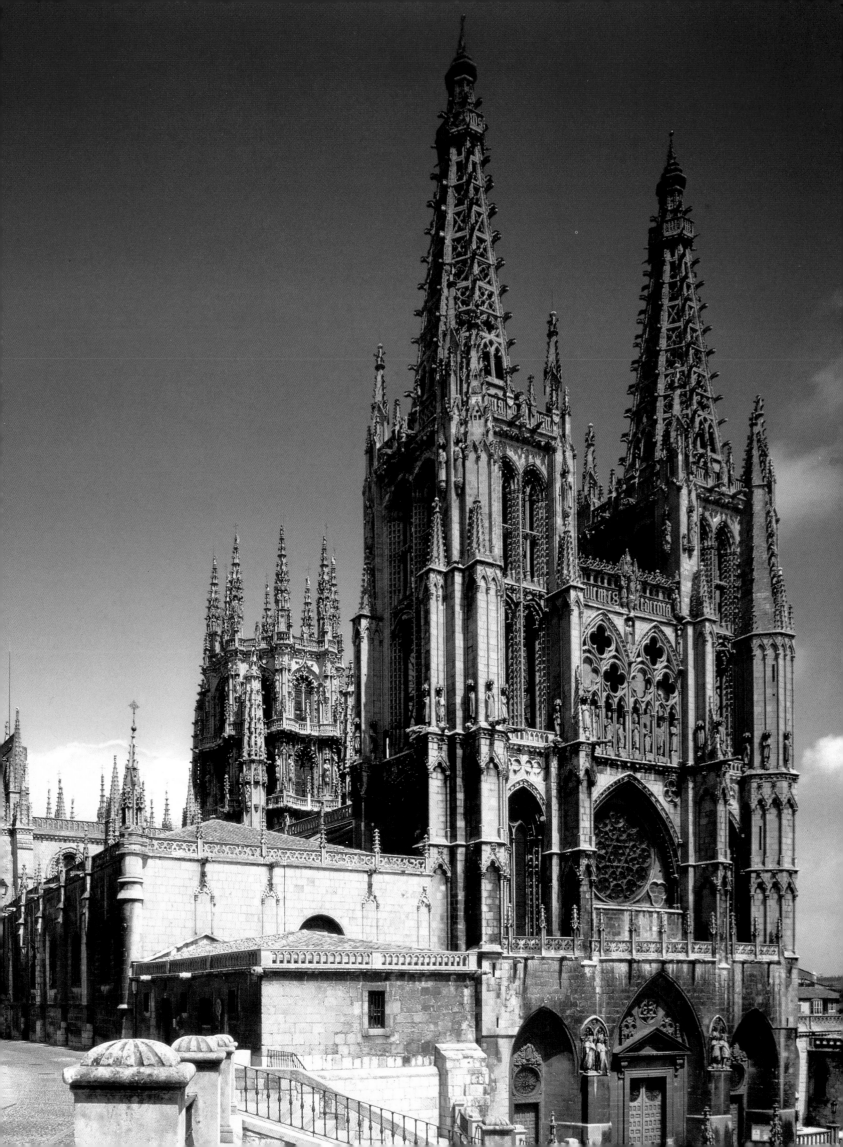

THE HUMANIST MOVEMENT

In the fifteenth century, something fundamental changed in a world where Europe had the lion's share of power. A new way of thinking about humanity and its relationship to the world developed, supported by a new interpretation of antiquity. The plastic arts played an important role in this. After building its cathedrals, Europe deserved a rest. It did not, however, rest for very long. On the contrary, the creative momentum of the Middle Ages, although weak in the countries where it originated—France and Germany—continued by radically renewing its expressions. Actually, the idea of the Renaissance was Italian: the country that was the locus of the glory that was Rome rediscovered, after centuries of oblivion, its ambition and vigor. The heart of Italy, which had not been very Gothic, started beating strongly, but not in Rome this time. In Florence, beginning in 1434, it was the Medicis who had the power, wealth, and culture. Then all of Italy awakened with new ideas, simultaneously reinventing the fine arts and literature. All of Europe was swept into this curious revolution that looked backward as much as forward, and invented a future by rediscovering its past.

Ideas and behavior changed completely in Europe over the course of the fifteenth and sixteenth centuries. It was a long and difficult metamorphosis that did not resolve all its contradictions and took different forms in different countries: it would be an oversimplification to say that the Gothic order made way for the classical order, that the spiritual impulse made way for humanist reasoning, that the free towns made way for centralized monarchies, and that imagination made way for analytical thinking.

Europe centered on a reawakening Latin spirit, to which the papacy gave a newly imperial luster. North and south found a new equilibrium between Germanic, Scandinavian, and Slavic shadows and Mediterranean brightness. Reason regained the status it had enjoyed in the era of the Greek philosophers. Artists, carried on a great wave of creativity, experienced a golden age during which they were more encouraged than ever; they were admired and celebrated as the new heroes—adventurers of the mind as others were explorers of the oceans. But the Renaissance was also a grand illusion.

[1]

[1] Jean de Limbourg (14th century–before 1416); *Les Très Riches Heures du duc de Berry* (October), 1413–1416. Illumination on vellum, H: 15.5cm; W: 13.5cm. Chantilly, Musée Condé.

[2] Hugo van der Goes (c. 1440–1482); right panel of the Portinari triptych (Maria and Margherita Portinari protected by Saint Mary Magdalene and Saint Margaret), c. 1475. Oil on panel, H: 2.52m; L: 5.86m (total). Panels, H: 2.52m; W: 1.41m. Florence, Galleria degli Uffizi.

[2]

The Renaissance in the 14th and 15th Centuries

In the beginning, there was a simple idea: people can live well in this world, here and now, and their destiny in another world—in another time—is not the key to their life on earth. Sin, which allows the Church to exercise control over individuals and society (along with the complementary idea of redemption), was no longer an obsession. Antiquity, as adapted by the Middle Ages, was stripped of its pagan joy; the antiquity of the Renaissance, at least initially, was critical in a different way: it was an engine of war against the omnipotence of the Church, an effort by humanity to loosen the bonds that join it to God. The Church, however, was a clever strategist, and the popes were very powerful, although their might wavered for a period. In the fourteenth century, a schism divided the papacy between Avignon and Rome. But the Church regrouped, gathered its lost authority, rebuilt a Rome in ruins, reestablished the glory of the throne of Saint Peter in that city, and brought the humanist movement back onto the Christian path: human beings could be the center of the world if they admitted that they carried God within. The Church even became humanist itself in order to control this force that threatened it and so set its limits—even if this meant putting its authority and prestige before the letter of the Gospels.

New ideas, images, and forms appeared in Italy, spreading like fire on a train of gunpowder, conquering spirits and crossing borders. A few enlightened rulers, like Lorenzo de' Medici, patronized writers and artists. Like kings and popes, princes and bishops wanted to shine by means of the works they commissioned from architects, painters, and sculptors. Art was the main business of the Renaissance, but it was a new art in which man no longer submerged himself in the glory of God. Architecture—less grandiloquent than before—was designed for humanity, a humanity whose image in painting and sculpture owed almost everything to anatomy and mathematics.

[3] Fra Filippo Lippi (1406–1469); *Madonna and Child*, 1452. Oil on panel, diam: 1.35m. Florence, Palazzo Pitti.

[4] Andrea del Verocchio (1435–1488); equestrian statue of the condottiere Bartolommeo Colleoni. 1481–1486. Cast by Alessandro Leopardi between 1490 and 1495. Bronze, H: 3.96m. Venice, Campo di SS. Giovanni e Paolo.

[4]

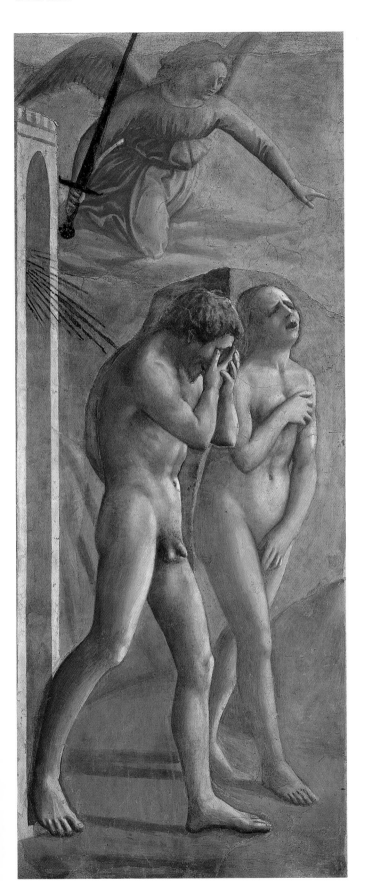

The Renaissance truly began in Florence with three great artists. Brunelleschi built the cathedral's very high dome and discovered the laws of perspective. Masaccio used these laws in painting to represent the third dimension and give his frescoes the illusion of depth. Donatello created a realistic sculpture inspired by Roman classicism. All three artists bear witness to an era in which science and art joined to produce a new picture of humanity and the world.

The Medicis

A family of bankers dominated Florence in the fifteenth century. Cosimo de' Medici pulled the strings of the republic from 1440 until his death in 1464. This efficient manager—an enlightened despot, a friend to the humanists and an audacious patron—sponsored the Platonic Academy and gave Brunelleschi, Donatello, and Fra Angelico the opportunity to demonstrate their talent. From 1469 to 1492, his grandson Lorenzo the Magnificent ruled the city with an iron fist. Also a humanist, a connoisseur of art, and, a friend to artists, he restored the city's influence, but led the family business and the city itself to ruin. After the dark period of Savonarola's revolution, the Medicis returned to Florence, became dukes of Tuscany, gave two popes to Christianity and two queens to France: Catherine and Marie de Médicis.

[2]

[1] Filippo Brunelleschi (1377–1446); Pazzi Chapel, Church of Santa Croce, Florence. 1430–1443.

[2] Tommaso Masaccio (1401–1428); *Expulsion of Adam and Eve from Paradise,* c. 1426. Fresco, H: 2.08m; W: 0.88 m. Florence, Brancacci Chapel, Santa Maria del Carmine.

[3] Donatello (c. 1386–1466); *Saint George.* 1415–1417. Marble, H: 2.09m. Florence, Museo Nazionale del Bargello.

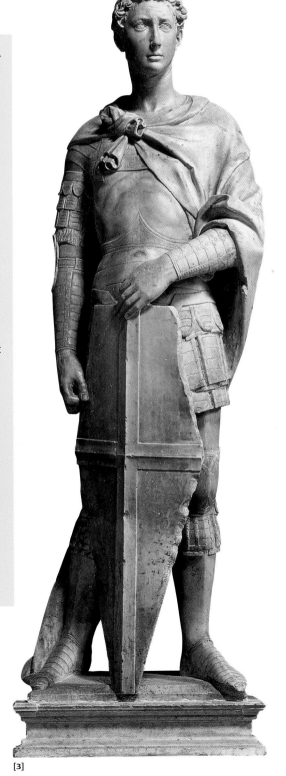

[3]

◄ [1]

1453
End of the Hundred Years' War between England and France

1472
War between the France of Louis XI and the Burgundy of Charles the Bold

1491
Charles VIII, King of France, weds Anne of Brittany.

In the fourteenth and fifteenth centuries, Avignon was an important center for the arts. The papal court attracted artists from Italy, and King René, who was Duke of Provence from 1434 to 1480, was an enlightened patron. In Avignon, Enguerrand Quarton painted a masterpiece of the French Renaissance that set his skilled representations of the third dimension against a Gothic-inspired flat setting. In northern France, Jean Fouquet was the master of the new art of portraiture, while the Limbourg brothers had already demonstrated a keen feeling for landscape in their manuscript miniatures.

[1]

[2]

[1] Tomb of Philippe Pot, Seneschal of Burgundy, c. 1480. Painted stone, H: 1.81m; L: 2.6m; W: 1.67m. From the abbey church of Cîteaux. Paris, Musée du Louvre.

[2] Enguerrand Quarton (active 1444–1466); *The Villeneuve-lès-Avignon Pietà*, c. 1455. Oil on panel, H: 1.63m; L: 2.18m. Paris, Musée du Louvre.

[3] Jean Fouquet (1415/1420–1477/1481); *Virgin and Child Surrounded by Angels*, after 1452. Tempera on panel, H: 91cm; W: 81cm. Antwerp, Koninklijk Museum voor Schone Kunsten.

[3]

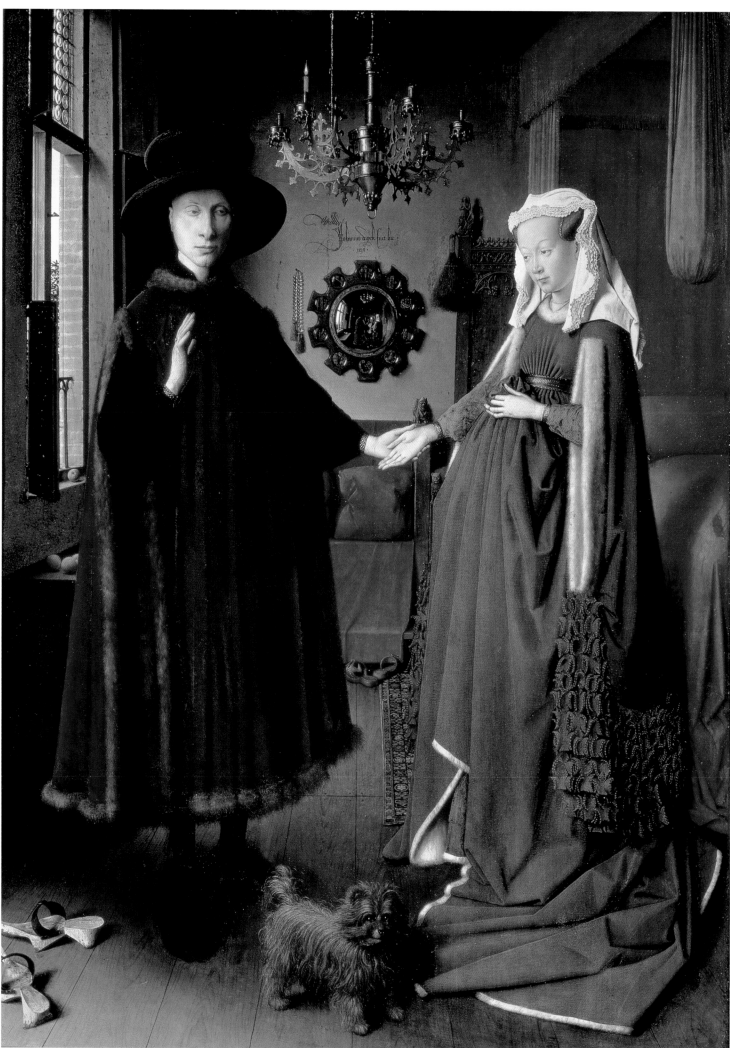

[1]

1384
Philip the Bold,
Duke of Burgundy,
becomes Count of Flanders.

1426
Founding of the
University of Louvain

1460
First European stock
exchange is set up in Antwerp.

Italy, turning back to antiquity, invented a new artistic order, but the spirit of humanism took other forms in northern Europe. Gothic beauty continued its evolution in Flanders, for example, which was less obsessed with Rome and Athens. Beginning in the early fifteenth century, the Master of Flémalle and the Van Eyck brothers were able to draw in perspective and use light to model faces. In addition, they implemented a revolutionary technique they had perfected: oil painting instead of egg tempera, which allowed more precision and finesse.

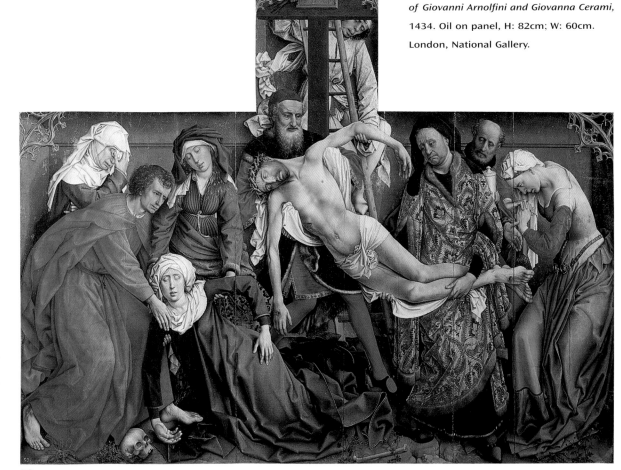

[1] Jan Van Eyck (1390–1441); *The Marriage of Giovanni Arnolfini and Giovanna Cerami*, 1434. Oil on panel, H: 82cm; W: 60cm. London, National Gallery.

[2]

[2] Rogier Van der Weyden (1399/1400–1464); *The Descent from the Cross*, c. 1435. Reredos, oil on panel, H: 2.2m; L: 2.62m. Madrid, Museo del Prado.

[3] Hans Memling (c. 1440–1494); *Triptych of Saint John the Baptist and Saint John the Evangelist*, 1474–1479. Oil on panel, H: 3.31m; L: 5.25m. Bruges, Hôpital Saint-Jean.

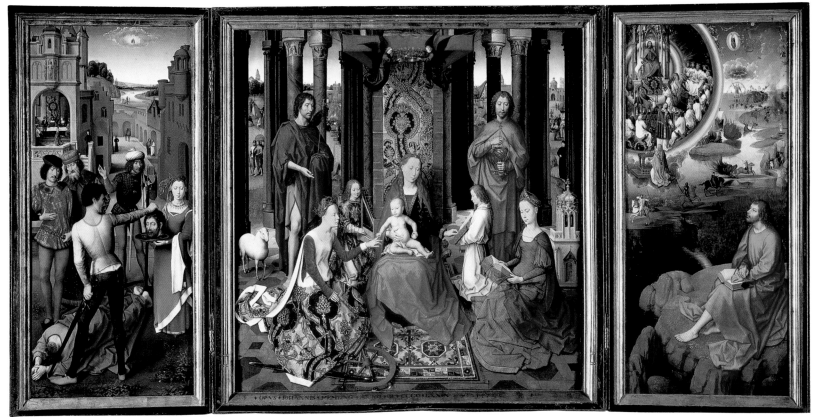

[3]

1385
Founding of the
University of
Heidelberg

1437
Gutenberg invents
movable type.

1438
Beginning of the
Hapsburg dynasty

The transition from Gothic to Renaissance was also very gradual in Germany. Stefan Lochner seems to have remained faithful to the religious imagery of the previous century, while adopting the spirit the new age: eschewing the heaviness of dogma, his work is fresh and natural. Of a completely different temperament, Konrad Witz was a somewhat naive painter, but he set his lively fishing apostles in Lake Geneva, in the most realistic landscape ever painted thus far.

[1] Gregor Erhart (c. 1470–1540); *Saint Mary Magdalene,* early 16th century. Painted wood, H: 1.77m. Paris, Musée du Louvre.

[2] Konrad Witz (1400/1410–c. 1445); *The Miraculous Draught of Fishes,* 1444. Oil on panel, H: 1.32m; L: 1.54m. Geneva, Musée d'Art et d'Histoire.

[3] Stefan Lochner (1410–1452); *The Virgin of the Rose Bush,* c. 1440. Oil on panel, H: 51cm; W: 40cm. Cologne, Wallraf-Richartz Museum.

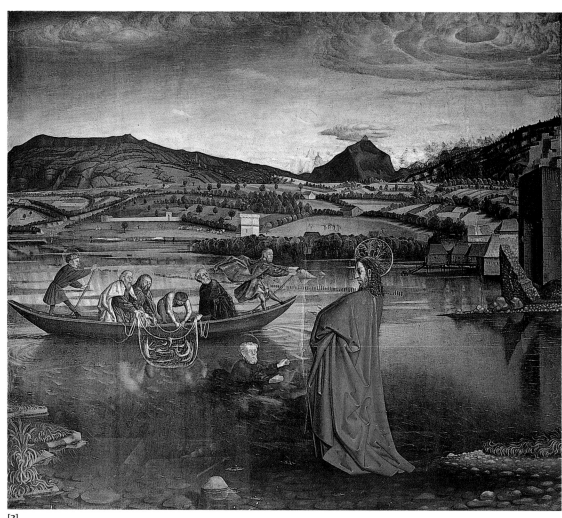

[2]

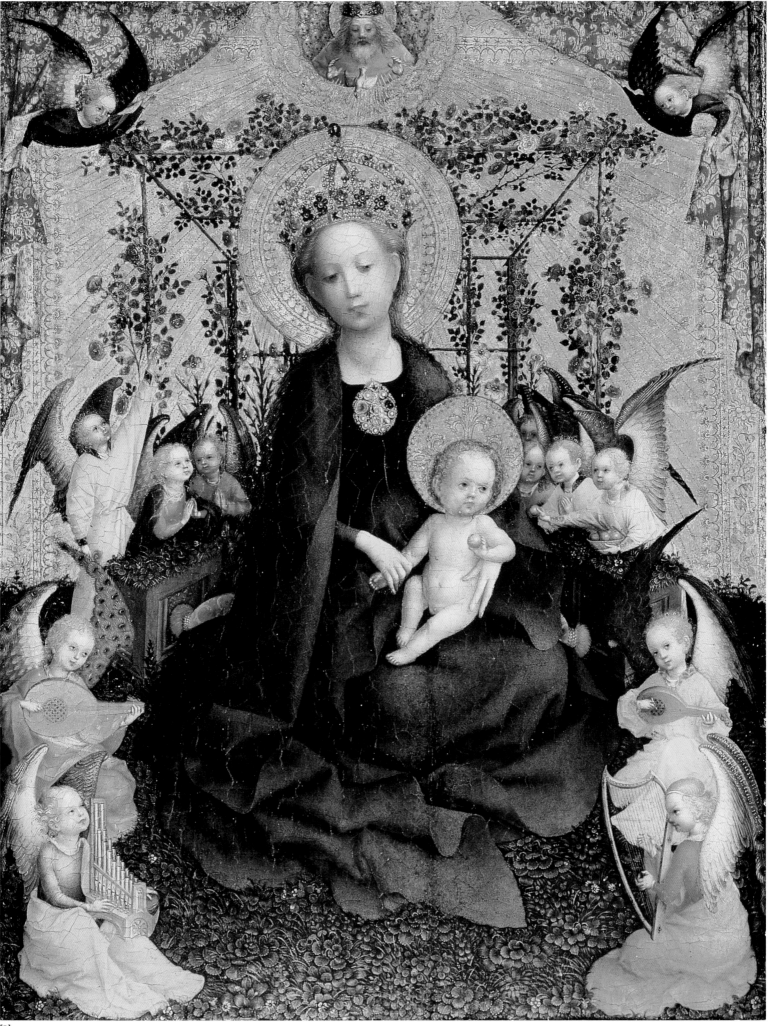

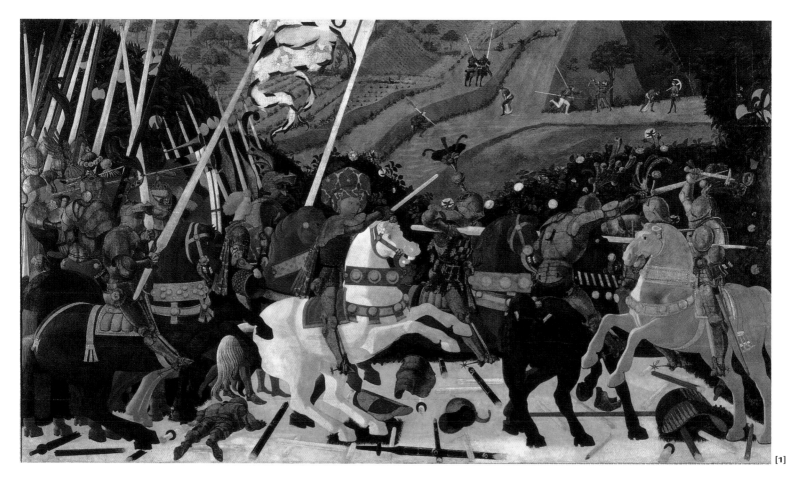

[1]

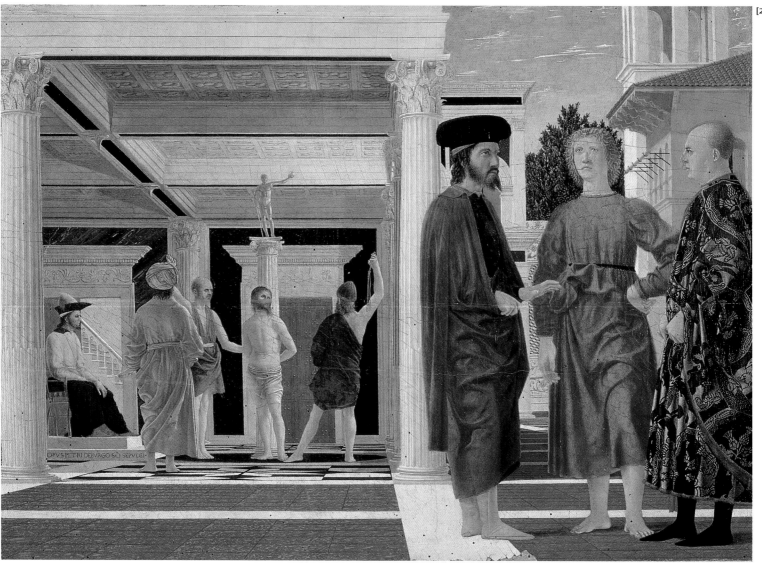

[2]

Florentine sculptor
Ghiberti writes his
Commentaries on Art.

War between Pope
Sixtus IV and
Lorenzo de' Medici

Savonarola is executed
in Florence.

Art was not overwhelmed by science. The mastery of perspective gave painting a new foundation and founded a new style. The artists' vision, although more objective, truer to the human gaze, was not cold. The firm construction of their paintings neither stifled their sensitivity nor constrained their idealism. On the contrary, their rigorous compositions support Paolo Uccello's dramatic lyricism, Fra Angelico's religious tenderness, and Piero della Francesca's spiritual élan.

[1] Paolo Uccello (c. 1397–1475); *The Battle of San Romano*, c. 1456–1460. Oil on panel, H: 1.81m; L: 3.2m. London, National Gallery.

[2] Piero della Francesca (c. 1416–1492); *The Flagellation of Christ*, c. 1459. Oil on panel, H: 59cm; L: 81cm. Urbino, Galleria Nazionale delle Marche.

[3] Fra Angelico (1387–1455); *The Annunciation*, 1440–1441. Fresco, H: 1.87m; W: 1.57m. Florence, Museo di San Marco.

[4] Anonymous; *The Ideal City*, c. 1470. Oil on panel, H: 0.6m; L: 2m. Urbino, Galleria Nazionale delle Marche.

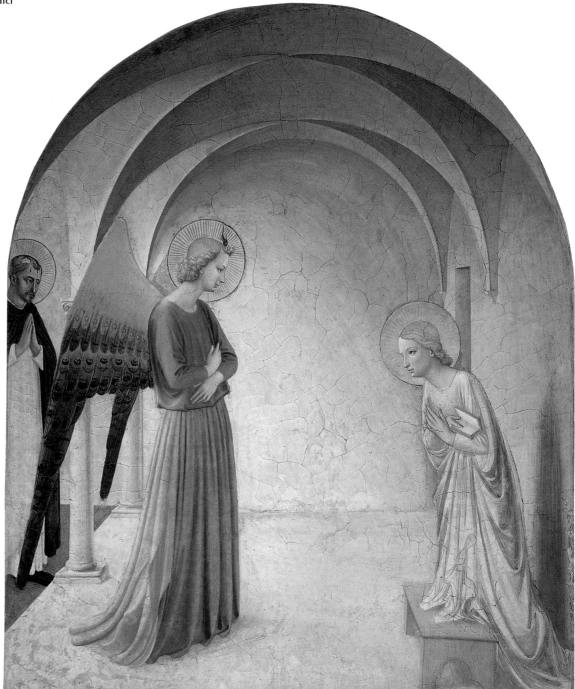

[3]

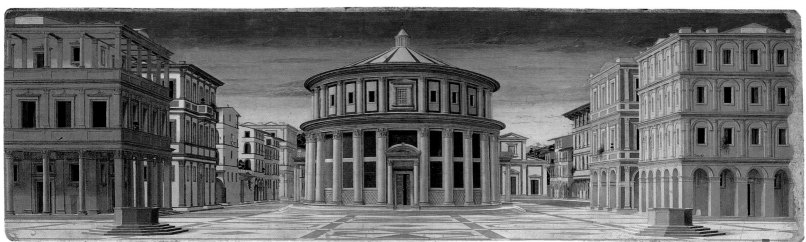

[4]

1447
Pope Nicholas V decides
to rebuild Saint Peter's
in Rome.

Circa 1475
Piero della Francesca
writes his treatise
on perspective.

1503
Spain annexes the
kingdom of Naples.

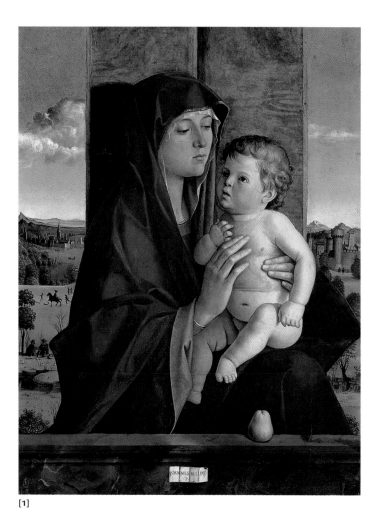

[1]

The spirit of the Renaissance spread throughout Italy, inspired less by ancient Rome than by a love of life that was new to Europe. Secular art blossomed, whether illustrating Latin mythology or the Christian faith: Venus and Mary were women first, before being mythological figures. Architecture, too, took on new curves that gave churches the air of pagan temples.

> " *The Renaissance is the art of peaceful beauty. It offers us a liberating beauty that we experience as an overall well-being and a steady increase in our life force.* "
>
> **Heinrich Wöfflin**

[1] Giovanni Bellini (1430–1516); *Virgin and Child,* c. 1487. Oil on panel, H: 84cm; W: 65cm. Bergamo, Accademia Carrara.

[2] Donato Bramante (1444–1514); Il Tempietto, San Pietro in Montorio, Rome. 1502.

[3] Andrea Mantegna (1431–1506); *The Family of Lodovico II Gonzaga and His Court,* 1473. Fresco. Mantua, Ducal Palace.

[4] Sandro Botticelli (1445–1510); *Spring,* c. 1470. Tempera on panel, H: 2.03m; L: 3.14m. Florence, Galleria degli Uffizi.

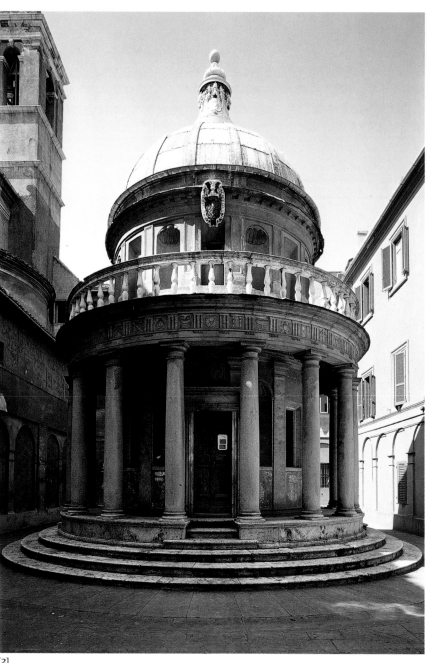

[2]

[3]

[4]

THE NEW WORLD ORDER

In a world that was still tearing itself apart, the Renaissance dreamed of a new harmony. The republic did not establish itself in Florence any more than it had in ancient Rome. The spirit of the free towns, which had allowed each city to distinguish itself, now dissolved into new authoritarian regimes. Politics, which had became more rational in the wake of the new movement in thought, became more centralized and better organized. Just as perspective unified vision in art, so France reinvented a monarchy whose territory it expanded. Italy, more fragmented, bent to papal domination. In Flanders, the bourgeoisie controlled the cities in a more collective manner, but society was nonetheless regimented. The Renaissance was inclined to order. But life does not let itself be contained; it overflows on every side. As a swollen river overwhelms its man-made constraints, the current of strong emotions flooded Europe, which was still in its youth. The adventurous spirit of the Renaissance sent caravels across the oceans. The Renaissance was sen-

[1]

suality, confidence in nature, a taste for earthly goods, and the assertion of the individual. Wars, whether civil or between nations, still tore peoples apart. For about twenty years, a puritan revolution plunged Florence into the apocalyptic delirium of a monk, Savonarola, who ended up burned at the stake—like Joan of Arc. France made peace with England, but war racked Italy, from where François I brought Leonardo da Vinci to the banks of the Loire. Charles V of Spain, the last great emperor of the Christian world, imposed his authority from Flanders onto Italy and Spain, but could not quash the resistance of the German princes who, as followers of Martin Luther's Reformation, refused to submit to the Pope's authority.

The ideas of the Italian Renaissance spread north, where they merged with what remained of the Gothic spirit. In northern Europe, however, humanism took another form. Flemish, German, and French artists went to Rome, attracted by the splendor of the new Italy. There, they gathered new ideas and images, but returned home unburdened and did not break from their own traditions. Italian artists were invited to foreign courts, but did not set fashions. This was because the Renaissance was a movement that went well beyond the borders of Italy, where from the start it had taken on a

[1] Hans Holbein (1497/1498-1543); *The Ambassadors* (Jean de Dinteville and George de Selve), 1533. Oil and tempera on panel, H: 2.07m; L: 2.09m. London, National Gallery.

The Renaissance in the 16th Century

[2]

more pronounced character than elsewhere. Humanism arose throughout Europe, adapting to each nation's character. So much so that the Renaissance, controlled by the Church in Latin Europe, was confronted with another Renaissance, Germanic in inspiration, and less concerned with artistic luxury and the joy of living, but far more respectful of individuals.

The mathematical rule of perspective that structured the new artistic vision was not a dominant absolute. It encouraged the straight line and the firmness of Piero della Francesca's clever and masterful architecture; it let itself be softened by the mists that Leonardo da Vinci laid over his landscapes; it was vivified by Michelangelo's passionate strength, rendered supple by Raphael's arabesques, and seduced by the glorious colors of the Venetian school. In a single movement, the Renaissance analyzed and dreamed; thought and took pleasure. In France, Germany, and Flanders, the Mediterranean light—to which Italy gave a new form, far diffferent from the cold Roman idealism—married the epic myths of the north and the east, with their troubled thoughts born of cold seas and infinite spaces. Albrecht Dürer, with all his precision and insight, also engraved figures that were emblematic of melancholy. Lucas Cranach translated all human frailty into images. Throughout Europe, painting was the predominant art. Architecture, although it was bold and imposing and established a frame for a new art of living, was less prestigious. Sculpture, despite Michelangelo, suffered from being too physical an art. It was the painters who were courted by the masters who employed them. Painting was the great art of the Renaissance because the revolution of the gaze, which triumphed in the fifteenth century, is the key to the new

[2] François Clouet (c. 1505/1510–1572); *Lady in Her Bath*, c. 1550. Oil on panel, H: 92cm; W: 81cm. Washington, D.C., National Gallery of Art.

[3] Paolo Caliari, known as Veronese (1528–1588); *Christ in the House of Levi*, 1573. Oil on canvas, H: 5.55m; L: 12.8m. Venice, Galleria dell'Accademia.

humanist culture, Europe's maturity. In Venice, painting, under the brush of the sublime Titian, was satisfied just to be itself: colored matter that refused to be restrained by drawing, taking lightly the sparkling of a world

[3]

that, of itself, gave itself to humanity without the intervention of any god.

1503
Julius II is pope.

1527
Rome is sacked
by the troops of
Charles V.

1534
Ignatius Loyola founds
the Society of Jesus
(the Jesuits).

Neither Leonardo da Vinci, Michelangelo, nor Raphael remained in Florence. The first two made their debuts in that city, and the third studied there for a time, but they all expressed their greatness elsewhere. Da Vinci did so in Milan, while the others went to Rome where Pope Julius II gave them work. Da Vinci was not just a painter; he was also an engineer. Michelangelo maintained that he was a sculptor first. But it would be the more moderate Raphael who would best fulfill the Renaissance ideal by perfectly joining sensitivity and compositional rigor.

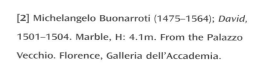

[1] Raffaello Sanzio, known as Raphael (1483–1520); *Portrait of Agnolo Doni*, 1505-1506. Oil on panel, H: 63cm; W: 45 cm. Florence, Palazzo Pitti.

[2]

[2] Michelangelo Buonarroti (1475–1564); *David*, 1501–1504. Marble, H: 4.1m. From the Palazzo Vecchio. Florence, Galleria dell'Accademia.

[3] Leonardo da Vinci (1452–1519); *Mona Lisa*. Oil on panel, H: 77cm; W: 53cm. Paris, Musée du Louvre.

[1]

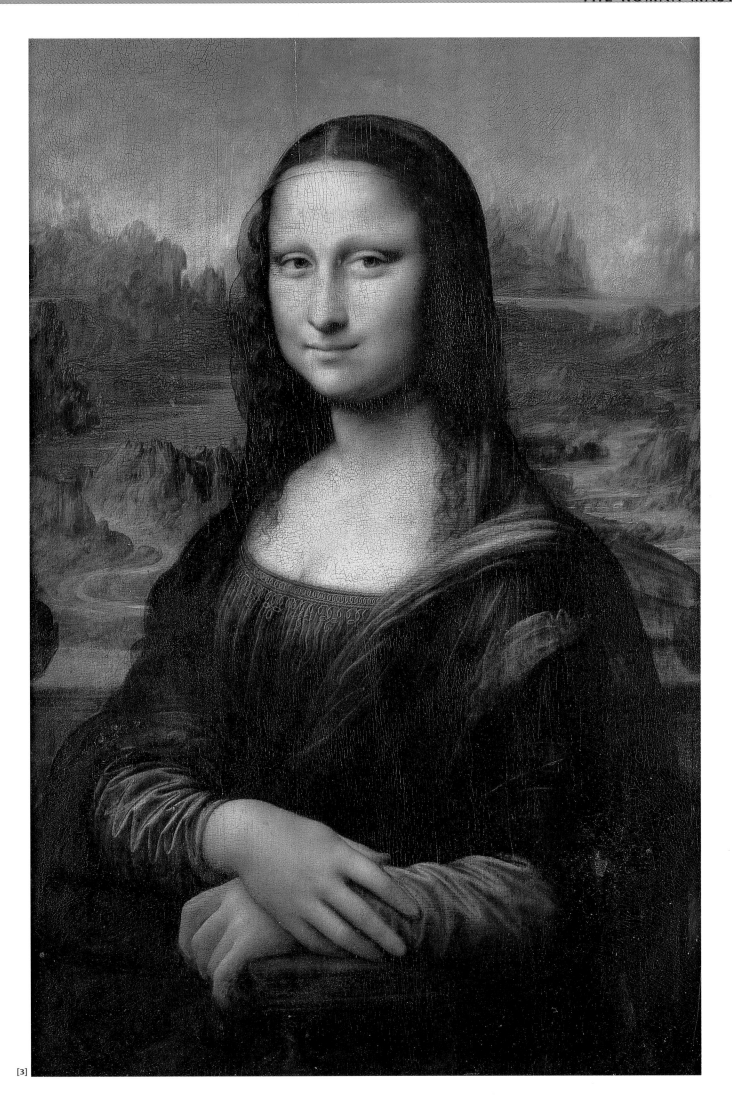

1530
François I founds
the Collège de France.

1562
First religious war
in France

1598
The Edict of Nantes
grants political rights
to French Protestants.

ROYAL FRANCE

[1] Great stairway of the
François I wing, Château
de Blois. 1515–1524.

[2] Jean Clouet (c. 1485/
1490–c. 1541); *François I*,
c. 1520–1525. Oil on
panel, H: 96cm; W: 74cm.
Paris, Musée du Louvre.

[3] Germain Pilon,
(c. 1528–1590); *The Three
Graces;* Monument to the
heart of Henri II, c. 1560–
1566. Marble, H: 1.5m.
Paris, Musée du Louvre.

[2]

The French monarchy asserted its prestige by renovating and build-
ing the castles of the Loire valley. Blois was reborn. Beginning in
1519, Chambord was turned into a luxurious palace for a court that
enjoyed the mild Angevin climate. Less than thirty years later, François
I commissioned Pierre Lescot to transform the grim Louvre castle into a
sovereign's palace, giving rise to a new French taste. The sculptor Jean
Goujon decorated the new home of the kings of France with a superb
sculptural program. Not long after, Germain Pilon demonstrated a talent
that was more powerful, more profound, and with a broader register—
one capable of both grace and emotion.

[3]

◄ [1]

FLEMISH GENEROSITY

1566
The Gueux, Flemish gentlemen, revolt against the Spanish.

1570
The first atlas is published in Antwerp.

1581
Independence of the northern Flemish provinces (the United Provinces)

[1]

In 1450, in 's-Hertogenbosch, in the south of what is now the Netherlands, a most extraordinary painter was born. Hieronymus Bosch seems to be so much outside the parameters of the Renaissance that he is usually considered part of the last flowering of the Middle Ages. He is hardly Gothic, however, and it would be more useful to see in him a whimsical profusion comparable to that of Rabelais, the undisputed emblematic figure of humanism in France. In Bosch's work, there is a generosity that the Flemish—notably Quentin Massys and Pieter Bruegel the Elder—amply demonstrated on other occasions.

[1] Quentin Massys (1465/1466–1530); *The Banker and His Wife*, 1514. Oil on panel, H: 70cm; W: 67cm. Paris, Musée du Louvre.

[2] Pieter Bruegel the Elder (c. 1525/1530–1569); *The Parable of the Blind*, 1568. Tempera on canvas, H: 0.86m; L: 1.54m. Naples, Galleria Nazionale di Capodimonte.

[3] Hieronymus Bosch (1450–1516); *The Haywain*, 1500–1502. Central panel of a triptych. Oil on panel, H: 1.35m; W: 1m. Madrid, Museo del Prado.

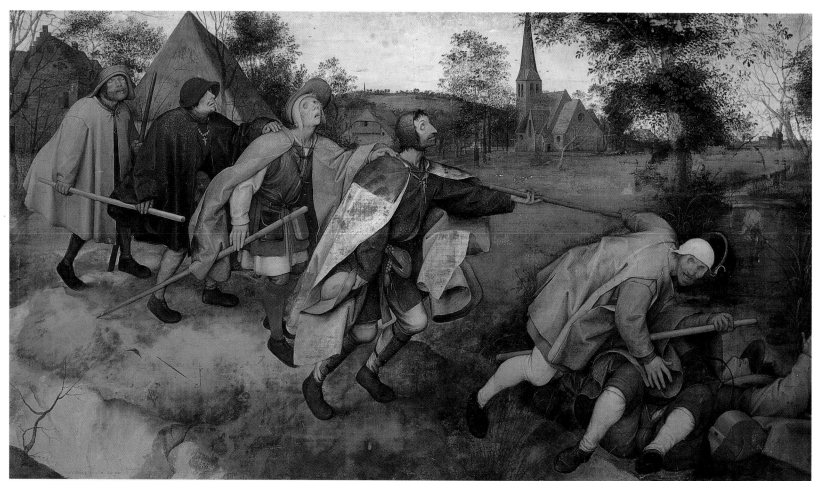

[2]

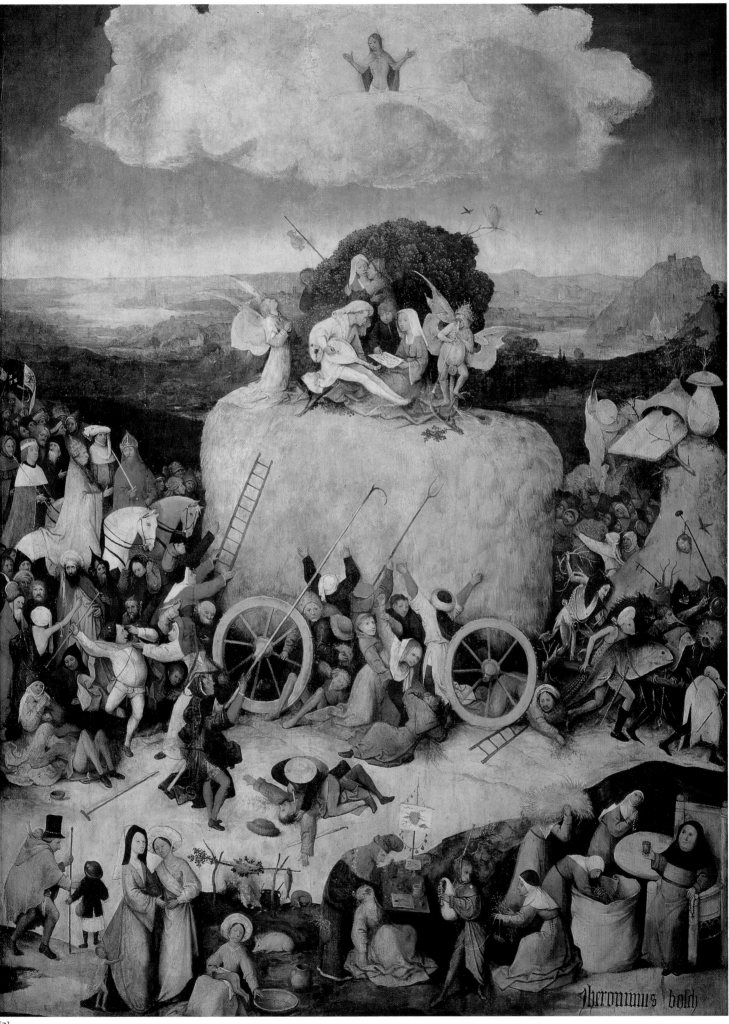

[3]

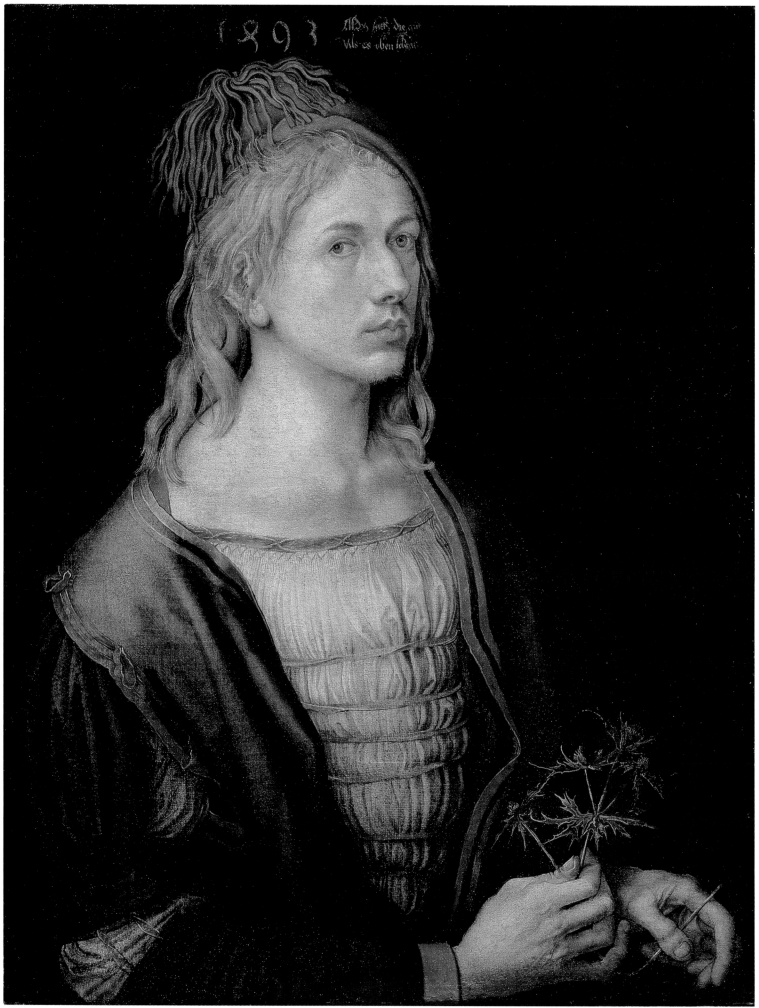

[1]

Germany rebelled against both Pope and Emperor (the former crowned the latter in 1530). Martin Luther embodied this rebellious spirit, giving it the austere framework of the Reformation. The art did not lag behind. Already at the turn of the sixteenth century, Albrecht Dürer was providing an accomplished version of Renaissance art. A true humanist, he seconded Luther's Theses and practiced art as a way of thinking, handling symbolism and perspective with the same assurance. The more mannered Lucas Cranach and the more emotional Matthias Grünewald both gave their sensitivity free rein.

[1] Albrecht Dürer (1471–1528); *Self-portrait*, 1493. Parchment glued on canvas, H: 56cm; W: 44cm. Paris, Musée du Louvre.

[2] Matthias Grünewald (c. 1475–c. 1528); *The Crucifixion*, 1512–1516. Central panel of the reredos, Monastery of the Antonites, Issenheim (Upper Rhine). Oil on panel, H: 2.69m; L: 3.07m. Colmar, Museum Unter den Linden.

[3] Lucas Cranach the Elder (1472–1553); *Venus with Veil*, 1532. Oil on panel, H: 37cm; W: 25cm. Frankfurt, Städelisches Kunstinstitut.

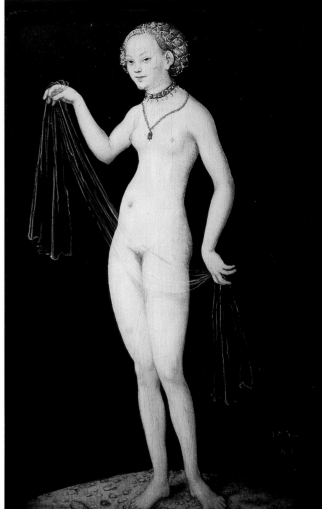

[3]

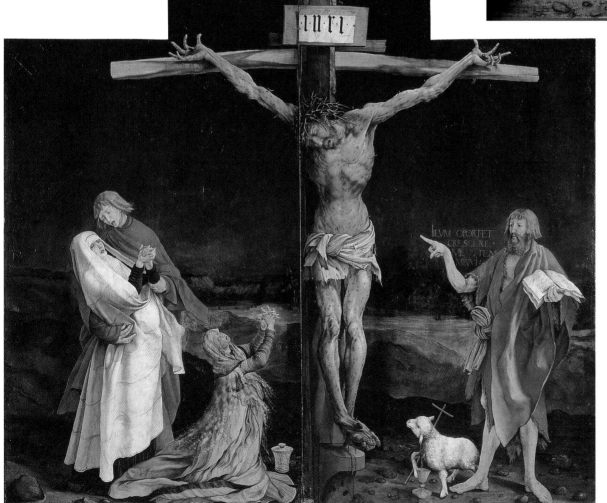

[2]

Martin Luther

Martin Luther (1483–1546) is one of the key figures of the Renaissance. In a world dominated by a papacy that co-opted humanism so as to protect it from too much freedom, Luther reminded the Church of elementary morals (less luxury and hypocrisy) and affirmed the rights of the individual conscience against the Roman institution. He nonetheless believed in man's submission to God and, like the pope, left religion hostage to political forces. From then on, two Europes, one Catholic, the other Protestant, would go head to head.

THE VENETIAN MASTERS

1499–1502
War between Venice
and the Ottomans

1550
Vasari publishes
his *Lives*

1571
The Turks are defeated
at the Battle of Lepanto.

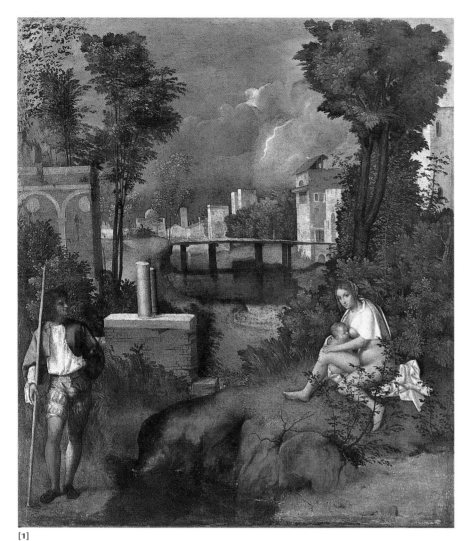

[1]

In the late sixteenth century, the Renaissance moved east in Italy. Born in Florence, it blossomed in Rome. But it was in Venice, in painting, that it shone its brightest: the sense of order, supported by the laws of perspective, was enriched by a sensuality in which color was unconstrained by drawing. Giorgione, Titian, Veronese, and Tintoretto were the four giants of a new revolution that, beyond the requirements of illustration, exalted the very material of painting and the gesture of the painter.

> **"***If the moral sense seemed to disappear from the life of the Venetians, it was to let the sensual feeling of the whole body of nature surge forth in an irresistible explosion.***"**
>
> Élie Faure

[1] Giorgio da Castelfranco, known as Giorgione (1477/1478–1510); *The Tempest*, c. 1507. Oil on canvas, H: 82cm; W: 73cm. Venice, Galleria dell'Accademia.

[2] Tiziano Vecelli, known as Titian (c. 1485–1576); *The Venus of Urbino*, c. 1538. Oil on canvas, H: 1.19m; L: 1.65m. Florence, Galleria degli Uffizi.

[3] Jacopo Robusti, known as Tintoretto (1518–1594); *Transport of the Body of Saint Mark*, 1562–1566. Oil on canvas, H: 3.98m; W: 3.15m. Venice, Galleria dell'Accademia.

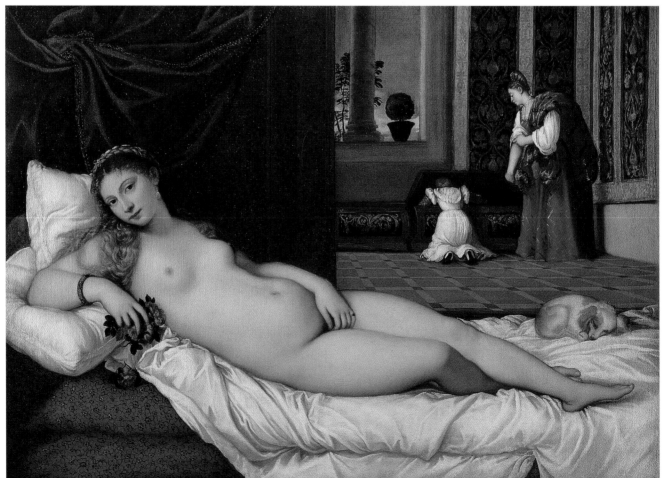

[2]

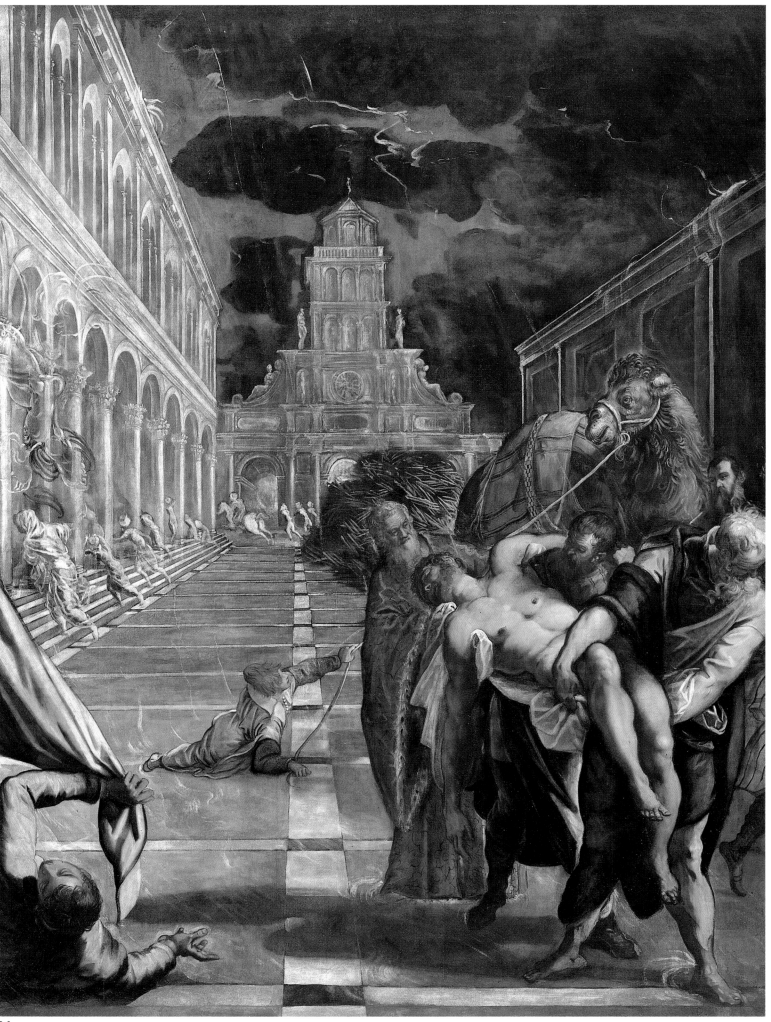

[3]

THE NEW ART OF THE HOME

1540
Gardens of the
Villa d'Este at Tivoli

1568–1603
Reign of Elizabeth I
of England

1570
Palladio publishes his
Four Books on Architecture.

Andrea Palladio—a self-taught architect and protégé of a shrewd patron—was the great architect of the Renaissance in the region surrounding Venice. No one was better able to use the classical language in a completely new spirit. A builder of churches and civic monuments, he is above all the harmonious designer of Venetian villas—those temples to a new art of living, raised in natural surroundings, with which the Renaissance sensibility joined in a new complicity.

[1] Giacomo Barozzi da Vignola (1507–1573); stairway of the Farnese Palace, Caprarola, near Viterbo. Constructed for Cardinal Alessandro Farnese. 1559–1564.

[2] Robert Smythson (1536–1614); Wollaton Hall, Nottinghamshire (England). 1580–1588.

[3] Andrea Palladio (1508–1580); Villa La Rotonda, Vicenza. Work commenced by Palladio in 1550, finished by Scamozzi in 1606.

[4] Giuliano da San Gallo (1445–1516); Villa Poggio, Caiano, Tuscany. Constructed for Lorenzo de' Medici. 1480–1485.

[3] ►

[4] ►

[1]

[2]

THE RUPTURE

The Baroque and classicism appeared as concurrent styles (the former slightly earlier than the latter), each drawing on the Renaissance heritage, but transforming the recently emerged forms in its own manner. More than to the humanist ideal on which the Renaissance was based, they were faithful to its look, to the pediment and the column in architecture, to anatomy in sculpture, and to perspective in painting. Even as it became preeminent, painting became gradually diluted, banal, and reduced to clichés or else caught in irreconcilable polemics. During the seventeenth and eighteenth centuries, Europe was groping its way along, seeking ways to surpass the grandeur and perfection it had already achieved, hesitating between the Baroque and the classical. More than two styles, these became two aesthetic categories: one associated with expansiveness and imagination, the other with order and reason.

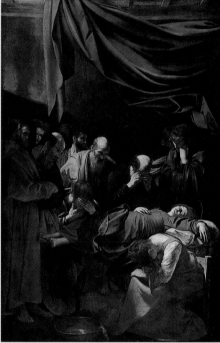

[1]

The word "Baroque" was initially used to describe something strange, something irregular: for example, a precious stone or a pearl deemed imperfect. It was only in the early twentieth century that the adjective would be applied to a style that appeared in Italy at the end of the sixteenth century, and that seemed to be both a bursting beyond the shapes of the Renaissance and a reaction to the Renaissance's obsession with the ancient. After so many rules, so much seriousness and so much idealism, art sought to be playful. It wanted to invent, instead of conforming to norms that some considered definitive. During the Renaissance, art, for the most part, lost its sacred aura. It no longer belonged to God, but fell into the domain of humanity, of individuals, of geniuses in the best cases. It was an adventure in which the heroes set off on a quest for beauty. Alternatively, it was a game in which buffoons had no other purpose but their pleasure and that of their audience.

[1] Michelangelo Merisi, known as Caravaggio (1573–1610); *Death of the Virgin*, 1605–1606. Oil on canvas, H: 3.69m; W: 2.45m. Paris, Musée du Louvre.

[2] Giacomo della Porta (1540–1602); facade of the Church of Il Gesù, c. 1575. Rome.

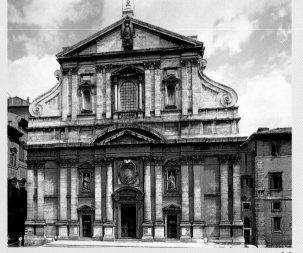

[2]

Italy, which had initiated the Renaissance, was the first to leave it behind. Catholicism had long had a taste for luxury, and not only for profane reasons, but because God had to be served amid splendor, despite the monastic movements that advocated austerity. Thus, it showed no qualms in displaying its wealth. In Rome, the papacy, shaken by the Reformation, which was hostile to so much pomp, and stimulated by the Jesuits, wished to give the Church a new image. The popes

entrusted this task to imaginative architects who designed theaters in which religion was performed and where painting and sculpture were decorative rather than significant. This occurred first in Italy, where Protestantism had little presence, then in the countries of the north, where it regained the ground it had lost and celebrated its triumph. From the vocabulary of the ancients, architecture retained the pediment and columns. From the vocabulary of the previous two centuries, it retained the plan and the dome. The design of the facade, however, was carved out, curved and twisted into scrolls. The interior was even more ornate, covered in decoration, painting, gold, and stucco. Everything became more complex, heavier, more dramatic. Art gained in imagination what it lost in depth. Inside, artists became decorators. Bernini, a formidable architect and sculptor, became the master of ceremony of the new papal pomp in the church of Saint Peter's in Rome, complete at last.

Spain, Germany, and Austria were gradually conquered by the Baroque wave, which intensified in those countries during the seventeenth century when it was time to rebuild after the Thirty Years' War. Then Latin America made it the first great colonial art. At the other extreme, Claude Perrault designed the eastern facade of the Louvre. Linear, rigorous, in an uncompromisingly ancient style that recurs—in a less pure form, of course—in Versailles, it demonstrates the classicism that Louis XIV sponsored in France and that was intended to celebrate his glory as the Sun King.

There was an expansive Baroque style in architecture with consistent features that evolved over two centuries and in several countries. There was also a restrained, classical style. With painting and sculpture, the distinction is less clear. Is El Greco Baroque? Is Poussin classical? Neither artist can be reduced to one style. Undoubtedly, each leaned more toward one or the other, but personality and originality make it impossible to force them into preestablished definitions. This is because "Baroque" and "classical" are two stylistic categories, whereas the Renaissance was a cultural movement. Henceforth, the greater the artist, the less he or she will conform to a collective style. Art will no longer be the unifying language of the Western European civilization. Nor will religion. Europe has just invented pluralism.

[3] Jean-Antoine Houdon (1741–1828); *Bust of Voltaire*, 1778–1779. Marble. Paris, Comédie-Française.

[4] Anthony Van Dyck (1599–1641); *Charles I, King of England, at the Hunt*, c.1635. Oil on canvas, H: 2.66m; W: 2.07m. Paris, Musée du Louvre.

[3]

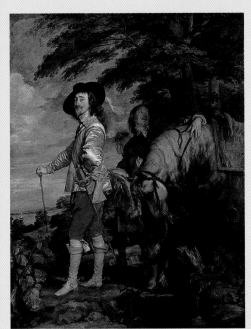

[4]

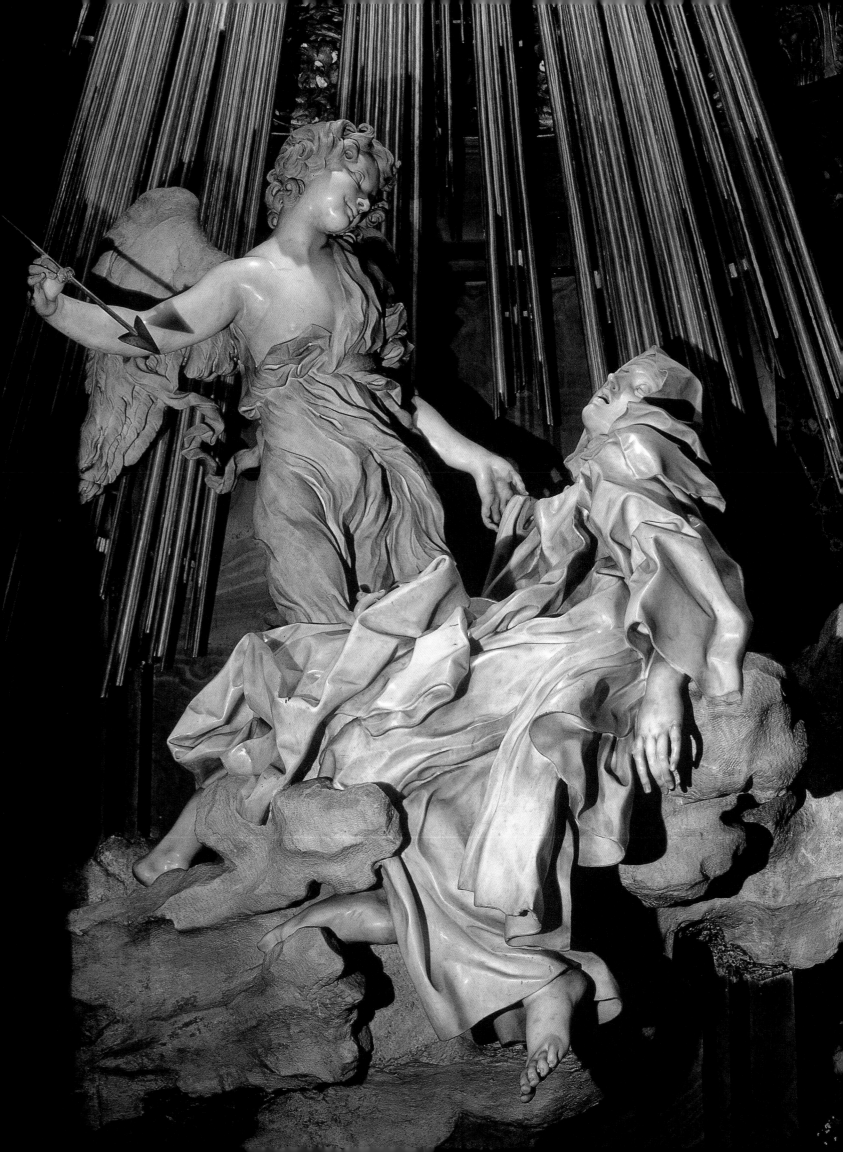

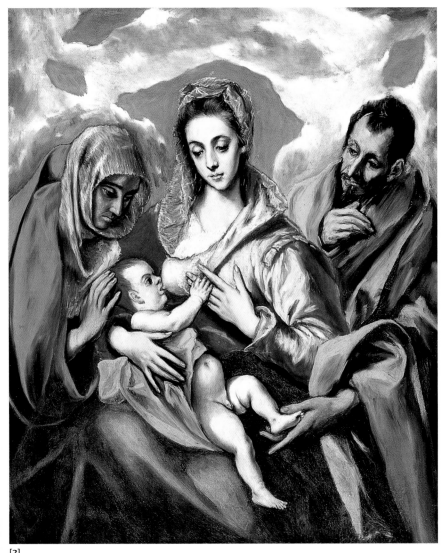

[2]

Baroque art introduced a new harmony, more seductive than imposing, into the classical tradition that the Renaissance took from antiquity. Although it made its appearance at the end of the sixteenth century in religious architecture, the Baroque was not religious in nature: it was more concerned with the decor than with the meaning of the Christian celebration. Within the religious themes of his commissions, Bernini gave his theatrical imagination free rein. Austria and Bavaria outdid themselves in decorative fantasy, far from any spirit of meditation. On the other hand, the art of El Greco, another painter who liked scrolls, was intensely spiritual.

[1] Gianlorenzo Bernini (1598–1680); *The Ecstasy of Saint Theresa*, 1644–1647. Rome, Cornaro Chapel, altar of Santa Maria della Vittoria.

[2] Domenikos Theotokopoulos, known as El Greco (1541–1614); *The Holy Family*, c 1590. Oil on canvas, H: 1.27m; W: 1.06m. Toledo, Tavera Hospital.

[3] Benedictine Abbey, Melk, Austria. Work started by Jakob Prandtauer in 1702 and finished by Franz Munggenast in 1747.

◄ [1]

[3]

1610–1617
Regency of
Marie de Médicis

1648
Creation of the Royal
Academy of Painting
and Sculpture in Paris

1648–1652
Mazarin defeats
the Fronde.

> *The Baroque spoke the same language as the Renaissance, but in a savage dialect.*
>
> Jacob Burckhardt

The Baroque direction was that of a newly sensual pleasure that concealed itself less and less behind misleading alibis. If Charles Le Brun or Pierre Puget still needed religious or mythological pretexts, Peter Paul Rubens expressed in his work the exaltation of the flesh and the pleasure of painting. This happy artist, a bourgeois of his time and a casual genius, not only had no pretensions to the sacred but exemplified eroticism without guilt.

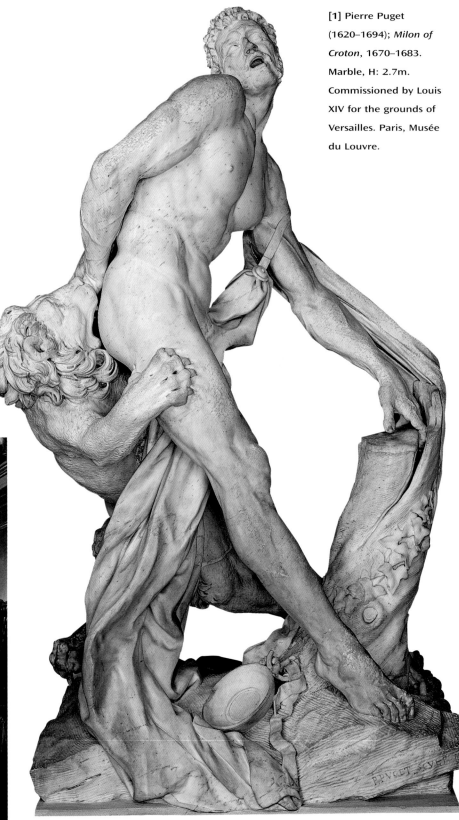

[1] Pierre Puget (1620–1694); *Milon of Croton*, 1670–1683. Marble, H: 2.7m. Commissioned by Louis XIV for the grounds of Versailles. Paris, Musée du Louvre.

[1]

[2]

[2] Charles Le Brun (1619–1690); *Mary Magdalene Renouncing All Earthly Vanities*, c. 1650. Oil on canvas, H: 2.52m; W: 1.71m. Paris, Musée du Louvre.

[3] Peter Paul Rubens (1577–1640); *The Education of Marie de Médicis*, 1621–1625. Oil on canvas, H: 3.94m; W: 2.95m. Painted for one of the two galleries of the palace of Marie de Médicis in Paris, now the Palais du Luxembourg. Paris, Musée du Louvre.

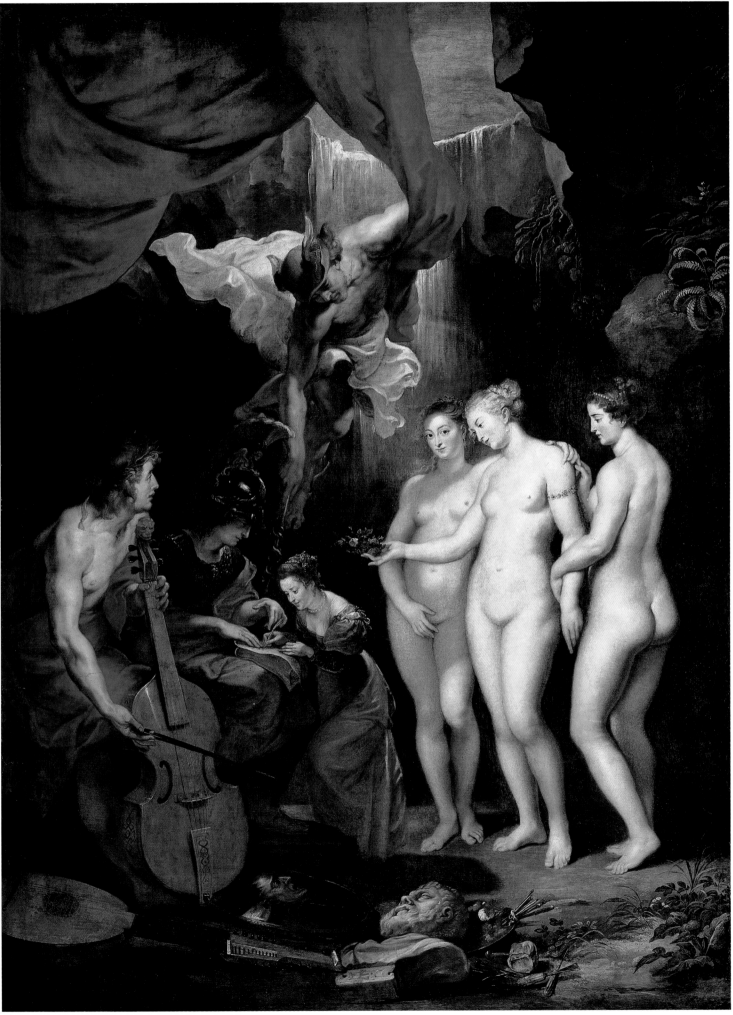

[3]

[3]

The Baroque impulse that led art into new adventures did not suppress Europe's longstanding love for ancient art. When in the former all is movement, the obsession with an unchanging order dominates in the latter. Versailles, in its repetitive immensity, was the emblem of an absolute monarchy that claimed to be as eternal as the the sun's own brilliance. French politics, however, was not the only reason for the survival of this movement, which produced other examples in other countries. Nicolas Poussin, Roman by adoption, rendered sublime the static gestures of ancient marbles in sophisticated compositions.

◄ [1]

◄ [2]

[1] Christopher Wren (1632–1723); Saint Paul's Cathedral, London. 1675–1711.

[2] Louis Le Vau (1612–1670) and Jules Hardouin-Mansart (1646–1708); Château of Versailles, garden facade. 1669–1685.

[3] Claude Gellée, known as Claude Lorrain (c. 1602–1682); *Ulysses Returns Chryseis to Her Father*, c. 1644. Oil on canvas, H: 1.19m; L: 1.5m. Paris, Musée du Louvre.

[4] Nicolas Poussin (1594–1665); *The Arcadian Shepherds (Et in Arcadia ego)*, c. 1638. Oil on canvas, H: 0.85m, L: 1.21m. Paris, Musée du Louvre.

[4]

1605–1615
Publication of
Miguel de Cervantes'
Don Quixote

1609
Founding of the
Bank of Amsterdam

1715
Flanders is
transferred
to Austria.

[1]

[1] Rembrandt Harmenz
van Rijn, known as
Rembrandt (1606–1669);
*Self-Portrait as the Apostle
Paul*, 1661. Oil on canvas,
H: 91cm; W: 77cm.
Amsterdam, Rijksmuseum.

[2] Frans Hals
(1581/1585–1666);
*Banquet of the Officers of
the Order of Saint George*,
1616. Oil on canvas,
H: 1.75m; L: 3.24m.
Haarlem, Frans
Halsmuseum.

[3] Diego Velázquez
(1599–1660); *Las Meninas*,
1656. Oil on canvas,
H: 3.16m; W: 2.76m.
Madrid, Museo del Prado.

New concerns arose, and new freedoms were won. The gaze, increasingly attentive to the reality of the world, rid itself of what remained of its idealism. After Caravaggio, the great observer of the life of the people, Rembrandt and Frans Hals in Holland, and Diego Velázquez in Spain founded an art without illusions that showed humanity and objects as they were. By persistently scrutinizing his own image, Rembrandt, more than anyone, surrendered to reality.

[2]

[3]

[1]

[2]

| 1668 | 1672 | 1720–1722 | TIME SUSPENDED |

Independence
of Portugal

Louis XIV
invades Holland.

Last great plague

A mid the pandemonium of history that was relentlessly shaking Europe, and as architecture froze into symmetrical immobility, certain painters very discreetly remained detached. Intimately close to people and objects, they proved to be open and tender toward the simplicity of daily tasks. No great movements, no eccentricities, no important ideas to illustrate. Nothing but painting that was delicate and precise, luminous testimony in favor of a world in which humanity appears to be at peace with itself. Time seems to stop, fixed upon a gesture or the simple presence of a few objects.

[1] Antonio Canale, known as Canaletto (1697–1768); *View of the Doge's Palace, Venice*, c. 1768. Oil on canvas, H: 51cm; L: 83cm. Florence, Galleria degli Uffizi.

[2] Jan Vermeer (1632–1675); *View of Delft*, 1661. Oil on canvas, H: 0.98m; W: 1.17m. The Hague, Mauritshuis.

[3] Jean-Baptiste-Siméon Chardin (1699–1779); *The Basket of Grapes*, c. 1726–1728. Oil on canvas, H: 69cm; W: 58cm. Paris, Musée du Louvre.

[4] François Mansart (1598–1666); Château de Maisons, Maisons-Laffitte (Yvelines, France), garden facade. 1642–1646.

[3]

[4]

1751
Publication of Denis
Diderot and Jean Le Rond
d'Alembert's *Encyclopedia*

1755
Lisbon is destroyed
by an earthquake.

1762–1796
Reign of Catherine
the Great in Russia

[1]

It was now up to man, who no longer expected everything from God, to see to it that his time on earth would be as pleasant as possible. Architects, not content with serving the lords of Church and State, tried to put their art, thought, and imaginations at the service of a better world, a more harmonious life, and a more just society. Claude-Nicolas Ledoux and Étienne-Louis Boullée, without breaking with classical culture, devised an architecture of dreams, while in England the art of the garden developed as if resurrecting memories of a paradise lost.

[1] James Gibbs (1682–1754); bridge over the River Serpentine in the grounds of Stowe (Buckinghamshire, England). 1737.

[2] Étienne-Louis Boullée (1728–1799); plans for a cenotaph for Isaac Newton. 1784. Paris, Bibliothèque nationale de France.

[3] Claude-Nicolas Ledoux (1735–1779); Les Salines, Arc-et-Senans (Doubs, France). 1775–1779.

[2]

[3] ▶

1752–1754
War between England
and Holland

1773
Pope Clement XIV
suppresses the
Jesuit order.

1789
Beginning of the
French Revolution

[1]

Freedom of thought and morality expanded during the eighteenth century. The Church no longer ruled the world. Absolute monarchies were faced with the opposition of people increasingly inclined to resist, and who wanted to live well in the here and now. In the age of Casanova, pleasure was, for many, an obsession, and lightheartedness a way of life. Neither life nor art was burdensome for those painters who celebrated the world's delights with a deft touch.

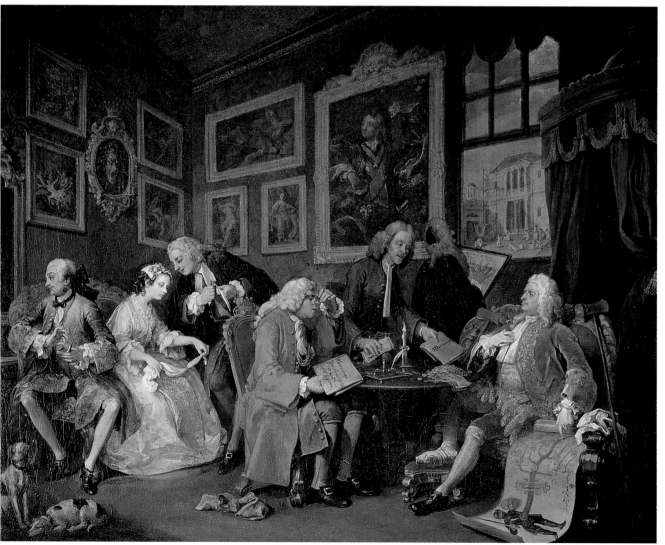

[1] Jean-Honoré Fragonard (1732–1806); *The Bolt*, c. 1784. Oil on canvas, H: 73cm; L: 93cm. Paris, Musée du Louvre.

[2] William Hogarth (1697–1764); *The Contract*, 1744. Oil on canvas, H: 69cm; L: 89cm. London, National Gallery.

[3] Gianbattista Tiepolo (1696–1764); *Venus Receives Mars*. Fresco. Venice, Palazzo Pisani.

[4] Jean-Antoine Watteau (1684–1721); *The Embarkation for Cythera*, 1717. Oil on canvas, H: 1.29m; L: 1.94m. Paris, Musée du Louvre.

[2]

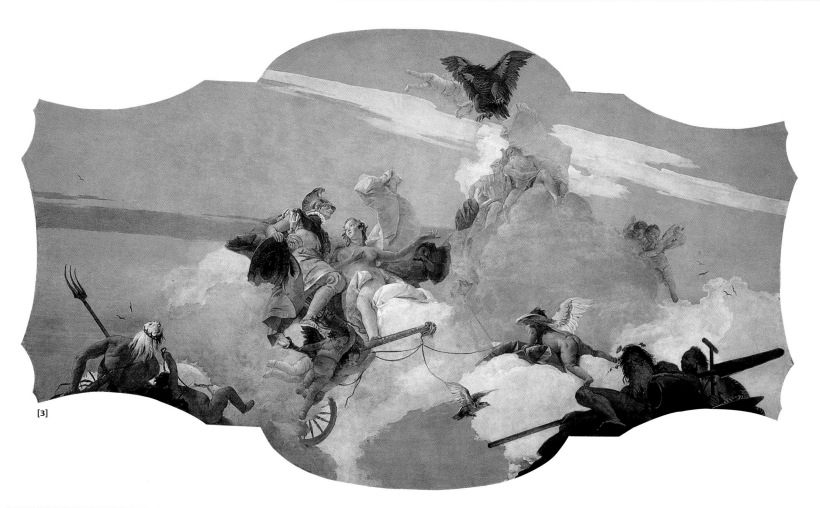

[3]

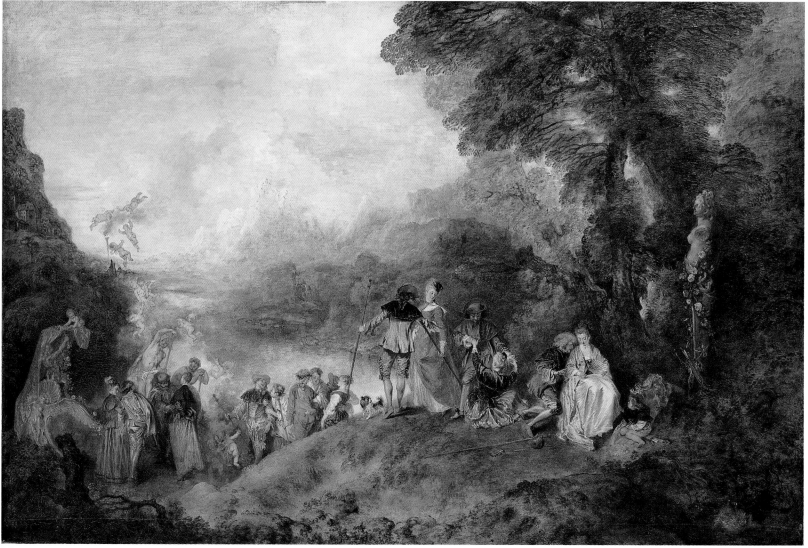

[4]

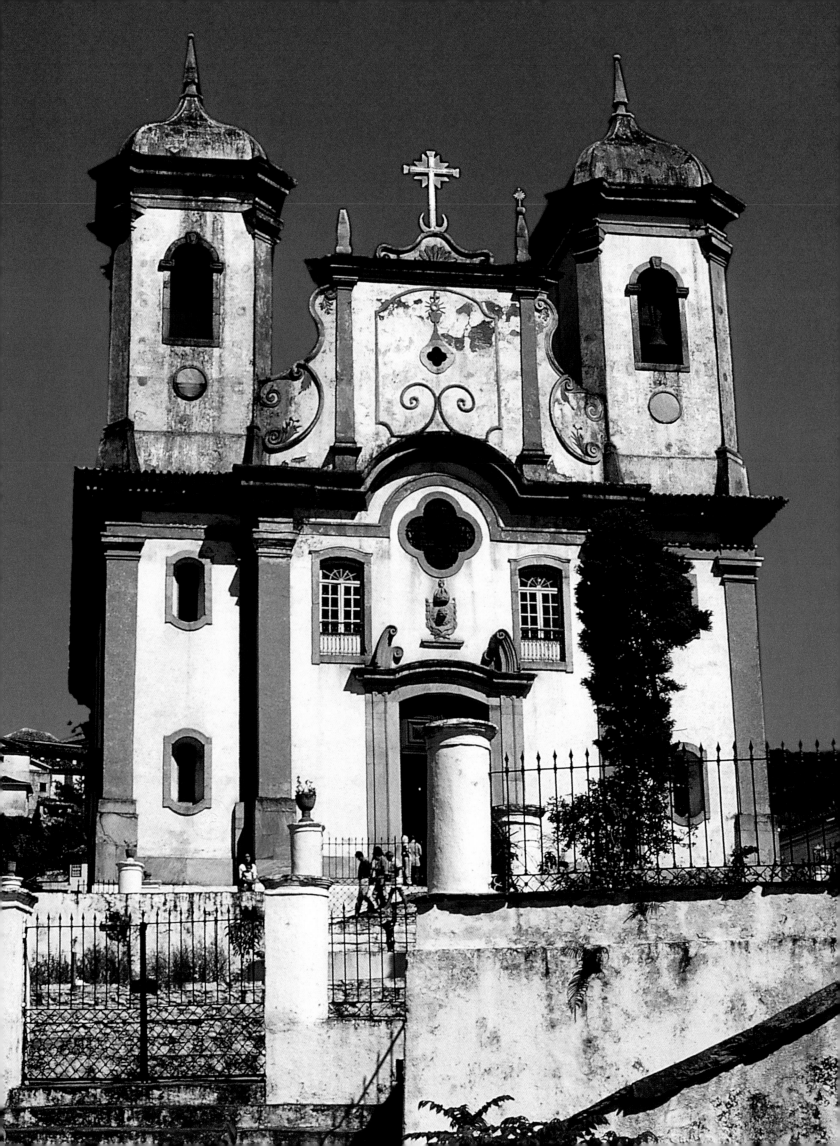

Louis XV cedes Canada to Great Britain.

Beginning of the American War of Independence

The United States declares independence from Great Britain.

The Independence of the United States

On July 4, 1776, thirteen North American British colonies declared their independence. George Washington headed the revolt that led to a seven-year war with Great Britain. France supported the rebels, and the Federal Republic of the United States was recognized by a peace treaty signed in Paris in 1783. A constitution that is still in force was adopted in 1787. Two years later, the French Revolution began in Paris, where a short-lived republic was established.

America was the first colonial continent. In Santo Domingo, capital of the New World, the construction of the first church began eleven years after Christopher Columbus discovered the island. Afterward, missionary Spain proved to be a great builder: first Gothic, then a follower of the Renaissance. It was not until the eighteenth century that a truly original art would develop in the New World: a flamboyant Baroque, heralded by the Brazilian architect and sculptor Aleijadinho. In the United States, with the pride of a newfound independence (won in 1783), classicism dominated.

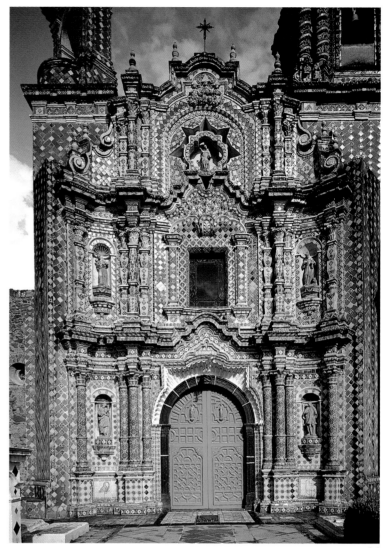

[2]

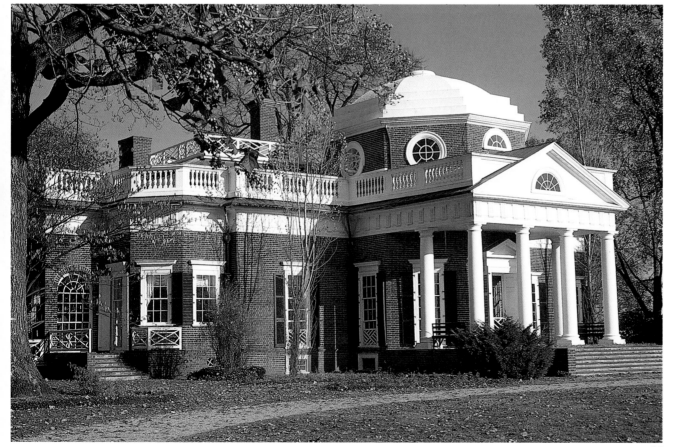

[1] Antônio Francisco Lisboa, known as Aleijadinho (1738–1814); Nossa Senhora do Carmo, Ouro Prêto (Brazil). 1770–1795.

[2] Church of San Francisco, Acatepec (State of Puebla, Mexico), c. 1730. Facade covered with multicolored tiles.

[3] Thomas Jefferson's house, Monticello (Virginia). 1796–1806.

◀ [1]

[3]

THE TRIUMPH OF THE INDIVIDUAL

Preoccupied with the present, or lost in dreams of ancient times, the art of the late eighteenth century ignored the great turns of history. Caught up in the game of aristocratic commissions, art was out of touch with the rising anger of the people; yet, when at last swept into the revolutionary winds, it wholeheartedly entered current events. Jacques-Louis David, who organized great festivals celebrating the nation's cohesiveness, was not a very revolutionary painter. But in Spain, Francisco Goya was a rebel witness to the French occupation. During the nineteenth century, art was stronger in opposition to than in the service of institutions.

Neither the French Revolution nor the Empire period that followed it founded a grand new style. By now, it was individuals who made art history, not styles. While, in the past, individuals and styles entered art history together, they gradually fell out of step; style became what is left when great artists pass. Thus, Romanticism is a spirit rather than a style. It had no formal coherence, and its innovation, its new horizon, was its exaltation of the individual through imagination and sensibility—even when it retained conventional themes and manners. While Europe tore itself apart in a new war, and the Napoleonic epic was bogged down in an autocracy that did not stimulate the arts, in northern Europe a new wind was blowing. Caspar David Friedrich gave German Romanticism the images that a movement borne by a most stunning poetic wave deserved: a movement that ran counter to the ideal of reason at the heart of the Renaissance. Indeed, the more progress scholars and builders make in mastering the world, the more humanity becomes aware of its own complexity and surprised by its own depth. In England, John Constable and Joseph Mallord William Turner, preferring atmosphere to subject matter, widened the scope of landscape painting by straying from its draftsman-like manner. In France, Eugène Delacroix was more powerful, more splendid, and less innovative. As for Jean Auguste Dominique Ingres, he brought Neoclassicism, the era's official art, to its apex. In its time, Romanticism represented the artistic avant-garde; then it, too, became academized, as would Realism and Impressionism after it. The fact is that the movement of art had become driven, like life, by the idea of progress. Some hoped for a

[1]

[1] Jean-Auguste-Dominique Ingres (1780–1867); *Portrait of Louis-François Bertin, known as Bertin the Elder*, 1832. Oil on canvas, H: 1.16m; W: 0.95m. Paris, Musée du Louvre.

[2] Jean-Baptiste Corot (1796–1875); *Souvenir of Mortefontaine*, 1864. Oil on canvas, H: 65cm; L: 89cm. Paris, Musée du Louvre.

[2]

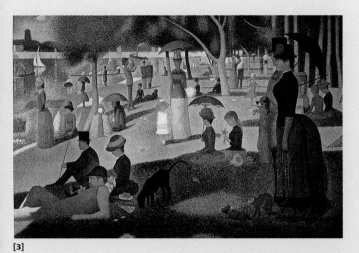

[3]

[4]

[3] Georges Seurat (1859–1891); *A Sunday on the Grande Jatte*, 1885. Oil on canvas, H: 2.06m; L: 3.06m. Chicago, Art Institute of Chicago.

[4] Antoni Gaudí (1852–1926); Sagrada Familia, Barcelona. 1883–1985.

better future, while others feared that the passage of time would bring only disorder and unhappiness. Some dreamed of adventures, while others believed in tradition.

All told, however, Realism won out during the nineteenth century. It was a time when science, technology, and world exploration made great strides. The new art of photography forced painters to challenge it. Out of that confrontation, Impressionism emerged—in formal terms, it was the century's great artistic revolution. When, fifty years later, it had established a new style of painting, its best practitioners would move on, each pursuing his or her own path.

Art history accelerated. Each generation turned on the previous one, accusing it of being stuck in a soulless style. Artists invented their own worlds, defining themselves by the distance between them and the well-known styles. More than one artist ended up alone, because the patrons (institutions and collectors) had trouble keeping up with innovations. Others—Vincent van Gogh is the classic example—were "damned," condemned to poverty and despised before achieving posthumous glory. In France, during the nineteenth century, art increasingly followed two different routes: one in the service of institutions (the State, which commissioned art, and the Academy, which controlled the Salon, an artist's only opportunity for reknown); the other at a permanent remove from the dominant style. However, not everything came down to this endless and constantly-renewed polemic: even as the exhausted century was on the verge of a more radical break than ever before, art was manifesting a multiplicity of parallel experiences, and the great artists were those who mistrusted absolute artistic categories and doctrines. In the nineteenth century, genius was solitary and painting overtook sculpture because it is more pliant, easier to practice. As for architecture, it declared its independence, splitting off from the other "fine arts" because—except when losing itself in tedious redundanies—it now came into its own, addressing without flourishes the function it was expected to fulfill. Since then, architecture has played only a very small part in the history of art, which has instead been dominated by painting.

1799
Napoleon Bonaparte
becomes First Consul
by coup d'état.

1822
Jacques-Joseph
Champollion deciphers
hieroglyphics.

1830
Belgium declares
independence from
the Netherlands.

The French Revolution was a violent shock to minds and spirits throughout Europe. Although there had been freedom of thought and expression for only a short time, a breach had been made: intellectuals and artists would thenceforth demand these rights. Art joined the fray. Jacques-Louis David, who was obsessed with antiquity, briefly abandoned academicism to serve the Revolution and Napoleon. Francisco Goya was the first painter to depict the real life rebellion of free consciences in the dramatic heat of current events. Théodore Géricault illustrated a tragic news story that challenged the actions of the maritime authorities.

[1]

[1] Francisco Goya (1746–1828); *The Third of May 1808: The Execution of the Defenders of Madrid*, 1814. Oil on canvas, H: 2.66m; L: 3.45m. Madrid, Museo del Prado.

[2] Théodore Géricault (1791–1824); *The Raft of the Medusa*, 1819. Oil on canvas, H: 4.91m; L: 7.16m. Paris, Musée du Louvre.

[3] Jacques Louis David (1748–1825); *The First Consul Crossing the Alps at Grand-Saint-Bernard Pass*, 1800. Oil on canvas, H: 2.59m; W: 2.21m. Rueil-Malmaison, Château de Malmaison.

[2]

[3]

[1]

1822
Greece declares
independence
from Turkey.

1837
Berlioz composes
his *Requiem*.

1848
Revolution spreads
through Europe.

[2]

R omanticism was first a literary and philosophical movement that originated in Germany. Nature and science, the individual and poetry were its pillars, but Romanticism proved more an impulse than a theoretical movement. It was a new consciousness of the world—with which human beings become one—a lyrical effusion and nostalgia for a paradise lost. While some let imagination run riot, others dreamed exotic dreams or left in search of landscapes to conquer. But all did so with a passion for color.

[1] Caspar David Friedrich
(1774–1840); *The Traveler
Above a Sea of Clouds*,
c. 1818. Oil on canvas,
H: 95cm; W: 75cm.
Hamburg, Kunsthalle.

[2] Joseph Mallord
William Turner (1775–
1851); *The Fighting
Téméraire*, 1838.
Oil on canvas,
H: 4.91m; L: 7.16m.
London, National Gallery.

[3] Eugène Delacroix
(1798–1863); *The Death
of Sardanapalus*, 1827.
Oil on canvas,
H: 3.92m; L: 4.96m.
Paris, Musée du Louvre.

[3]

1823
Joseph-Nicéphore Niepce
discovers the principles
of photography.

1850
Charles Dickens
publishes
David Copperfield.

1865
Édouard Manet's
Olympia scandalizes
the Paris Salon.

Painting on the spot, and not only in watercolor, became possible with the invention of tubes for oil paint. Landscape painters proliferated in the countryside: in Italy with the *macchiaioli* and in France with the painters of the Barbizon school. Gustave Courbet painted canvases outdoors with amazing spontaneity. He observed people and things with no preconceptions—which is what he called "realism." Édouard Manet and Courbet were highly controversial painters, accused, rightly, of being deliberately provocative.

[1]

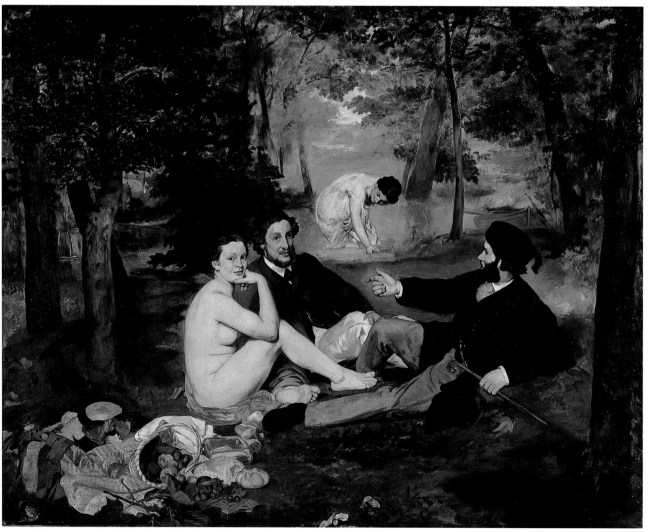

[2]

[1] Gustave Courbet (1819–1877); *The Stormy Sea* (also known as *The Wave*), 1870. Oil on canvas, H: 1.17m; L: 1.60m. Paris, Musée d'Orsay.

[2] Édouard Manet (1832–1883); *Déjeuner sur l'herbe*, 1863. Oil on canvas, H: 2.08m; L: 2.64m. Paris, Musée d'Orsay.

[3] John Constable (1776–1837); *Tree Trunk*, c. 1821. Oil on canvas, H: 30cm; W: 24cm. London, Victoria and Albert Museum.

[3]

1851
Herman Melville
publishes *Moby-Dick*.

1861–1865
American Civil War

1876
The Sioux defeat
General Custer at
Little Big Horn.

Despite its independence, the United States had a difficult time asserting its cultural identity. The country did not lack painters, but they were often second-rate, often either too academic or too naive. The best were attracted to Europe (John Singleton Copley, James Abbot McNeill Whistler, John Singer Sargent, Mary Cassatt), but a few, far away from the quarrels of the old continent, produced a specifically American style of painting (Winslow Homer, Thomas Eakins, George Catlin).

[1]

[2]

[1] Winslow Homer
(1836–1910); *Summer
Night*, 1890. Oil on
canvas, H: 0.76m;
L: 1.02m. Paris,
Musée d'Orsay.

[2] James Abbot McNeill
Whistler (1834–1903);
*Arrangement in Grey and
Black, No. 1: The Artist's
Mother*, 1871. Oil on
canvas, H: 1.44m;
L: 1.62m. Paris,
Musée d'Orsay.

[3] John Singer Sargent
(1856–1925); *Lady Agnew
of Lochnaw*, 1892–1893.
Oil on canvas,
H: 1.24m; L: 0.99m.
Edinburgh, National
Gallery of Scotland.

[3]

[1]

1869
Ferdinand-Marie Lesseps
starts work on the
Suez Canal.

1871
Paris Commune

1894
Beginning of the
Dreyfus Affair

[2]

[1] Auguste Renoir (1841–1919); *The Swing*, 1876. Oil on canvas, H: 92cm; W: 73cm. Paris, Musée d'Orsay.

[2] Claude Monet (1840–1926); *Gare Saint-Lazare*, 1877. Oil on canvas, H: 0.75m; L: 1.04m. Paris, Musée d'Orsay.

[3] Edgar Degas (1834–1917); *Young Dancer of Fourteen* or *The Great Dancer Dressed*, 1880–1881. Bronze, tulle tutu, pink satin ribbon in the hair, H: 98cm. Paris, Musée d'Orsay.

[3]

The Paris Salon

In the nineteenth century, Paris was the capital of the fine arts—or at least of painting, since sculpture and architecture were on the back burner. The Salon, run by the Academy and the École des Beaux-Arts, was the annual or biennial event (it varied) that ruled the lives of artists because it held a virtual monopoly on exhibitions. It was at the Salon that the State, king, or emperor bought works or commissioned them. Art galleries only became important after the advent of Impressionism. Thanks to the galleries, a private market developed where collectors could sometimes trust that their artists would one day become famous. At the end of the century, artists organized themselves and created their own salons: the Salon of the Independents and the Autumn Salon.

The word "Impressionists" had its origins in the sarcasm of a critic who mocked one of Claude Monet's paintings, *Impression soleil levant*. The artists decided to exploit this label, using it for a series of exhibitions between 1874 and 1886 that grouped together painters then considered avant-garde. They no longer plumbed history, religion, or mythology for their subjects, regarded Manet as their forebear, and advocated "light-filled painting." The label was applied to artists who were, in fact, very different from one another. A few of the strong personalities left the group, including Monet and Auguste Renoir—the two great artists who had remained loyal to this movement of their youth and had made their personal styles from it. Edgar Degas, more a draftsman and sculptor, was inspired by the new vision made possible by photography.

1869
Le Comte de
Lautréamont writes
Les Chants de Maldoror.

1895
First Venice
Biennale

1898
Émile Zola publishes
his *J'accuse.*

❝ *Everything I have learned from others has held me back.* **❞**

Paul Gauguin

They were the second generation of the Impressionist adventure. First Paul Cézanne, then Vincent van Gogh and Paul Gauguin, all essentially passing through a style not their own, developed their own style in reaction to Impressionist principles of light. Unable to limit themselves to the charms of an aestheticized gaze, in the end, these three strong-willed fin-de-siècle geniuses had to invent their own paths. And each of them did, in his own fashion, while sacrificing his life to painting.

[1]

[1] Paul Gauguin (1848–1903); *Arearea*, 1892. Oil on canvas, H: 75cm; L: 94cm. Paris, Musée d'Orsay.

[2] Paul Cézanne (1839–1906); *Mont Sainte-Victoire*, c. 1894–1900. Oil on canvas, H: 69cm; L: 90cm. Cleveland, Museum of Art.

[3] Vincent van Gogh (1853–1890); *L'Église d'Auvers-sur-Oise*, 1890. Oil on canvas, H: 94cm; W: 74cm. Paris, Musée d'Orsay.

[2]

[3]

1853
Giuseppe Verdi's
La Traviata

1870
France becomes
a republic.

1897
The Parthenon marbles
arrive in London.

[1]

[1] William Bouguereau (1825–1905); *The Birth of Venus*, 1879. Oil on canvas, H: 3m; L: 2.18m. Paris, Musée d'Orsay.

[2] Jean-Léon Gérôme (1824–1904) and Aimé Morot (1850–1904); *Gérôme Executing "The Gladiators." Monument to Gérôme*, 1878. Bronze, H: 3.6m; W: 1.8m; D: 1.7m. Paris, Musée d'Orsay.

[3] Charles Garnier (1825–1898); stairway, Opéra Garnier, Paris. 1861–1875.

[2]

"**P**ompier: Emphatically academic, used to describe a style, or someone who practices it." (*Larousse Multimedia*) Whatever the ambitions of later avant-garde artists, many—and not just mediocre ones—resisted them. Jean-Léon Gérôme led the enemies of Impressionism. Charles Garnier, who represented a current called "eclecticism," built in the center of Paris a monumental opera house meant to mark the heart of a city redesigned by Baron George-Eugène Haussmann. Garnier combined Neoclassical, Neo-Baroque, and Neo-Romantic styles within an architecture smothered by its own ornateness.

[3] ▶

[2]

[1] Edvard Munch (1863–1944); *The Scream*, 1893. Casein on paper, H: 83cm; W: 66cm. Oslo, Munch Museet.

[2] James Ensor (1860–1949); *Remarkable Masks*, 1891. Oil on canvas. Brussels, Musée des Beaux-Arts.

[3] Auguste Rodin (1840–1917); *The Kiss*, 1886. Marble, H: 1.83m; W: 1.10m; D: 1.18m. Paris, Musée Rodin.

[3]

Many traditional barriers to artistic expression fell during the nineteenth century, a period in the history of art marked by the conquest of freedom. If they so desired, artists could be the sole masters of their style. No one could stop them from asserting their individuality—as long as they had the courage to face the critics. With a little luck and a lot of hard work, they could make their originality succeed. Auguste Rodin reawakened sculpture from its century of slumber. Edvard Munch was a bundle of nerves; an artist on the edge of madness. James Ensor was obsessed by fantastic faces—though always with a touch of caustic irony.

1837–1901
Reign of Queen Victoria

1880
Creation of the
Musée des Arts
décoratifs in Paris

1886
Rimbaud's
Illuminations
is published.

SYMBOLISM

F or the Symbolists, reality is more profound and more complex than it appears. Behind superficial appearances, networks of meaning link things together; Charles Baudelaire, the poet who originated Symbolism, called these links "correspondences." As opposed to the Realists and the Impressionists, for whom painting was concerned with what is seen, the Symbolists asserted a subjectivity that resembles literature, or even a more or less esoteric philosophy. Some were very energetic (Gustave Moreau, Michael Vroubel) while others gravitated towards melancholy sweetness (Edward Burne-Jones, Fernand Khnopff).

[1] Gustave Moreau (1826–1898); *The Unicorns*, 1885. Oil, tempera and watercolor on canvas, H: 1.15m; W: 0.9m. Paris, Musée Gustave-Moreau.

[2] Odilon Redon (1840–1916); *The Cyclops*, c. 1898–1900. Oil on panel, H: 64cm; W: 51cm. Otterlo, Rijksmuseum Kröller-Müller.

[3] Edward Burne-Jones (1833–1898); *Sleeping Beauty*, 1880. Oil on canvas, H: 1.22m; L: 2.29m. Buscot, Farringdon Collection.

[2]

[3]

1853
The first elevator
is shown at the
New York World's Fair.

1876
Alexander Graham Bell
invents the telephone.

1889
World's Fair
in Paris

Architecture finally emerged from the mannered style that was still blending elements of the classical and the Gothic, even as the world was undergoing an astonishing transformation. Now aware that it was different in kind than painting and sculpture, architecture joined the new world that was being born. A sign rising by the Seine, the Eiffel Tower hallowed the use of metal in construction. To the fine gesture, modern architecture preferred the right form, adapted to its function and served by the new techniques that dynamic engineers were constantly perfecting.

[1]

[2]

[1] Dankmar Adler (1844–1900) and Louis Sullivan (1856–1924); Auditorium Building, Chicago. 1886–1893.

[2] Gustave Eiffel (1832–1923); Eiffel Tower. 1887–1889.

[3] Henri Labrouste (1801–1875); interior, Sainte-Geneviève Library, Paris. 1843–1850.

[3] ▶

THE SECESSION AND ART NOUVEAU

1867–1918	1897	1901
Austro-Hungarian monarchy	Viennese Secession	Freud publishes *The Interpretation of Dreams*.

[1]

[2]

"**S**ecession": the word stands for an entire program. The artists who used it to name the groups they formed in Munich, Berlin, and Vienna thereby affirmed their desire to break with the past. This solidly modernist movement, influenced by the Fauves and Munch, reached its peak in Vienna. Painting, sculpture, architecture, and the decorative arts were all interconnected there, in a rebellious exuberance that was also emulated in Brussels, London, and Paris under the name "Art Nouveau."

[1] Victor Horta (1861–1947); Maison Tassel, Brussels, 1892–1893.

[2] Josef Hoffman (1870–1956); Palais Stoclet, Brussels, 1905–1911.

[3] Gustav Klimt (1862–1918); *Adele Bloch-Bauer*, 1907. Oil and gold on canvas, H: 1.38m; W: 1.38m. Vienna, Galerie im Belvedere.

[3]

“To every age its art; to every art its freedom.”

Motto of the Secession

ART EXPLODES

The First World War and the Russian Revolution were radical breaks with the past at the dawn of the twentieth century. In Moscow, Zurich, and Berlin, then Rome and New York, art, too, was attempting to refashion itself upon new foundations. First Dada, a provocative and iconoclastic movement, then the Surrealists, who proclaimed the primacy of the subconscious, sought to sweep away the old order and promote an absolute freedom to think, create and live as each individual saw fit. In the Soviet Union and Italy, the Constructivists and Futurists were preoccupied with using geometry, movement, and mechanics to invent a truly modern art. More subtle, but still in the visual realm, Cubism subverted perspective, the pride of the Renaissance, and defined new ways of seeing by means of multiple viewpoints in a single image. Pablo Picasso, along with Georges Braque, was the hero of Cubism; he would dominate all twentieth-century painting with his polymorphous genius, imagination, seriousness and longevity. Picasso quickly became a living legend—embodying the myth of the artist who is liberated, always surprising, ever self-reinventing.

[1] Walter Gropius (1883–1967); Bauhaus School, Dessau (Germany), 1925.

[2] Kurt Schwitters (1887–1948); *Merzbild 9 b*, 1919. Collage, H: 96cm; W: 70cm. Cologne, Museum Ludwig.

Dada declared everything—or nothing—to be art, which amounted to the same thing. Marcel Duchamp exhibited a bottle carrier and a urinal as others exhibited paintings or sculptures. Kasimir Malevich painted elementary images as degree-zero painting, a new starting point for the art of the modern age. In art, everything was now possible. All freedoms had been won. This does not mean, however, that tradition was out of the picture. While the radicals continued to assert the need for a complete break, others, no less modern—including Picasso—consulted the works of the past. The rise of "abstract painting," which was not interested in producing images of the world, preferring instead to invent another one, did not mean that "figurative painting" was not practiced by great painters who revivified it. The same was true of sculpture.

Experiments, personalities, ideologies, divergent or convergent theories coexisted, carving out their share of respect and the market—at least in countries that did not repeal their freedoms. Totalitarian regimes, set on persecuting consciousness, wanted only

[1]

[2]

[3]

[3] Marc Chagall (1887–1985); *Double Portrait with Wineglass*, 1917–1918. Oil on canvas, H: 2.35m; W: 1.37m. Paris, Centre Georges Pompidou/Musée national d'Art moderne.

[4] Marcel Duchamp (1887–1968); *Fountain (Urinal)*, 1917–1964. White porcelain covered with ceramic glaze and paint, H: 63cm; W: 48cm; D: 35cm. Replica of original lost in 1917 produced in 1964 under the artist's supervision. Paris, Centre Georges Pompidou/Musée national d'Art moderne.

art that could serve as propaganda. Fascist realism and social realism displayed their similarities in an identical art: a heroic version of academicism that glorified leaders, devised simplistic symbols and illustrated political slogans. Between the wars, Paris, once more the capital of the arts, took in many exiled artists. The German occupation of France shifted the world's center of creativity to New York, from where most of the avant-garde movements would set out to conquer Europe.

Technological advances in the United States stimulated a creativity that took over the new media, from painting with acrylics to the computer via television. Whole new disciplines were born—video art, body art, land art, installations, conceptual art, virtual art, and so on—which quickly entered galleries and museums, overthrowing the very order of art. New ideas and new practices spread all over the planet thanks to the efficiency of new means of communications that have been continually multiplying since the turn of the century: the commonness of color images diminished the importance of academic instruction. The schools ignored the avant-garde for as long as possible in the name of the tradition they thought it their mission to defend. Up until the 1970s, or the time of "contemporary art," this nebula of activity—in which painting and sculpture were only some elements among others—settled in the art market as much as in public institutions. It became difficult to be subversive in a society that could absorb everything, and the most scandalous was soon out of date. Despite a few attempts in the 1930s to reunite the arts, architecture pursued its own autonomous path. It became concerned with shapes, and thus some architects were artists; for the most part, however, it was a profession that owed more to science and technology than to the imagination.

The death of art was proclaimed several times. Nevertheless, throughout the course of the century, art proved that it had the staying power and ability to renew itself when it appeared to be exhausted. The deaths of painting and sculpture were also announced. These two ancient arts, born even before writing, are, of course, still alive. Yet art is constantly questioning its nature, function, and means, and this may be what is keeping it alive at the dawn of the twenty-first century.

[4]

1905
Einstein's theory
of relativity

1908
The Congo becomes
a Belgian colony.

1914
Beginning of the
First World War

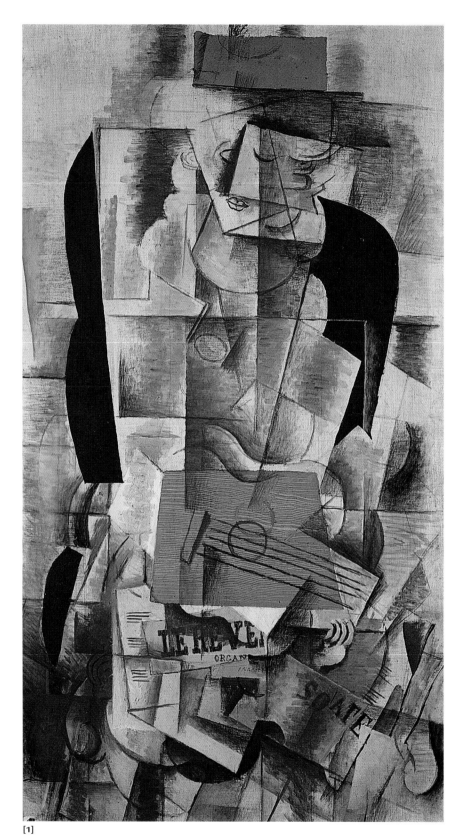

[1]

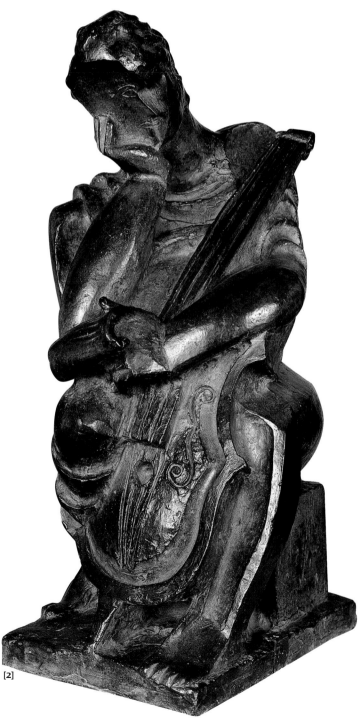

Cubism is first the story of the friendship between Georges Braque and Pablo Picasso. So close were the two painters for a time that it is difficult to tell whose work is whose. Picasso, who had already demonstrated a revolutionary talent by painting *Les Demoiselles d'Avignon*, may be considered, along with Braque, Cézanne's heir. Their originality lies in their way of drawing a person or an object from several angles, and in introducing elements such as wallpaper or newspaper that they glued to their paintings. Their techniques became very popular, and Cubism began to spread even as they were leaving it behind.

[1] Georges Braque (1882–1963); *Woman with Guitar*, 1913. Oil on canvas, H: 1.30m; W: 0.73m. Paris, Centre Georges Pompidou/Musée national d'Art moderne.

[2] Ossip Zadkine (1890–1967); *The Composer*, 1935. Bronze, H: 43cm. Orléans, Musée des Beaux-Arts.

[3] Pablo Picasso (1881–1973); *Les Demoiselles d'Avignon*, June–July 1907. Oil on canvas, H: 2.43m; W: 2.33m. New York, The Museum of Modern Art. Acquired through the Lillie P. Bliss Bequest.

[2]

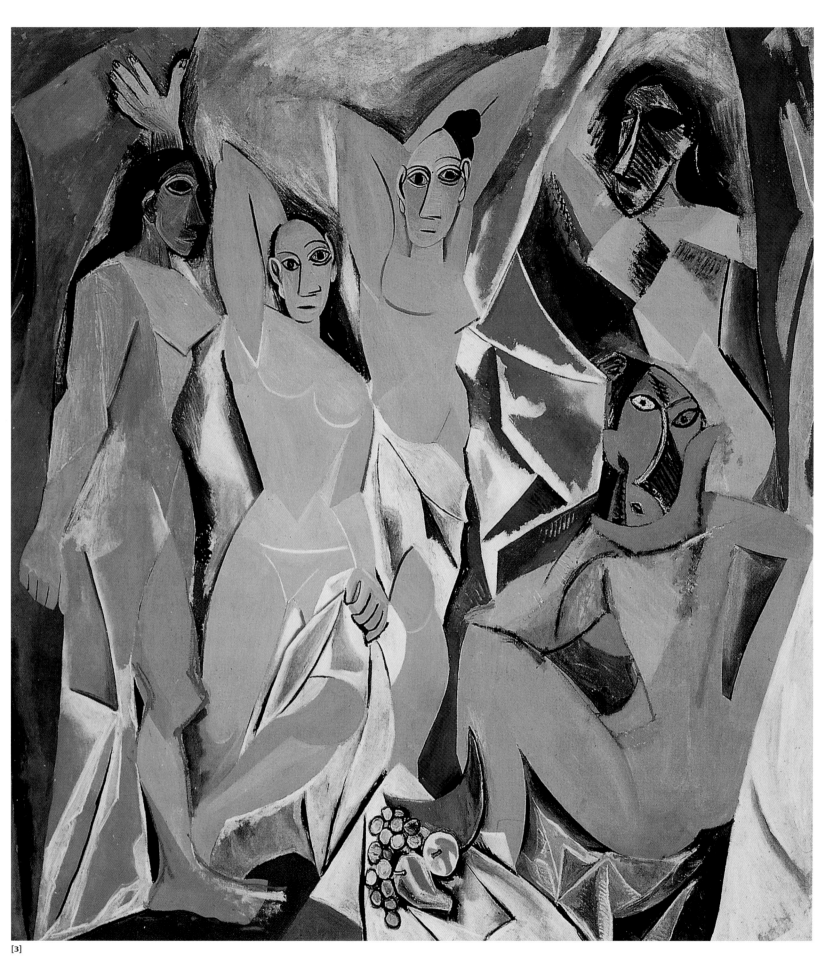

[3]

"Painting is stronger than I; it makes me do what it wants."

Pablo Picasso

ABSTRACT PAINTING

1917	1917	1920
Russian Revolution	De Stijl is founded in Amsterdam.	Creation of the League of Nations

[1]

One day in 1908, in his studio, Vassily Kandinsky looked at a canvas that he had turned upside down. He found it beautiful that way—even though he could not make out the subject. This triggered something in him: two years later, he abandoned all references to the shape of things and invented his own artistic language. Other artists were doing the same at the same time. Kasimir Malevich adopted a more radical position by developing a minimalist geometry. As for Piet Mondrian, he came to abstraction only gradually, by reducing his drawing to its essentials. For all of them, however, feeling remained the key word.

[1] Piet Mondrian (1872–1944); *Composition in Red, Yellow and Blue*, 1928. Oil on canvas, H: 45.2cm; W: 45cm. Ludwigshafen, Wilhelm-Hack-Museum.

[2] Vassily Kandinsky (1866–1944); sketch for *Composition IV*, 1910. Oil on canvas, H: 0.94m; L: 1.3m. London, Tate Gallery.

[3] Kasimir Malevich (1878–1935); *Suprematist Composition: White on White*, 1918. Oil on canvas, H: 78.7cm; W: 78.7cm. New York, The Museum of Modern Art.

[2]

[3]

"Any flat picture plane is more alive than any face with two eyes and a smile."

Kasimir Malevich

[1]

1912
Arnold Schoenberg
composes his
Pierrot lunaire.

1919
The Treaty of Versailles
is signed.

1924
Thomas Mann publishes
The Magic Mountain.

ince the end of the nineteenth century, Germany had reacted strongly to Paris' presumption to rule the fine arts, and in answer made a brilliant start to the twentieth century. In 1905, a few young painters looked to Van Gogh, Gauguin, Munch, and Matisse in order to create an "expressionist" style of painting that was full of vitality and pointedly challenged Impressionism's now banal pleasantness.

[1] Ernst Ludwig Kirchner (1880–1938); *Marzella*, 1909–1910. Oil on canvas, H: 75cm; W: 60cm. Stockholm, Moderna Museet.

[2] August Macke (1887–1914); *Spaziergang im Garten*, 1914. Oil on canvas, H: 73cm; L: 103cm, Private collection, Krefeld, Germany.

[3] Max Beckmann (1884–1950); *Family Portrait*, 1920. Oil on canvas, H: 0.65m; L: 1m. New York, The Museum of Modern Art.

[2]

[3]

1900
First use of
reinforced concrete

1909
Filippo Tommaso Marinetti
launches the
Futurist movement.

1919
Walter Gropius founds
the Bauhaus in Weimar.

The revolutionary ardor of the most dynamic avant-garde artists did not prevent others from demonstrating a greater suppleness as they sought innovation closer to tradition. Purity of line in painting, sculpture, and architecture was the obsession of those who sought the most accurate image or form (which the young Le Corbusier called "purism"). This aesthetic of the essential is an aspect of modernism as well, from the melancholy simplicity of Amedeo Modigliani to the functional beauty created by modernist architects.

[3] ►

[4] ►

[2]

[1]

[1] Amedeo Modigliani (1884–1920); *Nude Sitting on a Couch*, 1917. Oil on canvas, H: 1m; L: 0.65m. Private collection.

[2] Constantin Brancusi (1876–1957); *Mlle Pogany I*, 1912–1913. Terra-cotta, H: 44cm; W: 24.5cm; D: 30.5cm. Paris, Centre Georges Pompidou/Musée national d'Art moderne.

[3] Charles-Édouard Jeanneret, known as Le Corbusier (1887–1965); Villa Savoye, Poissy, France. 1929–1931.

[4] Ludwig Mies van der Rohe (1896–1969); German Pavilion, World's Fair, Barcelona. 1929.

[1]

[2]

1916
Birth of Dada

1923
Man Ray creates
his rayograms.

1924
André Breton writes
The Surrealist Manifesto.

THE IMAGINARY

[3]

Surrealism in painting began with Giorgio De Chirico, who was a Surrealist without knowing it. André Breton and his friends founded the new movement in the early 1920s, using De Chirico as an example because his paintings looked like images from dreams. Some excellent artists followed this original path, where imagination refused to be restricted by reality. They produced paintings and sculptures that resemble nothing else; they also made objects by means of collage or assemblage of diverse elements. Salvador Dali and Max Ernst were the most inventive artists of this new genre.

[1] Salvador Dali (1904–1989); *The Persistence of Memory*, 1931. Oil on canvas, H: 24cm; L: 33cm. New York, The Museum of Modern Art.

[2] Giorgio De Chirico (1888–1878); *Melancholy*, c. 1912. Oil on canvas, H: 0.75m, L: 1.05m. Frankfurt, Galerie Françoise Knabe.

[3] Paul Klee (1879–1940); *Senecio*, 1922. Oil on canvas, H: 40.5cm; W: 38cm. Basel, Kunstmuseum.

[4] Max Ernst (1891–1976); *Capricorn*, 1948–1964. Bronze, H: 2.45m; W: 2.07m; D: 1.57m. Paris, Centre Georges Pompidou/Musée national d'Art moderne.

[4]

[1]

1913
The Armory Show
exhibition launches modern
art in the United States.

1916
George Gershwin
composes
Rhapsody in Blue.

1929
The Wall Street
stockmarket crash
begins the Great Depression.

BIRTH OF AN AMERICAN ART

Between the wars, America was still turned toward Europe. Cubism and abstract painting inspired emulation, and Paris' Montparnasse district was a mecca of which many an artist dreamed. Certain American artists, however, imposed their own visions. Georgia O'Keeffe renewed floral painting. Thomas Hart Benton and Edward Hopper held up a mirror to an America torn between the cult of its vitality and the melancholy of the Depression.

[2]

[1]] Georgia O'Keeffe (1887–1986); *Orchid*, 1941. Pastel on paper-covered board, H: 68cm; W: 53cm. Private collection.

[2] Edward Hopper (1882–1967); *City Sunlight*, 1954. Oil on canvas, H: 0.71m; L: 1.02m. Washington, Smithsonian Institution.

[3] Thomas Hart Benton (1889–1975); *Social Life*, 1930. Oil on canvas, H: 1.97m; L: 3.69m. New York, New School for Social Research.

Photography

Photography entered modern art in New York in the 1920s when Alfred Stieglitz showed prints by some of his friends, along with paintings and sculptures from Europe and works by black artists. For a century of its existence, in the realm between journalism and painting, photography tested its boundaries: anxious to both bear witness to the reality of the world, and to take its place among the fine arts. At a time when the very notion of the "fine" arts was crumbling, photography was labeled the modern art even as its uniqueness was affirmed: photography is not painting, but another way of seeing the world and creating a work of art.

[3]

1923
The Fascists take
power in Italy.

1933
Hitler takes power
in Germany.

1936
The Popular Front
forms in France.

[1]

Politics burst into art in the twentieth century. With a few exceptions, the fine arts had never addressed political themes, unless it was to serve the powers that be with conventional imagery. Now, however, art discovered its power for subversion in its struggle to survive. The harsh clashes between democracy, Fascism, and Communism soon enveloped art. Rebellion, hope, criticism, and propaganda sought new forms in the hands of artists for whom art was no longer a mere entertainment: they produced satire, photo-montage, and murals.

> *In my paintings, I attempt to unravel the meaning of our era.*
>
> Otto Dix

[1] Otto Dix (1891–1969); *The Seven Deadly Sins*, 1933. Mixed media on panel, H: 1.79m; W: 1.2m. Karlsruhe, Staatliche Kunsthalle.

[2] George Grosz (1893–1959); *Gray Day*, 1921. Oil on canvas, H: 1.15m; W: 0.8m. Berlin, Nationalgalerie.

[3] Fernand Léger (1881–1955); *The Builders*, 1951. Oil on canvas, H: 1.60m; L: 2.2m. Moscow, Pushkin Museum.

[4] Diego Rivera (1886–1957); detail from *The Great Tenochtitlán* (vegetable sellers), 1945. Fresco. Mexico, Palacio National.

[2]

[3]

[4]

COLOR AND SHAPE

1936–1939
Spanish Civil War

1940
Churchill becomes
prime minister of
Great Britain.

1945
Yalta Accords are signed.

[1]

A fter Fauvism, Henri Matisse remained faithful to the use of color, which he employed in masterful harmonies. His painting is pure pleasure: visual joy and the search for beauty in sensuality. He gave the twentieth century some of its most beautiful images of women. Joan Miró demonstrated the same visual sensibility but from within the freedom of an inexhaustible imagination. Henry Moore explored the human form brilliantly.

[1] Joan Miró (1893–1983); *Women, Bird by Moonlight*, 1949. Oil on canvas, H: 81cm; W: 66cm. London, Tate Gallery.

[2] Henry Moore (1898–1986); *Reclining Figure*, 1938. Bronze. Private collection.

[3] Henri Matisse (1869–1954); *The Peasant Blouse*, 1940. Oil on canvas, H: 92cm; W: 73cm. Paris, Centre Georges Pompidou/Musée national d'Art moderne.

[2]

[3]

174

1940
The Caves of Lascaux
are discovered.

1949
Proclamation of
the People's Republic
of China

1953
Death of Stalin

> ❝*It is through our subjectivity that we grasp reality.*❞
>
> Michel Leiris

The desire for a new harmony, which was the hope of modernism, had its flip side: the anxiety of a century traumatized by two world wars. The very nature of humanity was in question—its fragility and its suffering. Many artists studied the human figure in search of a deeper truth than that of facial features. If they deformed it, it was less out of aggression (and they were reproached for exactly that) than to show us a reality that was hard to look at.

[3]

[1] Francis Bacon (1909–1992); *Untitled*, Triptych: right panel, August 1972. Oil on canvas, H: 1.98m; W: 1.47m. Private collection.

[2] Alberto Giacometti (1901–1966); *Walking Man*, c. 1949. Bronze, H: 48cm. Private collection.

[3] Chaim Soutine (1893–1943); *The Little Pastry Cook*, Undated. Oil on canvas, H: 66.3cm; W: 50.3cm. Merion, Pennsylvania, The Barnes Foundation.

[2]

[1]

The United States
drops an atomic bomb
on Hiroshima.

The Marshall Plan
is launched.

The Korean War

[2]

New York became the center of the world in 1942, when Peggy Guggenheim opened the Art of the Century Gallery. This great collector, fleeing the war in Europe, showed established European artists but also young, unknown American artists such as Jackson Pollock, Arshile Gorky, and Mark Rothko. They reinvented painting, locating it between Surrealism and abstraction, and proudly manifesting their subjectivity. These were the "Abstract Expressionists," and Pollock was the most radical of them: he created huge paintings by dripping paint onto the canvas. For him, the process was as serious as any religious ritual.

[1] Mark Rothko (1903–1970); *Untitled*, c. 1959. Oil on paper glued to linen, H: 77.5cm; W: 55.5cm. Private collection.

[2] Arshile Gorky (1904–1948); *To Project, To Conjure*, 1944. Oil on canvas, H: 0.9m; L: 1.18m. Private collection.

[3] Jackson Pollock (1912–1956); *Guardians of the Secret*, 1943. Oil on canvas, H: 1.23m; L: 1.92m. San Francisco, Museum of Modern Art.

[3]

1963
Assassination of
John F. Kennedy

1964–1973
U.S. involvement
in Vietnam

1969
Neil Armstrong is the
first man on the moon.

[1]

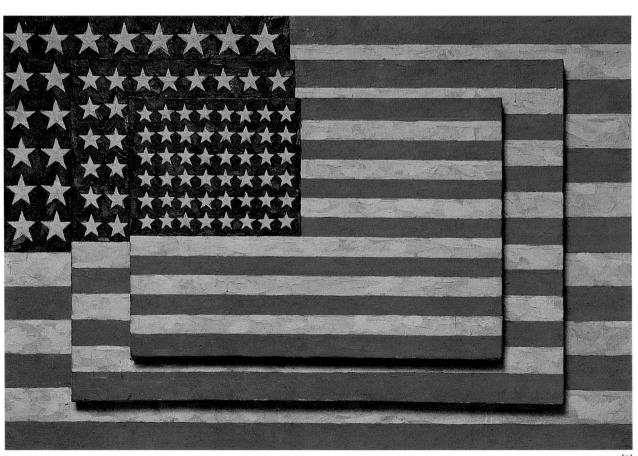

[2]

Art, no longer burdened by the weight of tradition, constantly sought out the new. The world was changing fast and art wanted to follow—if not lead. This meant constantly experimenting and inventing new signs. In the 1960s, Pop Art borrowed from the press, advertising, comic strips, television, and cinema to develop a popular language that was perfectly intelligible but not devoid of critical irony. Hyperrealism and narrative art followed suit.

[1]] Andy Warhol (1928–1987); *Campbell's Soup Can*, 1966. Mixed media, H: 1.01m; W: 0.69m. Private collection.

[2] Duane Hanson (1925–1996); *Tourists*, 1970. Edinburgh, National Galleries of Scotland.

[3] Jasper Johns (born 1930); *Three Flags*, 1958. Encaustic on canvas, H: 0.78m; L: 1.15m; D: 0.12m. New York, Whitney Museum of American Art.

[4] Robert Rauschenberg (born 1925); *Market Altar, Mexico*, 1985. Acrylic on canvas and collage. Private collection.

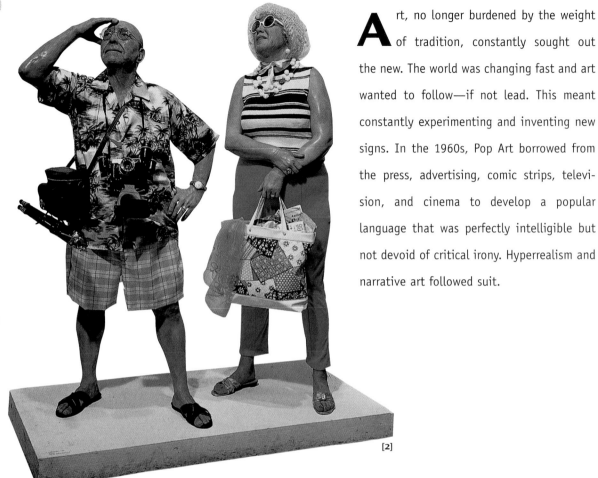

[3]

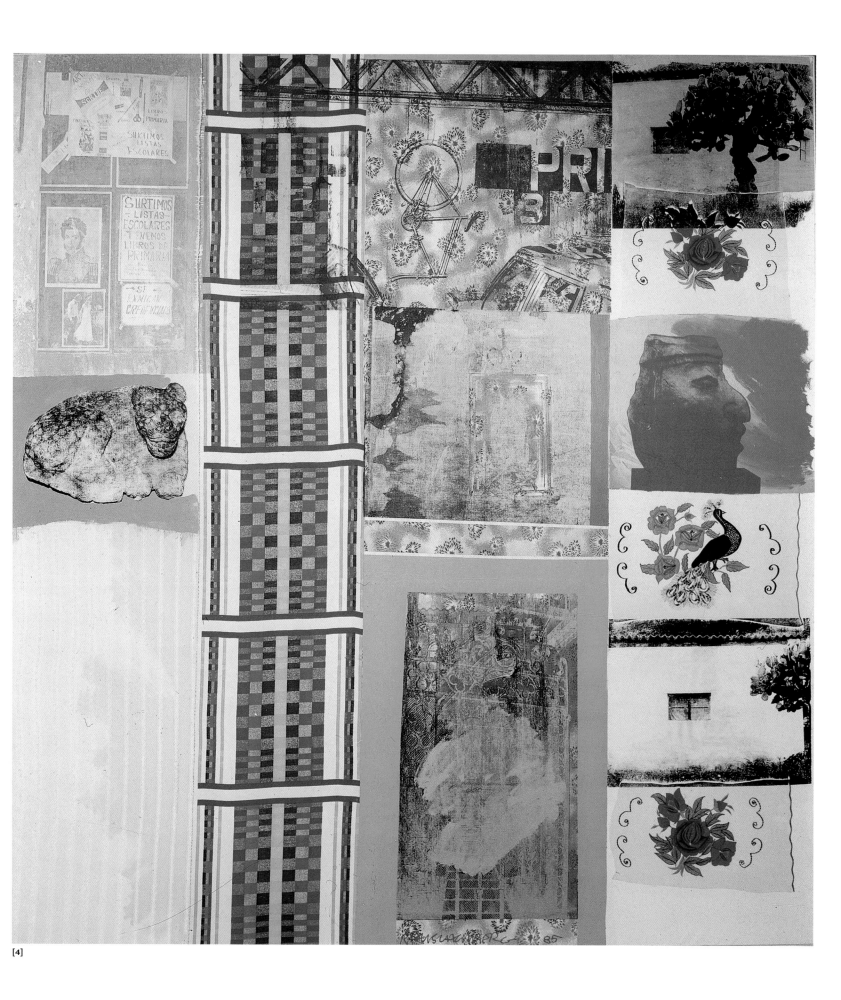

[4]

[1]

1951
Albert Camus
publishes *The Rebel*.

1956
Insurrection
of Budapest

1968
Student protests in
the United States
and Europe

[3]

During the Cubist era, some modern artists considered "primitive" works to be on a par with those of the great Western masters. Since then, these works have been admired, studied, and looked to for inspiration. So-called "civilized" man no longer felt superior to the "savages." He knew a savage lay dormant within him—and that it was not the worst part of himself. Quite a few artists sought art's primordial source. These were the "Modern Primitives."

[2]

[1] Jean Dubuffet (1901–1985); *Dhôtel nuancé d'abricot*, 1947. Oil on canvas, H: 1.16m; W: 0.89m. Paris, Centre Georges Pompidou/Musée national d'Art moderne.

[2] Willem De Kooning (1904–1997); *Woman IV*, 1952–1953. Oil and enamel on canvas, H: 1.42m; W: 1.17m. Kansas City, Nelson-Atkins Museum of Art.

[3] Jean-Michel Basquiat (1960–1988); *Self-Portrait as a Heel II*, 1982. Acrylic and soft lead pencil on canvas, H: 2.44m; W: 1.56m. Private collection.

❝Savageness is a value that should be preserved so that the spirit can awaken and hone itself.❞

Jean Dubuffet

1975
Francisco Franco
dies in Spain.

1991
The Gulf War

1992
First environmental summit
takes place in Rio de Janeiro.

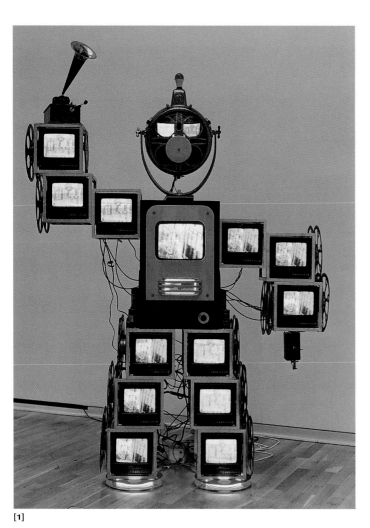

[1]

[1] Nam June Pak (born 1932); *High-Tech Allergy*, Video installation, November 1995–January 1996. Wolfsburg, Kunstmuseum.

[2] Joseph Beuys (1921–1986); *Homogeneous Infiltration for Grand Piano*, 1966. Piano covered in felt and cloth, H: 1m; L: 1.42m; D: 2.40m. Paris, Centre Georges Pompidou/Musée national d'Art moderne.

[3] Antoni Tàpies (born 1923); *Grand X*, 1988. Mixed media on card, H: 1.89m; W: 1.55m. Paris, Galerie Lelong.

During the 1970s, new disciplines appeared. In museums and galleries, painting and sculpture were competing with new artistic practices. Photography was no longer considered a poor relation. Video art—which was not broadcast on television—was included among the visual arts. Certain artists practiced collage and assemblage in space (inspired by set design), "performance art" (inspired by theater), body art (inspired by ritual), earth art (intervention in the landscape), and so on. One constant unites these new disciplines and characterizes painting and sculpture in their latest manifestations: the art of today is less about seeing than about thinking—it is "conceptual." This is the new universe that is called "contemporary art."

[2]

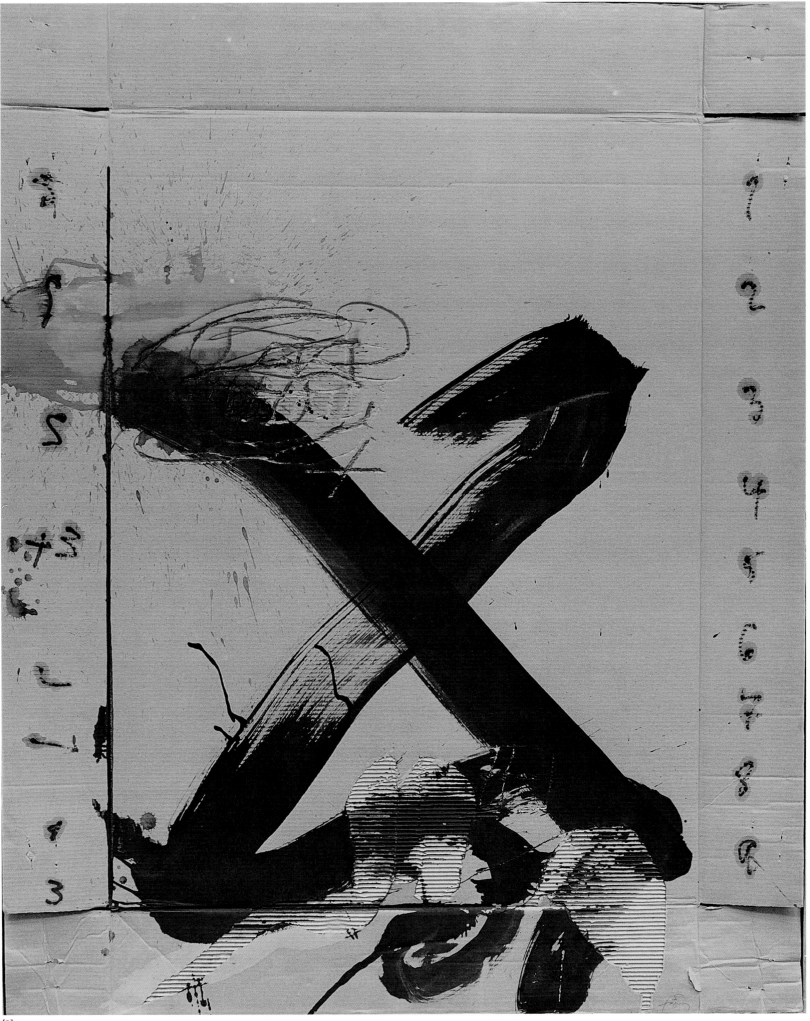

[3]

1985
Gorbachev comes
to power in the USSR.

1989
Fall of the Berlin Wall

1999
The Euro is launched.

Modern architecture, when it is more than the sum of its construction techniques, is concerned above all with inventing new spaces (domestic, professional, public) adapted to the lifestyles of their occupants. This does not mean that it is not interested in aesthetics. Design has become more supple because new materials and methods have increased its freedom. Unlike contemporary art, architecture could not allow itself everything; it assumed its autonomy nobly and continued to create beauty when beauty was no longer at the heart of the other arts.

[1]

[1] Ieoh Ming Pei (born 1917); Pyramid of the Louvre, Paris. 1986–1988.

[2] Frank Lloyd Wright (1867–1959); The Solomon R. Guggenheim Museum, New York. 1956–1959.

[3] Frank O. Gehry (born 1929); Guggenheim Museum, Bilbao. 1997.

[4] Renzo Piano (born 1937); Centre Jean-Marie Tjibaou, Nouméa (New Caledonia). 1995–1998.

[3] ►

[4] ►

[2]

ILLUSTRATION AND PHOTO CREDITS

RMN: Réunion des Musées nationaux (France)

Pages 8–9

[1] Michelangelo Buonarroti (1475–1564); *The Delphic Sibyl,* 1508–1512.
Credit: Momumenti, Musei e Gallerie Pontificie, Vatican.

[2] Pablo Picasso (1881–1973); *The Sculptor,* December 1931.
Credit: RMN/Photo B. Hatala, Paris-Succession Picasso, 1999, Paris.

Pages 10–11

[1] Bison. Magdalenian (c. 18,000 B.C.).
Credit: RMN/Photo R.-G. Ojeda, Paris.

[2] Head of a woman, known as the "Venus of Brassempouy."
Credit: RMN/Photo J.-G. Berizzi, Paris.

[3] Painted stones. Mesolithic (c. 10,000 B.C.).
Credit: RMN, Paris.

Pages 12–13

[1] Female statue known as the "Venus of Lespugue."
Gravettian (c. 27,000 B.C.).
Credit: Musée de l'Homme/ Photo B. Hatala, Paris.

[2] Hunters. Neolithic (c. 5000 B.C.).
Credit: Maximillien Bruggmann. Yverdon.

[3] Bull, horses and stag. Magdalenian (c. 18,000 B.C.).
Credit: Explorer/Photo F. Jalain, Vanves.

Pages 14–15

[1] Statue-Menhir, c. 2500 B.C.
Credit: RMN/Photo Hervé Lewandowski, Paris.

[2] Group of megaliths, Stonehenge (England).
3100–1550 B.C.
Credit: Hoa Qui/Photo Zefa, Paris.

[3] Funerary chambers of the burial mound, Barnenez (Finistère, France), known as the "Barnenez Cairn,"
c. 4600 B.C.
Credit: Dial/Photo Daniel Faure, Paris.

Pages 16–17

[1] The goddess Sekhmet. 18th Dynasty (c. 1450–1310 B.C.).
Credit: RMN, Paris.

[2] Alley of sphinxes with rams' heads, Temple of Amon-Ra, Karnak; 19th Dynasty (c. 1310–1200 B.C.).
Credit: Explorer/Photo H. Volz, Vanves.

[3] Head of Nefertiti. 18th Dynasty (c. 1450–1310 B.C.).
Credit: Bildarchiv Preussischer Kulturbesitz/Photo Margarete Büsing, Berlin.

[4] Pharaoh Psamtik II presenting Osiris. 26th Dynasty (c. 650–525 B.C.).
Credit: RMN/Photo Hervé Lewandowski, Paris.

Pages 18–19

[1] Palette of Narmer (Narmer, King of Upper Egypt, Triumph of the Peoples of the Delta).
1st Dynasty (c. 3100–2800 B.C.).
Credit: Jürgen Liepe, Berlin.

[2] Pyramid of Djoser, Saqqarah. 3rd Dynasty (c. 2660 B.C.).
Credit: Explorer/Photo René Mattes, Vanves.

[3] The Sphinx and the Pyramid of Khafre, Giza. 4th Dynasty (c. 2600–2480 B.C.).
Credit: Hoa Qui/Photo Zefa-Zefau, Paris.

Pages 20–21

[1] Triad of Menkaure (Menkaure between the goddess Hathor and the goddess protecting the "nome" [district] of Cynopolis).
4th Dynasty (c. 2600–2480 B.C.).
Credit: Jürgen Liepe, Berlin.

[2] Statues of Rahotep and Nofret.
Beginning of the 4th Dynasty (c. 2600 B.C.).
Credit: Jürgen Liepe, Berlin.

[3] *The Seated Scribe.* 4th or 5th Dynasty (c. 2600–2350 B.C.).
Credit: RMN/Photo Hervé Lewandowski, Paris.

Pages 22–23

[1] Throne of Tutankhamen (Ankhesenamen oils the body of her spouse, Tutankhamen).
18th Dynasty (c. 1326 B.C.).
Credit: Explorer/Photo P. Tetrel, Vanves.

[2] Amenhotep IV, Nefertiti and three of their daughters. 18th Dynasty (c. 1340 B.C.).
Credit: Bildarchiv Preussischer Kulturbesitz/Photo Margarete Büsing, Berlin.

[3] *Scene Showing the Official Nebanum Hunting Birds.* 18th Dynasty (c. 1340 B.C.).
Credit: British Museum, London.

Pages 24–25

[1] Ceiling detail, hypogeum of Ramses VI (two buttressing goddesses representing the night sky and the daytime sky respectively). 20th Dynasty (c. 1140 B.C.).
Credit: Explorer/Photo Baumgartner, Vanves.

[2] Temple of Amon, Luxor (papyrus-shaped columns of the peristyle court of Amenhotep III). 18th Dynasty (c. 1340 B.C.).
Credit: Explorer/Photo J. Darche, Vanves.

[3] Temple of Ramses II, Abu Simbel. 19th Dynasty (c. 1240 B.C.).
Credit: Hoa Qui/Photo Wojtek Buss, Paris.

Pages 26–27

[1] *The Archers of Darius.* 5th century B.C.
Credit: RMN/Photo Hervé Lewandowski, Paris.

[2] Statue of Gudea, Prince of Lagash, c. 2150 B.C.
Credit: RMN/Photo Jean, Paris.

[3] Standard of Ur (peace side). c. 2500 B.C.
Credit: British Museum, London.

Pages 28–29

[1] *La Parisienne.* 1600–1500 B.C.
Credit: Scala, Florence.

[2] Death mask. 1600–1500 B.C.
Credit: AKG, Paris.

[3] Painter of Brygos, detail of the central medallion of a red-figure vase, c. 490 B.C.
Credit: RMN/Photo Chuzeville, Paris.

[4] Apollo and a centaur. 470–460 B.C.
Credit: Scala, Florence.

Pages 30–31

[1] Palace of Knossos, north entrance (reconstruction), c. 1700 B.C.
Credit: Scala, Florence.

[2] Snake goddess, c. 1500 B.C.
Credit: Scala, Florence.

[3] Head of a Cycladic idol. 3200–2800 B.C.
Credit: RMN/Photo G. Blot, Paris.

Pages 32–33

[1] Polymedes of Argos, the twins Cleobis and Biton (?), c. 580 B.C.
Credit: Scala, Florence.

[2] Attributed to the Analatos painter, red-figure loutrophoros (a ritual vase used in wedding ceremonies or funeral rites), c. 700–680 B.C.
Credit: RMN/Photo Hervé Lewandowski, Paris.

[3] *Kore* dedicated by Cheramyes to Hera. 570–560 B.C.
Credit: RMN/Photo Hervé Lewandowski, Paris.

Pages 34–35

[1] *Discobolus* (Roman copy of the bronze statue by Myron), c. 450 B.C.
Credit: Scala, Florence.

[2] *Nike* ("Victory," messenger of Zeus) *Adjusting Her Sandal,* 409–406 B.C.
Credit: Scala, Florence.

[3] Doric temple of Poseidon, Paestum (southern Italy). 5th century B.C.
Credit: Scala, Florence.

Pages 36–37

[1] Circular temple ("tholos") of Delphi. Early 4th century B.C.
Credit: Hoa Qui/Photo Zefa-Damm, Paris.

[2] Theater of Epidaurus. Last quarter, 4th century B.C.
Credit: Explorer/Photo L.-Y. Loirat, Paris.

[3] Praxiteles; *Hermes Holding the Infant Dionysus* (Greco-Roman copy), c. 340 B.C.
Credit: Scala, Florence.

[4] Athlete with strigil. Ceramic amphora.
Credit: AKG, Paris.

Pages 38–39

[1] Young married couple. 150–100 B.C.
Credit: RMN/Photo Chuzeville, Paris.

[2] Battle of Alexander (Alexander conquering King Darius of Persia at Ixos). 1st century B.C. Copy of a Greek painting from 300 B.C.
Credit: AKG, Paris.

[3] *Victory of Samothrace,* c. 190 B.C.
Credit: RMN, Paris.

Pages 40–41

[1] *La Primavera,* 1st century A.D.
Credit: Scala, Florence.

[2] Roman noble holding the portraits of his ancestors (statue known as "Barberini"). Second half of the 1st century B.C.
Credit: Scala, Florence.

[3] Coliseum, Rome; A.D. 70–80.
Credit: Scala, Florence.

Pages 42–43

[1] Mars or combatant warrior. Mid-5th century B.C.
Credit: Lauros-Giraudon, Paris.

[2] Tomb of the Bulls, Tarquinia. Detail of painted wall (back wall: ambush of Prince Troilus by Achilles). 540–530 B.C.
Credit: Giraudon, Paris.

[3] Sarcophagus of the Spouses. Last quarter of the 6th century B.C.
Credit: RMN/Photo Hervé Lewandowski, Paris.

Pages 44–45

[1] Trompe-l'œil wall decoration, Boscoreale. 50 B.C.
Credit: Magnum/Photo Erich Lessing, Paris.

[2] Frieze from the Altar of Domitius Ahenobarbus (census episode: registration of citizens and sacrifice to the god Mars), c. 100 B.C.
Credit: RMN/Photo Chuzeville, Paris.

[3] The "Capitoline" she-wolf. First half of the 5th century B.C. (the twins date from the late 15th century).
Credit: Giraudon, Paris.

Pages 46–47

[1] Statue of Emperor Augustus, c. 20 B.C.
Credit: Scala, Florence.

[2] Interior of the Pantheon, Rome. Erected in 17 B.C., destroyed by fire in 80 A.D. and reconstructed by Hadrian in A.D. 123.
Credit: The Ancient Art & Architecture Collection/Photo R. Sheridan, Pinner.

[3] Forum, Rome (arch of Septimus Severus in the background, erected in A.D. 203).
Credit: Scala, Florence.

Pages 48–49

[1] Villa of the Emperor Hadrian at Tivoli. A.D. 117–134.
Credit: Hoa Qui/Photo Wojtek Buss, Paris.

[2] Detail of Trajan's Column. A.D. 107–113.
Credit: Scala, Florence.

[3] Aqueduct of Segovia (Spain). A.D. 98–117.
Credit: Explorer/Photo J.-P. Nacivet, Vanves.

Pages 50–51

[1] Funerary portrait of a young woman, c. A.D. 161–180.
Credit: RMN/Photo G. Blot, Paris.

[2] *Judgment of Paris;* c. A.D. 115.
Credit: RMN/Photo J. Schorman, Paris.

[3] Monumental arch, Palmyra (Syria). 3rd century A.D.
Credit: Hoa Qui/Photo M. Troncy, Paris.

Pages 52–53

[1] Chair of Bishop Maximien, Constantinople. Mid-6th century.
Credit: Cameraphoto/AKG, Paris.

[2] *Christ Pantocrator;* c. 1180–1194.
Credit: Scala, Paris.

[3] Detail of the Pala d'Oro (the archangel Michael). Early 12th century.
Credit: Cameraphoto/AKG, Paris.

[4] Icon of the Virgin of Saint Vladimir. 12th–13th century.
Credit: AKG, Paris.

Pages 54–55

[1] Sarcophagus of Junius Bassus. c. A.D. 389.
Credit: Magnum/Photo Erich Lessing, Paris.

[2] Catacombs of the Via Latina, Rome (view from a cubiculum, north room: Alcestis before Hercules and Cerberus). 4th century.
Credit: Scala, Florence.

[3] Church of Santa Constanza, Rome (mausoleum of Helen and Constantia, daughters of Constantine). 4th century.
Credit: Scala, Florence.

Pages 56–57

[1] Icon of the Virgin and Child (with Saint Theodore and Saint George). 6th century.
Credit: Hoa Qui/Photo Manaud, Paris.

[2] Hagia Sophia, Istanbul. Second third of the 6th century (minarets from the Ottoman period).
Credit: Hoa Qui/Photo E. Valentin, Paris.

[3] Empress Theodora and her court. Mid-6th century.
Credit: Scala, Florence.

Pages 58–59

[1] *Nativity;* 11th century.
Credit: AKG, Paris.

[2] Psalter of Paris (David and his flock). 10th century.
Credit: AKG, Paris.

[3] *Christ Praying at Gethsemane,* 1215–1220.
Credit: Scala, Florence.

Pages 60–61

[1] Fibulas shaped like eagles (Visigoth art). 6th century.
Credit: Bridgeman Art Library, Paris.

[2] Detail from the tapestry known as "The Bayeux Tapestry" (William, Duke of Normandy, haranguing his troops), c.1070–1080.
Credit: magnum/Photo Erich Lessing, Paris.

[3] Gislebertus; *Eve,* c. 1130.
Credit: AKG, Paris.

[4] The Church of Notre-Dame, Paray-le-Monial (Saône-et-Loire, France). Former abbey church, early 12th century.
Credit: Archipress/Photo F Eustache, Paris.

Pages 62–63

[1] Grip of Viking processional cudgel. 9th century.
Credit: Knudsens-Giraudon, Paris.

[2] Chalice. 8th century.
Credit: Bridgeman Art Library, Paris.

[3] Page from the collection of Gospels known as the "Lindisfarne Gospels" (northeast England), c. 698–700.
Credit: AKG, Paris.

Pages 64–65

[1] Page of the Gospels known as "Ebbo's Gospels" (Saint Matthew). 816–835.
Credit: Giraudon, Paris.

[2] *The Presentation at the Temple,* c. 1015.
Credit: Magnum/Photo Erich Lessing, Paris.

[3] Equestrian statuette of Charlemagne. 10th century.
Credit: RMN, Paris.

Pages 66–67

[1] Sénanque Abbey (Vaucluse, France). 12th century.
Credit: Hoa Qui/Photo E. Valentin, Paris.

[2] Gallery of the cloister of the abbey church Saint-Pierre de Moissac (Tarn-et-Garonne, France). Late 12th century.
Credit: Explorer/Photo F. Jalain, Vanves.

[3] *The Mystic Mill* (Moses emptying a sack of grain and Saint Paul gathering the flour). Capital, central nave, Church of the Madeleine, Vézelay (France), c. 1120–1140.
Credit: Explorer/Photo F. Jalain, Vanves.

[4] Detail from the fresco (Apocalypse scene) in the porch of the abbey church of Saint-Savin-sur-Gartempe, Vienne (France), c. 1100.
Credit: Hoa Qui/Photo N. Thibaut, Paris.

Pages 68–69

[1] Central nave, Cathedral of Tournai (Belgium). Second quarter of the 12th century.
Credit: Dominique Genet, Paris.

[2] Castle of the counts of Flanders, 's Gravensteen, near Ghent (Belgium), c. 1180.
Credit: AKG, Paris.

[3] Eastern apse, Cathedral of Spire (Rhineland, Germany). Late 11th–early 12th century.
Credit: Dominique Genet, Paris.

Pages 70–71

[1] Facade, Church of Santiago de Compostela (the Porch of Glory). 1188–1200.
Credit: Scala, Florence.

[2] Interior, Baptistery of Parma. 1196–1260.
Credit: Scala, Florence.

[3] The Campo of Pisa (in the foreground, the baptistery [1153–14th century]; cathedral [1063–13th century]; campanile [1173–1350]).
Credit: Scala, Florence.

[4] View of the apse, Church of Saints Mary and Donatus, Murano (Veneto, Italy). 12th century.
Credit: Cameraphoto/AKG, Paris.

Pages 72–73

[1] Duccio di Buoninsegna, (c. 1260–1318/1319), *Madonna and Child with Saints.* Obverse of the reredos for the main altar, Cathedral of Siena. 1398–1311.
Credit: Bridgeman Art Library, Paris.

[2] Claus Sluter (c. 1350–1406); *The Well of Moses,* c. 1400. Dado, Way of the Cross, cloister,
Credit: Lauros-Giraudon, Paris.

[3] The Church of Santa Croce, Florence. 1295–1413.
Credit: S. Domingie/AKG, Paris.

Pages 74–75

[1] Stained-glass window, Chartres Cathedral, c. 1220–1230.
Credit: Hoa Qui/Photo Zefa-Eugen, Paris.

[2] The Cathedral of Notre-Dame de Paris. 1163–early 14th century.
Credit: Bridgeman Art Library, Paris.

[3] Nave, Cathedral of Amiens, c. 1220–1250.
Credit: Dominique Genet, Paris.

Pages 76–77

[1] Entrance of the "Palais-Neuf," Palais des Papes, Avignon. Early 14th century.
Credit: Explorer/Photo D. Reperant, Vanves.

[2] House of Jacques Coeur, Bourges, France. 1443–1451.
Credit: Hoa Qui/Photo N. Thibaut, Paris.

[3] Hôtel-Dieu, Beaune (Côte-d'Or, France). Founded by Nicolas Rolin, chancellor of the Duke of Burgundy, c. 1443.
Credit: Hoa Qui/Photo N. Thibaut, Paris.

Pages 78–79

[1] *The Dormition of the Virgin.* 1220–1230.
Credit: Hoa Qui/Photo X. Richer, Paris.

[2] *Bonn Pietà,* c. 1300.
Credit: AKG, Paris.

[3] Vaults, Cologne Cathedral. 1248–1322.
Credit: Hilbich/AKG, Paris.

Pages 80–81

[1] Vaults of the nave, Exeter Cathedral, c. 1280–1290.
Credit: Magnum/Photo Erich Lessing, Paris.

[2] Detail of a stained-glass window, Canterbury Cathedral, c. 1180–1220.
Credit: Explorer/Photo B. Gérard, Vanves.

[3] Richard II. 1377.
Credit: Bridgeman-Giraudon, Paris.

ILLUSTRATION AND PHOTO CREDITS

Pages 82–83
[1] Simone Martini (1284–1344); *Guidoriccio da Fogliano,* c. 1330. Credit: Magnum/Photo Erich Lessing, Paris.

[2] Doges' Palace, Venice. 14th–15th century (facade on the jetty [14th century]; balcony [1404]; facade on the Piazzetta [1424–1442]). Credit: Explore/Photo M. Smith, Vanves.

[3] Giotto di Bondone (1266–1337); *The Dream of Innocent III,* late 13th century. Credit: AKG, Paris.

Pages 84–85
[1] The Court of the Lions, the Alhambra, Granada, Spain. Second half of the 14th century. Credit: Explorer/Photo R. Mattes, Vanves.

[2] Interior, Great Mosque of Cordoba. Late 10th century. Credit: Hoa Qui/Photo Ph. Body, Paris.

[3] The Cathedral of Burgos. 1221–1260 (upper portion and bell tower: 15th century). Credit: Bridgeman Art Library, Paris.

Pages 86–87
[1] Jean de Limbourg (14th century–before 1416); *Les Très Riches Heures du duc de Berry* (October), 1413–1416. Chantilly, Musée Condé. Credit: AKG, Paris.

[2] Hugo van der Goes (c. 1440–1482); right panel of the Portinari triptych (Maria and Margherita Portinari protected by Saint Mary Magdalene and Saint Margaret), c. 1475. Credit: S. Domingie/AKG, Paris.

[3] Fra Filippo Lippi (1406–1469); *Madonna and Child,* 1452. Credit: Alinari-Giraudon, Paris.

[4] Andrea del Verocchio (1435–1488), equestrian statue of the condottiere Bartolommeo Colleoni. 1481–1486. Cast by Alessandro Leopardi between 1490 and 1495. Credit: Cameraphoto/AKG, Paris.

Pages 88–89
[1] Filippo Brunelleschi (1377–1446); Pazzi Chapel, Church of Santa Croce, Florence. 1430–1443. Credit: S. Domingie/AKG, Paris.

[2] Tommaso Masaccio (1401–1428); *Expulsion of Adam and Eve from Paradise,* c. 1426. Credit: Scala, Florence.

[3] Donatello (c. 1386–1466); *Saint George,* 1415–1417. Credit: S. Domingie/AKG, Paris.

Pages 90–91
[1] Tomb of Philippe Pot, Seneschal of Burgundy, c. 1480. Credit: RMN, Paris.

[2] Enguerrand Quarton (active 1444–1466); *The Villeneuve-lès-Avignon Pietà,* c. 1455. Credit: RMN/Photo R.G. Ojeda, Paris.

[3] Jean Fouquet (1415/1420–1477/1481); *Virgin and Child Surrounded by Angels,* after 1452. Credit: AKG, Paris.

Pages 92–93
[1] Jan Van Eyck (1390–1441); *The Marriage of Giovanni Arnolfini and Giovanna Cerami,* 1434. Credit: Bridgeman Art Library, Paris.

[2] Rogier Van der Weyden (1399/1400–1464); *The Descent from the Cross,* c. 1435. Credit: Giraudon, Paris.

[3] Hans Memling (circa 1440–1494); *Triptych of Saint John the Baptist and Saint John the Evangelist,* 1474–1479. Credit: Giraudon, Paris.

Pages 94–95
[1] Gregor Erhart (c. 1470–1540); *Saint Mary Magdalene,* early 16th century. Credit: RMN/Photo R.G. Ojeda, Paris.

[2] Konrad Witz (1400/1410–c. 1445); *The Miraculous Draught of Fishes,* 1444. Credit: Bridgeman Art Library, Paris.

[3] Stefan Lochner (1410–1452); *The Virgin of the Rose Bush,* c. 1440. Credit: AKG, Paris.

Pages 96–97
[1] Paolo Uccello (c. 1397–1475); *The Battle of San Romano,* c. 1456-1460. Credit: Bridgeman Art Library, Paris.

[2] Piero della Francesca (c.1416–1492); *The Flagellation of Christ,* c. 1459. Credit: AKG/Photo Serge Domingie, Paris.

[3] Fra Angelico (c. 1387–1455); *The Annunciation,* 1440–1441. Credit: AKG/Photo Serge Domingie, Paris.

[4] Anonymous; *The Ideal City,* c. 1470. Credit: AKG/Photo Serge Domingie, Paris.

Pages 98–99
[1] Giovanni Bellini (1430–1516); *Virgin and Child,* c. 1487. Credit: AKG/Photo Serge Domingie, Paris.

[2] Donato Bramante (1444–1514); Il Tempietto, San Pietro in Montorio, Rome. 1502. Credit: Scala, Florence.

[3] Andrea Mantegna (1431–1506); *The Family of Lodovico II Gonzaga and His Court,* 1473. Credit: Scala, Florence.

[4] Sandro Botticelli (1445–1510); *Spring,* c. 1470. Credit: AKG, Paris.

Pages 100–101
[1] Hans Holbein (1497/1498–1543); *The Ambassadors* (Jean de Dinteville and George de Selve), 1533. Credit: Bridgeman Art Library, Paris.

[2] François Clouet (c. 1505/1510–1572); *Lady in Her Bath,* c. 1550. Credit: Scala, Florence.

[3] Paolo Caliari, known as Veronese (1528–1588); *Christ in the House of Levi,* 1573. Credit: Scala, Florence.

Pages 102–103
[1] Raffaello Sanzio, known as Raphael (1483–1520); *Portrait of Agnolo Doni,* 1505-1506. Credit: AKG/Photo Serge Domingie, Paris.

[2] Michelangelo Buonarroti (1475–1564); *David,* 1501–1504. Credit: AKG/Photo Serge Domingie and M. Rabatti, Paris.

[3] Leonardo da Vinci (1452–1519); *Mona Lisa.* Credit: RMN/Photo R.G. Ojeda, Paris.

Pages 104–105
[1] Great stairway of the François I wing, Château de Blois. 1515–1524. Credit: Hoa Qui/Photo Alfred Wolf, Paris.

[2] Jean Clouet (c. 1485/1490–c. 1541); *François I.* c. 1520–1525. Credit: RMN/Photo Hervé Lewandowski, Paris.

[3] Germain Pilon, (c. 1528–1590); *The Three Graces.* Monument to the heart of Henri II, c. 1560–1566. Credit: RMN/Photo D. Arnaudet et Scho, Paris.

Pages 106–107
[1] Quentin Massys (1465/1466–1530); *The Banker and His Wife,* 1514. Credit: RMN/Photo D. Arnaudet, Paris.

[2] Pieter Bruegel the Elder (c. 1525/1530–1569); *The Parable of the Blind.* Credit: Magnum/Photo Erich Lessing, Paris.

[3] Hieronymus Bosch (1450–1516); *The Haywain,* 1500–1502. Credit: Magnum/Photo Erich Lessing, Paris.

Pages 108–109
[1] Albrecht Dürer (1471–1528); *Self-portrait,* 1493. Credit: RMN/Photo D. Arnaudet, Paris.

[2] Matthias Grünewald (c. 1475–c. 1528); *The Crucifixion,* 1512–1516. Credit: Giraudon, Paris.

[3] Lucas Cranach the Elder (1472–1553); *Venus with Veil,* 1532. Credit: Bridgeman-Giraudon, Paris.

Pages 110–111
[1] Giorgio da Castelfranco, known as Giorgione (1477/1478–1510); *The Tempest,* c. 1507. Credit: Scala, Florence.

[2] Tiziano Vecelli, known as Titian (c. 1485–1576); *The Venus of Urbino,* c. 1538. Credit: AKG/Photo Serge Domingie, Paris.

[3] Jacopo Robusti, known as Tintoretto (1518–1594); *Transport of the Body of Saint Mark,* 1562–1566. Credit: AKG/Photo Cameraphoto, Paris.

Pages 112–113
[1] Giacomo Barozzi da Vignola (1507–1573); stairway of the Farnese Palace, Caprarola, near Viterbo. Constructed for Cardinal Alessandro Farnese. 1559–1564. Credit: Scala, Florence.

[2] Robert Smythson (1536–1614); Wollaton Hall, Nottinghamshire (England). 1580–1588. Credit: The Ancient Art & Architecture Collection, London.

[3] Andrea Palladio (1508–1580); Villa La Rotonda, Vicenza. Work commenced by Palladio in 1550, finished by Scamozzi in 1606. Credit: Bridgeman Art Library, Paris.

[4] Giuliano da San Gallo (1445–1516); Villa Poggio, Caiano, Tuscany. Constructed for Lorenzo de' Medici. 1480–1485. Credit: Bridgeman Art Library, Paris.

Pages 114–115
[1] Michelangelo Merisi, known as Caravaggio (1573–1610); *Death of the Virgin,* 1605–1606. Credit: RMN/Photo R.G. Ojeda, Paris.

[2] Giacomo della Porta (1540–1602); facade of the Church of Il Gesù, Rome, c. 1575. Credit: Scala, Florence.

[3] Jean-Antoine Houdon (1741–1828); *Bust of Voltaire,* 1778–1779. Credit: AKG, Paris

[4] Anthony Van Dyck (1599–1641); *Charles I, King of England, at the Hunt,* c. 1635. Credit: RMN/Photo C. Jean, Paris.

Pages 116–117
[1] Gianlorenzo Bernini (1598–1680); *The Ecstasy of Saint Theresa,* 1644–1647. Credit: AKG, Paris.

[2] Domenikos Theotokopoulos, known as El Greco (1541–1614); *The Holy Family,* c. 1590. Credit: AKG/Photo Joseph Martin, Paris.

[3] Benedictine Abbey, Melk, Austria. Work started by Jakob Prandtauer in 1702 and finished by Franz Munggenast in 1747. Credit: Hoa Qui/Photo S. Grandadam, Paris.

Pages 118–119
[1] Pierre Puget (1620–1694); *Milon of Croton,* 1670–1683. Credit: RMN /Photo C. Jean, Paris.

[2] Charles Le Brun (1619–1690); *Mary Magdalene Renouncing All Earthly Vanities,* c. 1650. Credit: RMN/Photo D. Arnaudet and Scho, Paris.

[3] Peter Paul Rubens (1577–1640); *The Education of Marie de Médicis,* 1621–1625. Credit: RMN /Photo C. Jean et H. Lewan, Paris.

Pages 120–121
[1] Christopher Wren (1632–1723); Saint Paul's Cathedral, London. 1675–1711. Credit: The Ancient Art & Architecture Collection/Photo Ronald Sheridan, Pinner.

[2] Louis Le Vau (1612–1670) and Jules Hardouin-Mansart (1646–1708); Château of Versailles, garden facade, 1669–1685. Credit: Hoa Qui/Photo X. Richer, Paris.

[3] Claude Gellée, known as Claude Lorrain (c. 1602–1682); *Ulysses Returns Chryseis to Her Father,* c. 1644. Credit: Lauros-Giraudon, Paris.

[4] Nicolas Poussin (1594–1665); *The Arcadian Shepherds (Et in Arcadia ego),* c. 1638. Credit: RMN, Paris.

Pages 122–123
[1] Rembrandt Harmenz van Rijn, known as Rembrandt (1606–1669); *Self-Portrait as the Apostle Paul,* 1661. Credit: Artephot/Photo A. Held, Paris.

[2] Frans Hals (1581/1585–1666); *Banquet of the Officers of the Order of Saint George,* 1616. Credit: Bridgeman Art Library, Paris.

[3] Diego Velázquez (1599–1660); *Las Meninas,* 1656. Credit: Bridgeman Art Library, Paris.

Pages 124–125
[1] Antonio Canale, known as Canaletto (1697–1768); *View of the Doge's Palace, Venice,* c. 1768. Credit: Scala, Florence.

[2] Jan Vermeer (1632–1675); *View of Delft,* 1661. Credit: Giraudon, Paris.

[3] Jean-Baptiste-Siméon Chardin (1699–1779); *The Basket of Grapes,* c. 1726–1728. Credit: RMN, Paris.

[4] François Mansart (1598–1666); Château de Maisons, Maisons-Laffitte (Yvelines, France), garden facade. 1642–1646. Credit: Gilbert Luigi, Paris.

Pages 126–127
[1] James Gibbs (1682–1754); bridge over the River Serpentine in the grounds of Stowe (Buckinghamshire, England). 1737. Credit: F.-X. Bouchart, Paris.

[2] Étienne-Louis Boullée (1728–1799); plans for a cenotaph for Isaac Newton. 1784. Credit: Bibliothèque nationale de France, Paris.

[3] Claude-Nicolas Ledoux (1735–1779); Les Salines, Arc-et-Senans (Doubs, France). 1775–1779. Credit: Hoa Qui/Photo C. Valentin, Paris.

Pages 128–129
[1] Jean-Honoré Fragonard (1732–1806); *The Bolt,* c. 1784. Credit: RMN/Photo Hervé Lewandowski, Paris.

[2] William Hogarth (1697–1764); *The Contract,* 1744. Credit: AKG, Paris.

[3] Gianbattista Tiepolo (1696–1764); *Venus Receives Mars.* Credit: AKG/Photo Cameraphoto, Paris.

[4] Jean-Antoine Watteau (1684–1721); *The Embarkation for Cythera,* 1717. Credit: RMN/Photo G. Blot, Paris.

Pages 130–131
[1] Antônio Francisco Lisboa, known as Aleijadinho (1738–1814); Nossa Senhora do Carmo, Ouro Prêto (Brazil). 1770–1795. Credit: Hoa Qui/Photo H. Ruiz, Paris.

[2] Church of San Francisco, Acatepec (State of Puebla, Mexico), c. 1730. Credit: Archipress/Photo François Loze, Paris.

[3] Thomas Jefferson's house, Monticello (Virginia). 1796–1806. Credit: Hoa Qui/Photo C. Lenars, Paris.

Pages 132–133
[1] Jean-Auguste-Dominique Ingres (1780–1867); *Portrait of Louis-François Bertin, known as Bertin the Elder,* 1832. Credit: RMN/Photo G. Blot, Paris.

[2] Jean-Baptiste Corot (1796–1875); *Souvenir of Mortefontaine,* 1864. Credit: RMN/Photo R.G. Ojeda, Paris.

[3] Georges Seurat (1859–1891); *A Sunday on the Grande Jatte,* 1885. Credit: AKG, Paris.

[4] Antoni Gaudí (1852–1926); Sagrada Familia, Barcelona. 1883–1985. Credit: Explorer/Photo S. Grandadam, Vanves.

Pages 134–135
[1] Francisco Goya (1746–1828); *The Third of May 1808: The Execution of the Defenders of Madrid,* 1814. Credit: AKG, Paris.

[2] Théodore Géricault (1791–1824); *The Raft of the Medusa,* 1819. Credit: RMN/Photo Arnaudet, Paris.

[3] Jacques Louis David (1748–1825); *The First Consul Crossing the Alps at Grand-Saint-Bernard Pass,* 1800. Credit: RMN, Paris.

Pages 136–137
[1] Caspar David Friedrich (1774–1840); *The Traveler Above a Sea of Clouds,* c. 1818. Credit: AKG, Paris.

[2] Joseph Mallord William Turner (1775–1851); *The Fighting Téméraire,* 1838. Credit: AKG, Paris.

[3] Eugène Delacroix (1798–1863); *The Death of Sardanapalus,* 1827. Credit: RMN/Photo Hervé Lewandowski, Paris.

Pages 138–139
[1] Gustave Courbet (1819–1877); *The Stormy Sea* (also known as *The Wave*), 1870. Credit: RMN, Paris.

[2] Édouard Manet (1832–1883); *Déjeuner sur l'herbe,* 1863. Credit: RMN/Photo Hervé Lewandowski, Paris.

[3] John Constable (1776–1837); *Tree Trunk,* c. 1821. Credit: Bridgeman Art Library, Paris.

Pages 140–141
[1] Winslow Homer (1836–1910); *Summer Night,* 1890. Credit: RMN/Photo Hervé Lewandowski, Paris.

[2] James Abbot McNeill Whistler (1834–1903); *Arrangement in Grey and Black, No. 1: The Artist's Mother,* 1871. Credit: RMN/Photo Jean Schormans, Paris.

[3] John Singer Sargent (1856–1925); *Lady Agnew of Lochnaw,* 1892–1893. Credit: Bridgeman Art Gallery, Paris.

Pages 142–143
[1] Auguste Renoir (1841–1919); *The Swing,* 1876. Credit: RMN/Photo Hervé Lewandowski, Paris.

[2] Claude Monet (1840–1926); *Gare Saint-Lazare,* 1877. Credit: RMN/Photo Hervé Lewandowski, Paris-ADAGP, 1999, Paris.

[3] Edgar Degas (1834–1917); *Young Dancer of Fourteen* or *The Great Dancer Dressed,* 1880–1881. Credit: RMN/Photo R.G. Ojeda, Paris.

Pages 144–145
[1] Paul Gauguin (1848–1903); *Arearea,* 1892. Credit: RMN/Photo Hervé Lewandowski, Paris.

[2] Paul Cézanne (1839–1906); *Mont Sainte-Victoire,* c. 1894–1900. Credit: AKG, Paris.

[3] Vincent van Gogh (1853–1890); *L'Église d'Auvers-sur-Oise,* 1890. Credit: RMN/Photo Gérard Blot, Paris.

ILLUSTRATION AND PHOTO CREDITS

Pages 146–147
[1] William Bouguereau (1825–1905);*The Birth of Venus*, 1879. Credit: RMN/Photo Hervé Lewandowski, Paris. 1883-1985.

[2] Jean-Léon Gérôme (1824–1904) and Aimé Morot (1850–1904); *Gérôme Executing "The Gladiators." Monument to Gérôme*, 1878. Credit: RMN/Photo Jean, Paris.

[3] Charles Garnier (1825–1898); stairway, Opéra Garnier, Paris. 1861–1875. Credit : Archipress/Photo Franck Eustache, Paris.

Pages 148–149
[1] Edvard Munch (1863–1944); *The Scream*, 1893. Credit: AKG, Paris/Munch Museet-The Munch Museum/ The Munch Ellingsen Group/ ADAGP, 1999, Paris.

[2] James Ensor (1860–1949); *Remarkable Masks*, 1891. Credit: Lauros-Giraudon-ADAGP, 1999, Paris.

[3] Auguste Rodin (1840–1917); *The Kiss*, 1886. Paris, Musée Rodin. Credit: Giraudon, Paris.

Pages 150–151
[1] Gustave Moreau (1826–1898); *The Unicorns*, 1885. Credit: RMN/Photo R.G. Ojeda, Paris.

[2] Odilon Redon (1840–1916); *The Cyclops*, c. 1898–1900. Credit: AKG, Paris.

[3] Edward Burne-Jones (1833–1898); *Sleeping Beauty*, 1880. Credit: Bridgeman Art Library, Paris.

Pages 152–153
[1] Dankmar Adler (1844–1900) and Louis Sullivan (1856–1924); Auditorium Building, Chicago. 1886–1893. Credit: Gilbert Luigi.

[2] Gustave Eiffel (1832–1923); Eiffel Tower, 1887–1889. Credit: Studio Chevojon, Paris.

[3] Henri Labrouste (1801–1875); interior, Sainte-Geneviève Library, Paris. 1843–1850. Credit: Archipress/Photo Franck Eustache, Paris.

Pages 154–155
[1] Victor Horta (1861–1947); Maison Tassel, Brussels. 1892–1893. Credit: Ch. Bastin and J. Evrard, Brussels-All rights reserved.

[2] Josef Hoffman (1870–1956); Palais Stoclet, Brussels. 1905–1911. Credit: Hilbich/AKG, Paris-All rights reserved.

[3] Gustav Klimt (1862–1918); Adele Bloch-Bauer, 1907. Credit: AKG, Paris.

Pages 156–157
[1] Walter Gropius (1883–1967); Bauhaus School, Dessau (Germany), 1925. Credit: AKG, Paris-All rights reserved.

[2] Kurt Schwitters (1887–1948); *Merzbild 9 b*, 1919. Credit: AKG, Paris-ADAGP, 1999, Paris.

[3] Marc Chagall (1887–1985); *Double Portrait with Wineglass*, 1917–1918. Credit: Photothèque Centre Georges Pompidou/Mnam/ Photo Adam Rzerpka, Paris-ADAGP, 1999, Paris.

[4] Marcel Duchamp (1887–1968); *Fountain (Urinal)*, 1917–1964. Credit: Photothèque Centre Georges Pompidou/Mnam/ Photo Philippe Migeat, Paris-Succession Duchamp/ADAGP, 1999, Paris.

Pages 158–159
[1] Georges Braque (1882–1963); *Woman with Guitar*, 1913. Credit: Lauros-Giraudon, Paris-ADAGP, 1999, Paris.

[2] Ossip Zadkine (1890–1967); *The Composer*, 1935. Credit: Giraudon, Paris-ADAGP, 1999, Paris.

[3] Pablo Picasso (1881–1973); *Les Demoiselles d'Avignon*, June–July 1907. Credit: The Museum of Modern Art, New York-Succession Picasso, 1999, Paris.

Pages 160–161
[1] Piet Mondrian (1872–1944); *Composition in Red, Yellow and Blue*, 1928. Credit: AKG, Paris-Mondrian/ Holzman Trust/ADAGP, 1999, Paris.

[2] Vassily Kandinsky (1866–1944); sketch for *Composition IV*, 1910. Credit: AKG, Paris-ADAGP, 1999, Paris.

[3] Kasimir Malevich (1878–1935); *Suprematist Composition: White on White*, 1918. Credit: AKG, Paris.

Pages 162–163
[1] Ernst Ludwig Kirchner (1880–1938); *Marzella*, 1909–1910. Credit: AKG, Paris-© Dr. Wolfgang & Ingeborg Henze-Ketterer, Wichtrach/Bern.

[2] August Macke (1887–1914); *Spaziergang im Garten*, 1914, Photo: Rolf Giesen, Krefeld

[3] Max Beckmann (1884–1950); *Family Portrait*, 1920. Credit: AKG, Paris-ADAGP, 1999, Paris.

Pages 164–165
[1] Amedeo Modigliani (1884–1920); *Nude Sitting on a Couch*, 1917. Credit: Edimedia, Paris.

[2] Constantin Brancusi (1876–1957); *Mlle Pogany I*, 1912–1913. Credit: AKG, Paris-ADAGP, 1999, Paris.

[3] Charles-Édouard Jeanneret, known as Le Corbusier (1887–1965); Villa Savoye, Poissy, France. Credit: Gilbert Luigi, Paris-FLC/ADAGP, 1999, Paris.

Pages 166–167
[1] Salvador Dali (1904–1989); *The Persistence of Memory*, 1931. Credit: AKG, Paris-ADAGP, 1999, Paris.

[2] Giorgio De Chirico (1888–1978); *Melancholy*, c. 1912. Credit: AKG, Paris-ADAGP, 1999, Paris.

[3] Paul Klee (1879–1940); *Senecio*, 1922. Credit: AKG, Paris-ADAGP, 1999, Paris.

[4] Max Ernst (1891–1976); *Capricorn*, 1948–1964. Credit: Photothèque Centre Georges Pompidou/Mnam/ Photo Philippe Migeat, Paris-ADAGP, 1999, Paris.

Pages 168–169
[1] Georgia O'Keeffe (1887–1986); *Orchid*, 1941. Credit: Private collection-ADAGP, 1999, Paris.

[2] Edward Hopper (1882–1967); *City Sunlight*, 1954. Credit: AKG, Paris-ADAGP, 1999, Paris.

[3] Thomas Hart Benton (1889–1975); *Social Life*, 1930. Credit: Giraudon, Paris-ADAGP, 1999, Paris.

Pages 170–171
[1] Otto Dix (1891–1969); *The Seven Deadly Sins*, 1933. Credit: AKG, Paris-ADAGP, 1999, Paris.

[2] George Grosz (1893–1959); *Gray Day*, 1921. Credit: AKG, Paris-ADAGP, 1999, Paris.

[3] Fernand Léger (1881–1955); *The Builders*, 1951. Credit: AKG, Paris-ADAGP, 1999, Paris.

[4] Ludwig Mies van der Rohe (1896–1969); German Pavilion, World's Fair, Barcelona. 1929. Credit: Archipress/Photo Franck Eustache, Paris-ADAGP, 1999, Paris.

[4] Diego Rivera (1886–1957); detail from *The Great Tenochtitlán* (vegetable sellers), 1945. Credit: Giraudon, Paris-INBA, México.

Pages 172–173
[1] Joan Miró (1893–1983); *Women, Bird by Moonlight*, 1949. Credit: AKG, Paris-ADAGP, 1999, Paris.

[2] Henry Moore (1898–1986); *Reclining Figure*, 1938. Credit: Bridgeman, Paris-The Henry Moore Foundation.

[3] Henri Matisse (1869–1954); *The Peasant Blouse*, 1940. Credit: AKG, Paris-Succession Henri Matisse, 1999, Paris.

Pages 174–175
[1] Francis Bacon (1909–1992); *Untitled*, Triptych: right panel, August 1972. Credit: AKG, Paris-ADAGP, 1999, Paris.

[2] Alberto Giacometti (1901–1966), *Walking Man*, c. 1949. Credit: AKG, Paris-ADAGP, 1999, Paris.

[3] Chaim Soutine (1893–1943); *The Little Pastry Cook*, Undated. Credit: AKG, Paris-ADAGP, 1999, Paris.

Pages 176–177
[1] Mark Rothko (1903–1970); *Untitled*. c. 1959. Credit: Private collection-Kate Rothko Prizel & Christopher Rothko/ADAGP, Paris.

[2] Arshile Gorky (1904–1948); *To Project, To Conjure*, 1944. Credit: Private collection-ADAGP, Paris.

[3] Jackson Pollock (1912–1956); *Guardians of the Secret*, 1943. Credit: AKG, Paris-ADAGP, 1999, Paris.

Pages 178–179
[1] Andy Warhol (1928–1987); *Campbell's Soup Can*, 1966. Credit: AKG, Paris-ADAGP, 1999, Paris.

Works cited

Page 12: Georges Bataille. *Lascaux ou la Naissance de l'art*. Geneva: Skira, 1980: 12.

Page 18: Ernst Gombrich. *Histoire de l'art*. Paris: Gallimard, 1998: 55.

Page 22: Élie Faure. *Histoire de l'art*. Paris: Le Livre de poche, vol. 1: 89.

Page 33: C.M. Bowra. *L'Expérience grecque*. Paris: Fayard, 1969: 175.

Page 37: Aristotle. *Éthique à Eudime*. Paris: Rivages Poche, 1994: 44.

Page 49: René Huyghe. *L'Art et l'Homme*. Paris: Larousse, 1957, vol. 1: 322.

Page 64: *Eugène Viollet-le-Duc. Dictionnaire raisonné de l'architecture française*, quoted in *Histoire de l'art*. Paris: Gallimard, La Pléiade, vol. 2: 346.

Page 74: Georges Duby. *L'Europe des cathédrales*. 215.

Page 78: Friedrich Heer. *L'Univers du Moyen Age*. Paris: Fayard, 1979: 149.

Page 98: Heinrich Wölfflin. *Renaissance et baroque*. Brionne: Gérard Monfort: 57.

Page 110: Élie Faure. *Histoire de l'art. L'art renaissant*. Paris: Denoël, Folio Essais, 1988: 209.

Page 118: Jacob Burckhardt. In *La Grande Encyclopédie*. Paris: Larousse, 1972, vol. 3.

Page 144: Paul Gauguin. Oviri. *Écrits d'un sauvage*. Paris: Gallimard, Idées, 1974: 339.

Page 155: Quoted in Carle Schorske. *Vienne fin de siècle*. Trans. Paris: Le Seuil, 1983: 215.

Page 159: Pablo Picasso. Quoted in M.-L. Bernadac and Paule du Bouchet, *Picasso, le sage et le fou*. Paris: Découvertes Gallimard, 1986: 125.

Page 161: Kasimir Malevich. *Écrits*. Paris: Ivrea, 1996: 198.

Page 170: Otto Dix. Quoted in Eva Karcher, *Dix*. Cologne: Benedikt Taschen, 1992: 200.

Page 175: Michel Leiris. *Francis Bacon ou la Brutalité du fait*. Paris: Le Seuil, 1995: 135.

Page 181: Jean Dubuffet. *Asphyxiante Culture*. Paris: Minuit, 1986: 48.